KRULL · WOMEN IN ART

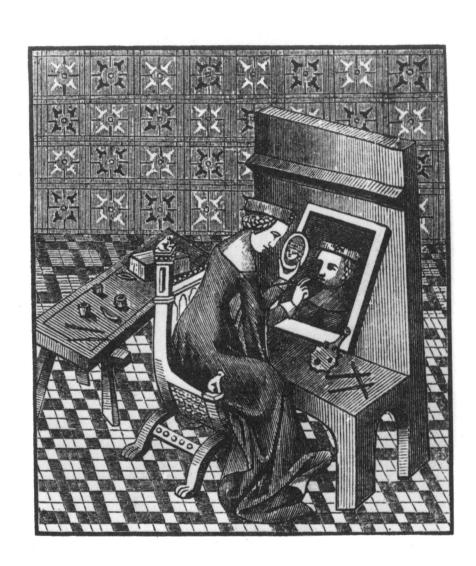

Edith Krull

WOMEN
IN ART

STUDIO
VISTA

Studio Vista

an imprint of
Cassell plc
Artillery House, Artillery Row
London SW1P 1RT

First published in Great Britain 1989

British Library Cataloguing in Publication Data

Krull, Edith, *1911 –*
Women in art: a history of women artists
1. Visual arts. Women artists.
I. Title
709'.22

ISBN 0-289-80019-6

Translated from the original German by
T Lux Feininger
Designed by Ulrike Weissgerber
Printed and bound in the German Democratic Republic

CONTENTS

FOREWORD

For more than a decade, but more particularly since 1975, the Year of the Woman, exhibitions and publications dealing with the products of female creative artists have multiplied. European and American authors, for the most part women, have begun specifically to discuss this topic. A major portion of these studies is devoted to the purpose of examining feminine creativity in the field of the Fine Arts, and has produced an impressive amount of information in regard to women artists and their distinctly noteworthy achievements, which had previously remained unknown. Recently valuable investigations have been undertaken into their sociological situation, as can be seen from Renate Berger's book *Malerinnen auf dem Weg ins 20. Jahrhundert* (Female painters on the road to the 20th century). More or less conservatively-minded male art and cultural historians had of course been giving attention to the subject of women in the arts since the middle of the last century, perhaps stimulated by their apprehensiveness relative to the growth of the Feminist Movement in those decades. Their drift may be summed up as admitting that women, chiefly because of their presumed tendency toward an accentuated sensibility, might do well enough (if it had to be) not only in nursing, pedagogical and similar specifically "feminine" activities but even in the arts, whose function, as well known, was, to ornament and embellish life rather than to interpret it, let alone to change it. The natural place of women in the arts was in the role of home decorators, or in performing uplifting musical or theatrical works, composed of course by men; the writer might even go so far as to grant them a talent for literature. This type of attitude was determined by a more or less conscious prejudice on the part of the writer, according to which the nature of the female sex forbade their being capable of acts of creation. This bias is even perceptible in otherwise quite ob-

jective investigations of the works of women in the visual arts on the part of male authors, such as Anton Hirsch and Hans Hildebrandt. Such men have spared no efforts to enumerate and comment on feminine achievements in these areas, but never abandoned the male standard of criticism which, especially with Hildebrandt, inevitably has a depreciating effect on the work criticized: pretty good for a woman.

All such authors have, however, overlooked one point of view of both sociological and cultural-historical significance in their commonly one-sided studies: the fact that the visual arts have been the only skilled profession open to women, whose unbroken existence can be documented from Renaissance times on, i.e., for well over four centuries. This profession, based on a more or less systematically conducted previous apprenticeship, allowed women to engage in productive activity and consequently to gain a living in the arts; moreover, this occupation was always recognized and respected by society quite independently of the relative merits of the works of individuals.

It is true that women in literature enjoyed equal respect on the part of bourgeois society; but until our time, writing was not taught as a profession. On the other hand, musicianship and acting by women, while normally preceded by an apprenticeship, have not been regarded with the same approbation by society, with the exception of isolated cases of unusual prominence. The warning cry: "Take the washing off the line, the comedians are coming to town!" could still be heard in the early years of our century.

Concerning the feminine trades not related to the arts, e.g. midwifery, sick nursing or schoolteacher—let alone manual work (we are reminded of Christiane Vulpius, who earned her bread by making artificial flowers, before Goethe invited her into his household)—it is not possi-

ble to trace instruction being available in these occupations during the past several centuries, even though women were taught a great variety of skills in the nunneries of the 16th to 18th centuries.

In contrast to this, women in the visual arts, regardless whether "creative" or recreative, had to give evidence of having received instruction of whatever quality by a master before they could hope to gain recognition, not differing in this from their male colleagues.

With the exception of those periods of open sympathy with feminine life, e.g., the Renaissance or the Age of Enlightenment, when signs of the emancipation of women were viewed with relative benevolence, or were even encouraged by society, it must be said that the bourgeois attitude toward creative women remained in general full of distrust, because they aimed at an independence not readily granted. Nonetheless the bourgeois mentality found itself compelled to accept women artists willy-nilly in a great variety of their manifestations, for several reasons. Not only had it happened that women rose to the rank of court artist, or had been elected as members of renowned academies—which for lack of opportunities rarely or never happened to female writers or stage artists—but they belonged to a profession in which members of the upper classes loved to dabble as dilettantes themselves and the products of which, in great demand by collectors, could well contribute to an increase in status even of a member of the bourgeois middle class. This is, however, chiefly applicable for the 16th, 17th and 18th centuries; by the middle of the 19th century a transformation in the attitude toward women artists sets in, in keeping with the shifting social patterns of the epoch, as we shall demonstrate further on. But despite these changes their vocation continued to be a recognized skilled profession, albeit not free from controversy.

The purpose of our study is, to document the ways and manner in which women in the plastic arts have accomplished their goals in the course of four centuries, regardless of whether in an originating or a reproductive role; how they have dealt with obstacles opposing their career and, in general, how they have conducted their lives: the backgrounds from which they came, and the goals toward which they were striving. In this we shall be guided less by art-historical considerations than by the point of view of cultural-historical and socio-economical conditions.

In the choice of illustrations we have aimed at showing the manysidedness of the productions of women in the arts of a period spanning four centuries. The intention was not so much to present fresh evidence of the peak performances of female artists already sufficiently famous, as to illustrate the breadth of feminine creativity in the artistic life of their respective epochs, which was of course determined by masculine standards, although women played a considerable part in it, though perhaps mostly in the second or even third position.

The author's chief source was the *Künstlerlexikon* by Thieme-Becker despite information in this work being partly outdated, unprecise or incomplete, as we discovered when our investigations turned up a sizeable number of women artists not listed in the lexicon. Notwithstanding these defects the compendium became a useful basis after the appropriate controlling corrections had been applied. All volumes of the lexicon were systematically checked for the names of women artists. This presented some difficulties of identification, as a substantial number of artists were listed under their maiden names as well as in their married condition, in some cases without annotation.

The survey showed that amongst roughly 150,000 listings by *Thieme-Becker* some 6,000 are women, occupied almost exclusively in the fields of painting, printmaking and sculpting, whereas thousands of male artists were engaged in such crafts as cabinetmakers, upholsterers, gunstock makers, stone cutters, architects and similar trades closed to women. If it were possible to ascertain the numerical proportion of male and female art workers in the purely "classical" categories alone, the women would gain very considerably, but this kind of statistics is not available.

In contrast to this the *Thieme-Becker* material in some way does indicate traits of a shifting proportion of women artists in the European countries and later on also in America. Up to about 1700, Italy and the Netherlands are leading in the numbers of active women artists. From 1700 onwards begins a period in which the overall numbers of female artists show strong growth in all countries, France becoming their principal homeland. Ger-

many and England likewise register steady, at times considerable, increase of women in the Fine Arts until well beyond the year 1800, while the Italian and Dutch contingents dwindle markedly. Up to the end of the 19th century, Scandinavian and eastern European women are listed in rising quantities; but the chief increase lies in the numbers of American women artists after 1850, especially amongst sculptors. From 1850 on, France, Germany, Austria, England and the Scandinavian and eastern European countries represent steady growth, while Spain, Italy and also the Netherlands continue to recede in proportion. Obviously these proportionate changes reflect the importance assigned to art affairs in the respective areas, quite independently of the fact that the numbers of male artists undergo corresponding changes.

The principal theme of our study will be, to trace a professional profile of female painters, graphic artists and sculptors who had received training in one of these disciplines and who had subsequently practiced them.

Dilettantes are included only as an exception, since they did not gain their living by their art; for the same reason the "naive" or "Sunday" artists were excluded, but they were very few in number.

The study terminates approximately around 1920, this year marking the point in time when Germany, as the last of the European countries to make this concession, opened its art academies to female students, whereby they were integrated at least formally into art life on a basis of equality with men. Although the goal was to present as rounded a picture as possible of the living and working conditions of women artists in the various European countries, and later on also in America, the nature of the source material available to the author made for a certain preponderance of German artists. This is the place to emphasize that the situation of German women in the arts, due to the petty bourgeois tenor of life which prevailed far into the late 19th century, can be regarded as only conditionally symptomatic of the situation of female artists in other countries.

THE BEGINNINGS
OF FEMALE ARTISTIC CREATIVITY

The Renaissance offers a suitable point of departure to begin our examination of the professional image of women in the Fine Arts. It is the epoch when women came upon the scene in meaningful numbers as professionals, for the most part as painters. During the Renaissance, the status of the artist, irrespective of sex, underwent changes, as individual artists began to emerge from the hitherto more or less compulsory ties with the artisan class and achieved their emancipation by becoming "creative" or "free" artists—an evolution which could not help having a causal influence on the increasing presence of female artists as well.

It would be a mistake to assume that, prior to the Renaissance, women had been unknown in an artistic role. Pliny the Elder refers in Book No. 35 of his Encyclopedia to several female painters of Greco-Roman antiquity, said to have created some famous works in their time. He speaks of a majority of them as the daughters of artists.

In the Middle Ages, both convents and the courts of princes were centers of female art productions, although these qualify only very conditionally as professional activity in the sense claimed by the author. The inmates of nunneries were economically bound to their convents, regardless of what their activities produced: whether embroideries, book illuminations and miniatures, calligraphic texts, tapestries or, in isolated cases, even paintings or small sculptures. Although they engaged in creating works and may even have been trained for such work in particular cases, it was not their profession, i.e., the exercise of faculties largely dependent on the individual's own, freely disposable earning powers, is not to be confused with the conditions which existed in family and workshop situations, to be discussed later.

Neither did the ladies at princely courts, who are mentioned as embroiderers, book illuminators and tapestry makers, practice art professionally, although they cannot be called dilettantes either. Their half-way status brings to mind those women who were employed in the partly artistic, partly mechanical production of tapestries, textiles, embroideries, lace making or silk spinning, often in regular workshops such as feudal lords maintained at their castles and courts, and which employed up to 300 bondswomen as spinners, weavers, seamstresses and embroidery makers. Some cloisters also had such workshops.

In 13th and 14th century France, silk spinners, weavers, milliners, embroiderers and purse makers were organized in guilds, presided over by a guild mistress. Cologne and other German urban centers had also sizeable female trade corporations. Female artisanship flourished especially in the time between the early 13th and the late 15th centuries, this being a period when labor was relatively scarce. During the time when economic difficulties of various kinds caused a general worsening of conditions and led to the nearly total expulsion of women from the various guilds, as the economically weaker party, they had to yield to male labor taking over their previous employment as tapestry workers, lace makers, textile and bead workers, etc.

Making due allowance for differences in training concepts then and now, the professional type of the female fine artist first emerged in Italy during the Renaissance, as already stated; the Netherlands followed soon after, subsequently other European countries as well. The humanist ideal of education, first applied to both sexes in Italy, included acquaintance with the liberal arts, literature, music, painting; professionally speaking, however, painting and sculpture were almost the only branches in which women became engaged, for the principal reason that access to them was open to everyone, e.g., in the

churches, while music and literature were mainly cultivated by the dilettantes at courts and in patrician homes. As it was common for women to do some artistic work, nothing unseemly was attached to the idea that some of them might make it a regular vocation: to the contrary, contemporary writers, e.g. Vasari, were apt to bestow high praise on female artists. Amongst the names singled out by him for particular mention we find the sculptor and engraver Properzia de Rossi, the painting nun Plautilla Nelli and especially the painter Sofonisba Anguissola. With few exceptions such women were the daughters of artists; they became professional painters in their own right after studying with their fathers in the tradition of antiquity, and well into the 19th century, this was the usual professional background for female artists. Those women who did not come from artistic families must have found it much harder to obtain professional preparation in the skills of the painter and engraver, let alone of the sculptor.

An early example of such an exception is Sofonisba Anguissola (1535 or 1540–1625), the first Renaissance woman painter to reach European fame in art. Descended from a patrician family of Cremona, she was one of six sisters, all of whom were trained to become painters. Sofonisba was the most gifted, and attained fame so early in life that Philip II of Spain appointed her court painter where she drew a handsome salary. But the careers of people like Lavinia Fontana (1552–1614) or Artemisia Gentileschi (1593–1652) are more typical; the former was an artist's daughter from Bologna and often commissioned by patrons, including again Philip II, who seems to have favored female painters and who paid her 1,000 ducats for her painting "The Holy Family with John the Baptist"; the latter became a member of the Academy of Florence at the age of 23; both her father and her grandfather had been painters.

Such painters, soon joined by many more, of equal fame, such as Barbara Longhi (1552–1638) or Elisabetta Sirani (1638–1665), to name only these two, established the professional image of the creative woman artist in their time. Changes in the general social structure, and of course also in modes of artistic production, brought certain modifications in the post-Renaissance centuries. For a long period, as is easily seen in *Thieme-Becker* and other

sources, the basic professional requirement for any artist was the ability to give evidence of being qualified for his or her vocation; such qualification usually consisted of instruction received from a master or some equivalent training situation, particularly of course in the times before art schools became established. For a long while it was sufficient to have had some training in the studio of some artist or in a workshop specializing in reproduction methods. Academic training as we understand it today began to have importance only in the course of the 19th century.

Modern research shows that the part of women in the Fine Arts of the Renaissance was much greater than had previously been supposed. *Thieme-Becker* identifies approximately 30 female artists in Italy in the 15th century, and about 90 in the 16th century. Jacob Burckhardt, in his *Kultur der Renaissance in Italien* (The culture of the Renaissance in Italy), could still write that the female contingent in the visual arts, compared to their part in poetry for example, was extremely modest. Actually however, while it is true that women artists were overshadowed by the huge numbers of famous painters and sculptors of their period, this fate was shared by many of their talented male colleagues, who, if they had lived in less "opulent" times, would have received more attention.

If one compares the artistic achievements of women painters of the Renaissance with those of subsequent eras, the former excel both in freedom of concept and in technical mastery. The vigor of the intellectual climate of the Renaissance vivified men and women alike. Enjoying considerable personal freedom, and helped by generous patrons, it is no wonder that the talents of gifted women could flourish and that their creativity unfolded spontaneously—a faculty which succeeding generations were again and again to try to deny them.

One might almost say that the women artists of the Italian Renaissance carried their goal at the first try and reached positions which those of other countries and times had to reconquer all over again: they became court artists, like Sofonisba Anguissola, or highly sought-after teachers, like Elisabetta Sirani, who in her short life trained not only her two sisters but a whole row of painters, including some men. Some of these women were recipients of handsome honorariums, enabling them to

contribute materially to the support of their families. Thus Sofonisba's father was paid an annual salary of 800 lire by the Spanish king for his daughter's productions.

We have already spoken of the transformation of artisans into free artists taking place in Italy first. A Grandducal decree of 1571 liberated all Florentine academicians from compulsory membership in a guild, and consequently also from all restraints which had previously attended their apprenticeship. Most of the other European countries followed this example sooner or later. But as late as 1756 it was still possible for a German guild to forbid Anton Graff from Augsburg to paint, because he had not served the required training period. In general, however, one may say that, with the Renaissance, corporate rule ceased to hold sway over free artists, which facilitated access to the visual arts to women, inasmuch as the only kind of reference required of them was the same as for men, i.e., previous study with a master. We have already said that in most cases such early schooling would come from a father, sometimes also from a brother or husband, in rarer cases from a teacher outside of family connections. No standards were set for admission to art training after the guild rules were lifted. It must be said that one of the consequences of the lowering of the barriers was the growth of a numerous art proletariat, documented as such for Italy and also, to a certain extent, for the Netherlands. Women, however, formed only a small part of it, because of their closer ties with their families and with tradition in general.

In other countries corporate compulsion maintained itself longer, as Netherlandish documents prove. Women were not exempt, of course. The Flemish miniature painter Maria van Deynum was granted a master's patent in 1668/1669 as master's daughter in Antwerp; likewise, in 1632/1633, the Flemish Angela Maria Dircksz (died 1678) and, in 1654, the Flemish master's daughter Katharina de Pepyn (1619–1688). Other female painters belonged to the *Lukasgilden* (guilds of St. Luke) of their respective hometowns, thus for instance Judith Leyster (1609–1660) who became famous.

One cannot help being struck by the large number of nuns of many different orders who were active in the Fine Arts, mostly in Italy but also in other countries. Even though cloisters had fostered the arts since the earliest times, the proportion of painting nuns rose steadily with the coming of the Renaissance. Many of them ornamented the churches and convents of their respective orders and not a few were held in high regard. It is likely that some of these nuns had had some art instruction prior to their taking the veil, but the majority were autodidacts. Possibly some of the painting nuns had entered their convents in the hope of being able to become painters, their social position prior to taking orders not affording them opportunities for study or the creative life. In the cloister no proof of instruction was required and native artistic ability had many possible outlets, not merely during the Renaissance which rejoiced in lavish imagery, but also later; and of course the pious sisters would not expect a honorarium for their labors. Therefore, if we consider their being economically dependent on their respective religious orders, we cannot regard them as professionals in the sense in which we have defined this term, but they approached this condition.

Besides the nuns there were a sizeable number of other female free artists who executed commissions for the decoration of churches and cloisters, and thereby competed with their male colleagues in the field.

After the professional image of female practitioners in the Fine Arts had consolidated to some extent during the Renaissance, it evolved, in the periods that followed the Golden Age, under the influence of conditions and assumptions which differed in more than a few ways from the rules governing male artists. The worst discriminatory feature became the difficulty of admission into art academies, from which ensued the near impossibility of life study of the male nude, of which more will be said later on; further, and more generally, the continuing erosion of any regard for feminine artistry which is so characteristic of the 19th century; lastly, and always, the biological and social factors of marriage, motherhood and family, imposing their limitations on all working women. Therefore the following chapters will concentrate specifically on those aspects which determined both living conditions and productivity of female artists.

OPPORTUNITIES
FOR TRAINING AND EXHIBITING

Until about the middle of the 19th century the training of women artists had changed but little. A majority of them studied with a private master as before. In the printshops of the 18th century, indeed, which were mostly copper engraving shops, it was no rarity for daughters and sons of the master/owner to receive the same technical training side by side. Beyond this, ambitious girls could apprentice themselves like the young men, to painters, engravers or sculptors of greater or lesser fame, who conducted ateliers for budding art workers. From the middle of the 18th century on, and particularly in France, we see such shops being headed by women with increasing frequency. The same as with an enterprise run by a man, the objective was, of course, to add to the income by way of tuition fees. Such ateliers were not necessarily confined to a female clientele (some workshops advertized themselves as open to "ladies and gentlemen"), but we may assume that the female contingent outnumbered the males, chiefly because parental anxiety would deem a daughter to be safer under the care of a woman. Irrespective of their sex, most of the pupils in such establishments did not think of their studies as vocational preparation, because acquaintance with the arts was in those times considered to be an essential part of gentle breeding.

In the early 19th century some women did succeed, despite obstacles, to gain admission to state Beaux-Arts schools, provided they had suitable sponsors. Maria Ellenrieder—she was deaf by the way—(1791–1863) was the first woman in Germany to matriculate at an academy; she became a pupil of Langer, at the Munich Academy; a Bishop Wesenberg had mediated her application. But it has largely escaped attention that, after making this beginning with Maria Ellenrieder, the Academy at Munich continued to accept other women students, as is shown by the class lists. In the period between 1813–1840 girls entered the school at an annual rate averaging between 1 and 5, fifty students being admitted during this period. With a single exception (Nicole Eichenlaub from Erbach, enrolled in 1840) who is listed as a sculpture student, they were all painting pupils in various specialized genres: miniature, historical, landscape, portrait, figure painting and drawing, and general painting. Most of them were Germans, but the following nationalities were represented each with one student: France, England, Italy, Switzerland. Their ages at the time of admission ranged from 13 to 28 years; very few of them became known by their art in later life.

Thieme-Becker's index lists only eleven of these women as artists, four of whom also appear in the *Maillinger-Chronik* (Maillinger chronicle) (Munich 1876–1886). It is likely that most of these pupils practiced their art as a sideline or as a dilettante; nevertheless the high figure is surprising. We have not examined material from other art schools, but it is known that some few German academies occasionally accepted female students in the 19th century, for instance at Dresden and Düsseldorf.

In the main, however, until the end of the 19th century women depended on private schools for their training; some of these had an excellent reputation, for example the Académie Julian in Paris. After the death of its founder, his wife, who was a professional artist herself, assumed the directorship of the school. Places at the academy were in such demand, especially with American women, that the director had to teach some of the classes herself. Paris was the Mecca of art aspirants in those times; the available establishments were scarcely sufficient to accomodate the masses of art students of both sexes clamoring for admission. Besides the schools, quite a few Parisian artists, including some fairly well known

ones, accepted male and female pupils in their ateliers for suitable fees. The following teachers are the most frequently named: the painters Chaplin, Regnault, Redouté, Bastien Lepage, Eugène Carrière, Greuze, David; a little later on Rodin's studio took in some sculpture students.

In their day, these ateliers were the centers of the artistic life of women converging upon Paris from many parts of the globe in vast numbers. Any art student of either sex, who could claim to have studied in Paris, at no matter how obscure an establishment, was rated as having a head start over their competitors in their various homelands. Women who intended to establish themselves as original free artists, could point to their Parisian studies as a qualification in itself, regardless of what, if anything, they might have learned there.

Seen superficially it might seem that art training at private schools was an adequate preparation for a professional career. But women in many countries of Europe became ever more insistent in their demands for admission to state institutions on an equal basis with male students. Reasons for their insistence were more complex than mere prestige. (We shall return to this problem further on.) Official responses to the demands varied from country to country.

In Germany, for instance, up to the early 20th century, women were almost totally dependent on studying with private instructors, the few exceptions being, here and there, an occasional admission under limiting conditions at some public academy. Another stopgap were women's art schools which had been organized by women's art associations with the primary purpose of protecting students from ruthless exploitation on the part of unqualified teachers: the ever increasing numbers of young women seeking to enter artistic activities made this a very necessary safeguard.

On the other hand, in Russia women had succeeded as early as 1854 to gain admission at the Saint Petersburg Academy. In these years the academy named its first group of stipendiaries, with scholarships for six years of foreign studies. In 1871 women students were officially permitted, and thirty female students enrolled already in the first year. Likewise the Moscow Institution for Painting and Sculpture opened its doors to women around the same period, and from the 1880s on, many art schools in the larger Russian cities gave much thought to the special requirements of girl students. Thus a first generation of academically schooled professional women artists was forming in the last decades of the 19th century in Russia.

Very generous attitudes toward women in higher education were shown in the Scandinavian countries from the middle of the 19th century on. Norwegian, Swedish, Danish and Finnish women studied at the Beaux-Arts schools of their countries, or their respective women's branches, where such existed. However the proportion of privately educated women remained high. A relatively large percentage of female art students received scholarships from public funds, mostly for study in Paris.

American women enjoyed similar privileges. They were taught both in private schools and in public art institutes, which however were not very numerous in mid-19th century America. The most important one was the Pennsylvania Academy which had instituted a ladies' life class with female models as early as 1868. But a great many Americans sought European training, Paris being far and away the preferred center; many Americans settled abroad for the rest of their lives. The greatest obstacle to the professional preparation of women art students, regardless of what country they had chosen, was, until well into the 20th century, the difficulty of being permitted to participate in life classes with male models. In America, Puritan objections were vociferous. The life classes at the London Royal Academy admitted men only; as late as 1894 women's life classes were still limited to draped male models, the degree of clothing to be worn being regulated by academy rules. Likewise the Académie Française excluded its female members from such advanced technical studies as a matter of principle. Art, as it was taught at the academies, centered around figural composition; the intensive study of the human body as an adjunct to anatomy had to be conducted before the nude model and formed the very basis for competent artistic expression; amongst the academic disciplines, figure study was the most highly rated. Not a few of the faults which have been found with pictures by women for centuries—not always unjustly either—i.e., poor drawing, flabby composition, deficiency in anatomical truth in the rendering of the human shape, etc., have their

cause in the lopsided formal training of women, which at best allowed drawing of the male body from plaster casts. This deficiency in anatomical acquaintance may be an explanation for female artists having specialized for such long times in portraiture, in flower, still life and genre painting, instead of the so much more popular and lucrative figural compositions of themes drawn from history and mythology. Painters of the rank, e. g., of an Angelika Kauffmann (1741–1807) or an Elisabeth Vigée-Lebrun (1755–1842) have stated very expressly that, despite their fame as portraitists, their specialization did not satisfy them artistically. We may add that Angelika Kauffmann had ventured into mythological subjects. In this context, Vasari's judgment of the work of the nun Plautilla Nelli (1523–1588) is of interest; he states that she would have done wonders if she had had the chance to study drawing and work from nature, like men.

A vital problem for all creative artists is the question of exhibiting. The most important exhibition site until the end of the 18th century were the academies, whose female members had won the right to show their works at the academy exhibitions after initial struggles. Next to these official events, public displays of work of art of varying importance were arranged by art dealers. And lastly, there were shows of a more private nature, when artists opened their studios to the public on specified days, as Elisabeth Vigée-Lebrun describes in her memoir. Only in 1791 did a woman member of the Académie Française since 1783, Adélaïde Labille-Guiard (1749–1803), succeed in persuading the academy to allow female artists to exhibit regardless of membership. Prior to this, women artists had already been able to show their works in the Parisian *Salon de la Jeunesse*, an unjuried exhibition first staged in 1759 for the special purpose of furthering young talents in the visual arts. In the course of the 18th century the London Royal Academy also admitted works by women artists to be shown.

With the increase in production of art works in most countries from the turn of the century on, and with a consequent growth of public interest in art, the possibilities for publicly appearing in art shows multiplied also for women artists. In a professional sense this increase was not an unalloyed gain. The exhibitions held at the Berlin Academy, for instance, were open to dilettantes in vari-

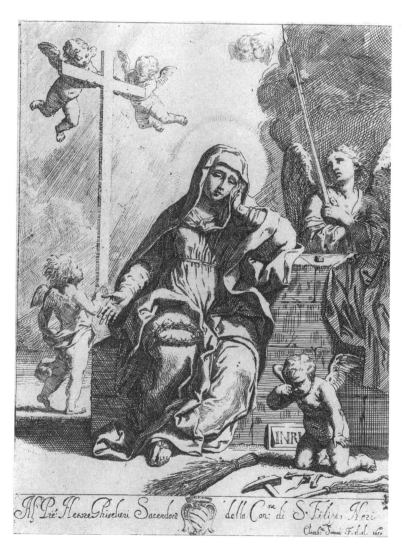

Sirani, Elisabetta
Mater Dolorosa

1657 / etching / 28.5 × 20.9 cm
Kunstsammlungen Veste Coburg

ous branches; an increase in women's names in the catalog is partly due to specimens of needlework and other crafts products, alongside of painting, sculptures and graphic works. The display of such artifacts as soap reliefs and similar curios violating the dictates of good taste could not help but have a lowering effect on the ensemble of exhibited works.

But even though art exhibitions became more frequent with the growth of production of art objects, the proportion of participating women professionals did not increase at the rate one would have expected to see when measured against the overall growth of male and female artists. This statement is based on the study of the relatively few exhibition catalogs and checklists which have been preserved, and applies to the period after the dilettante works had been weeded out of art shows. Even so recent a publication as the checklist of the Berlin Great Art Exposition 1912 lists only 95 women in a total of 1150 exhibitors. Neither the roster of 25 members of the Exhibition Committee, nor that of the 20 members of Admissions and Hanging Committees contain a single woman's name: women were not admitted to such public functions in the Germany of the period. A main cause of this disproportion was the inveterate prejudice toward feminine creativity affected in many places and constantly fuelled by such conservative critics as Scheffler and others.

Nineteenth century women artists, finding themselves under-represented in the public view, adopted measures of self-help. They formed several associations designed to safeguard their rights in various European capitals, and organized their own exhibitions. In 1859 the third exposition of the Society of Female Artists, which had been founded in 1850, was opened. Exhibitions of contemporary women artists followed in Amsterdam (1884), and in 1910 the first historical exposition with the theme "Die Kunst der Frau" (Art by women) was held at Vienna; works dating from the Renaissance through modern times were shown. After several events showing the works of living female artists, another major exhibition in 1930 had the theme "Zwei Jahrhunderte Kunst der Frau in Österreich" (Two centuries of art by women in Austria). Many women artists also sent works to international expositions where their finances permitted: at the Paris World's Fairs of 1878, 1889 and 1900, and at the Chicago World's Fair of 1893 a growing proportion of women were awarded medals and prizes. But despite such recognition women artists continued to be numerically underprivileged in open exhibitions. A group of energetic American women combatted the prejudice against female art by organizing, in 1975, the important exhibition "Women Artists 1550–1950" in conjunction with the celebrations of the Year of the Woman at Los Angeles. The art historians Linda Nochlin and Ann Sutherland Harris published an instructive catalog of the exhibition. They illustrate the occasionally outstanding achievements of women artists in the last four centuries with many examples, and also expose the discriminatory practices of exhibition committees in respect to admitting women.

In women's art circles of the present the view that exhibitions of female art are obsolete is often heard expressed. Art is art, it is said, by whomever created, women are no longer a special group requiring separate presentation.

This attitude has much to recommend it; it proves at least the contemporary generation of women artists has overcome much of the resistance, especially in the socialist countries, which their predecessors encountered in the early days, and which still confronts many female artists in the Western world. But still, historical events, such as the big show "Women Artists 1550–1950," continue to have a valid function in clarifying aims past and present, and in illustrating the professional problems of women in bygone times, because research in these matters has much to catch up with.

Anguissola, Sofonisba
Portrait of a Young Woman

1557 / 98 × 75 cm
Staatliche Museen / Preussischer Kulturbesitz,
Berlin (West), Gemäldegalerie

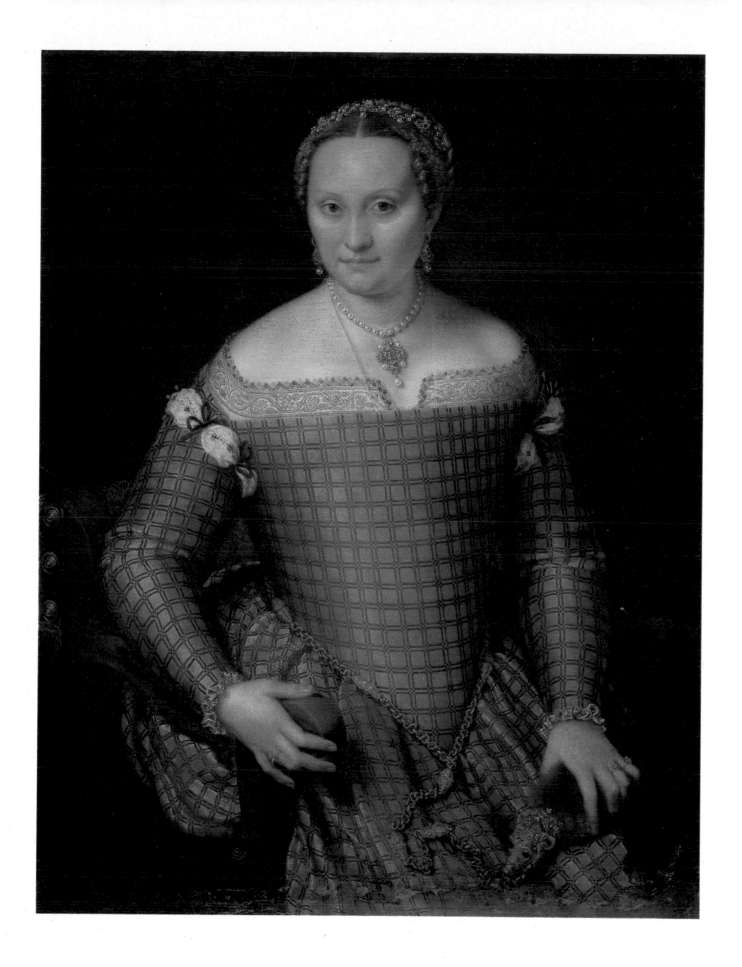

Anguissola, Sofonisba
The Three Sisters of the Artist at the Chessboard

1555 / 72 × 97 cm
National Museum Poznań

The self-portrait of Sofonisba is simple and unobtrusive, despite the fact that the artist had already considerable renown at the time of painting it. Five years later she received a call to the court of Spain and was received amongst the ladies of honor of the Infanta.

The picture of the sisters playing chess dates before this time—her five younger sisters all became painters too—it is a charming scene of the girls playing the "kingly game," which was then also very popular with women.

The portrait of the young woman in patrician dress is more stately; painted likewise before the journey to Spain, it is evidently a commission, in contrast to the two other works, accentuating the rendering of costly fabrics.

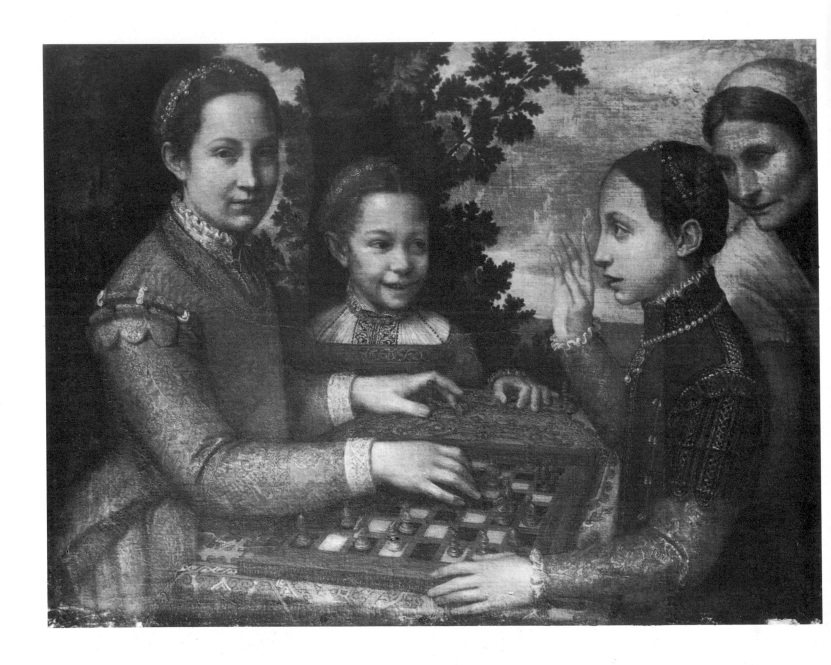

Anguissola, Sofonisba
Self-Portrait

1554 / 19.5 × 12.5 cm
Kunsthistorisches Museum Vienna

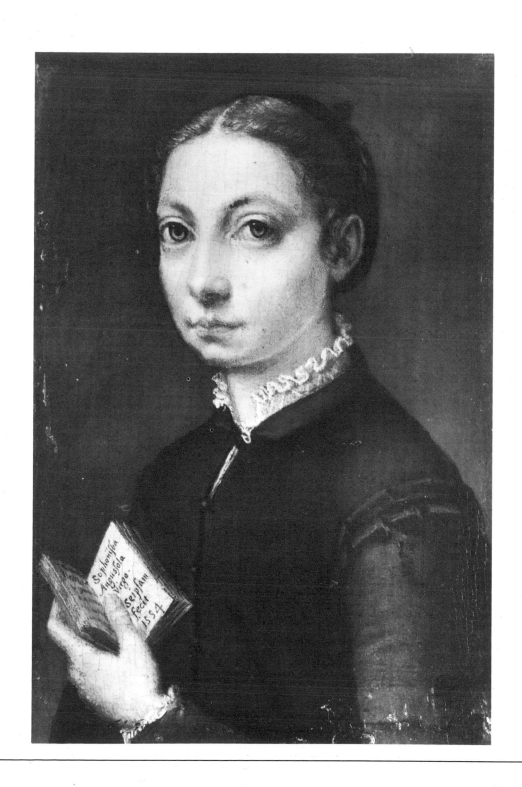

Sirani, Elisabetta
Saint Jerome

1661 / 47 × 35 cm
National Museum Warsaw

Elisabetta Sirani's composition of St. Jerome is a frequent theme of iconography. The Saint is shown doing penance in the desert, surrounded by his traditional attributes. But the way the artist has painted the lion makes one wonder whether she ever saw a live lion.

The allegorical female half-length, with a club in her right hand and grasping the jawbone of an ass as a symbol of strength, makes it understandable how this artist, famed as "the marvel of her time," who died at the early age of 27, could stand comparison with many a male painter of the period.

Her etching of the Mater Dolorosa shows at least a sound command of technique, even if it is not altogether convincing artistically.

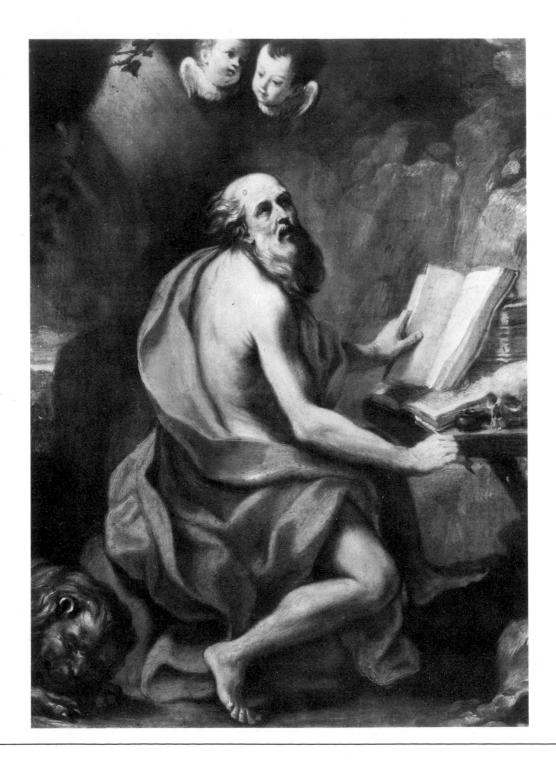

Sirani, Elisabetta
Allegorical Female Figure, Half Length (Allegory of Strength)

1651 / 80 × 65 cm
Staatliche Kunstsammlungen Dresden,
Gemäldegalerie Alte Meister

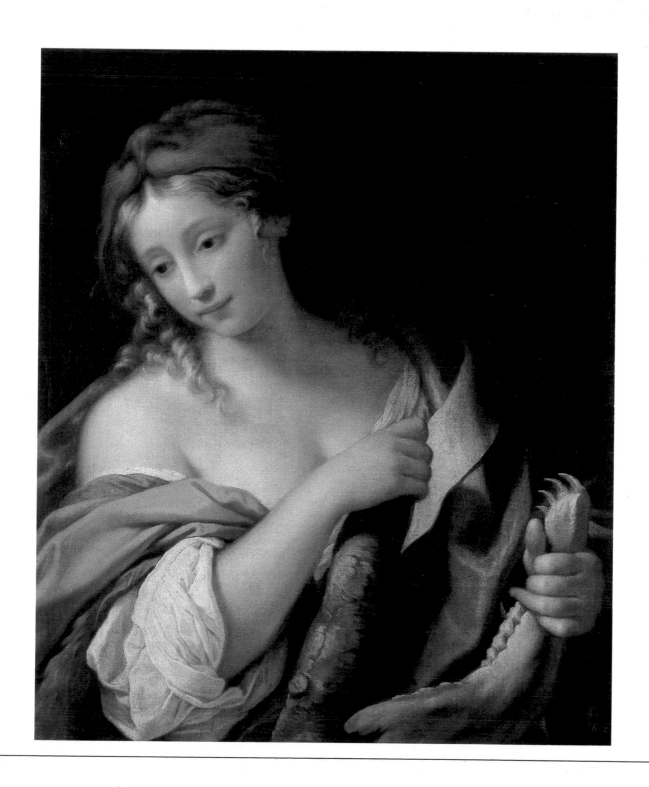

Hemessen, Catharina van
Self-Portrait

1548 / tempera / 31 × 25 cm
Oeffentliche Kunstsammlung Basel

The Dutch painter Catharina van Hemessen, a contemporary of Sofonisba Anguissola, was well-known in her time and, like Sofonisba, at the Spanish court for a while. Catharina was the daughter, pupil and occasional collaborator of Jan van Hemessen, the painter, and did mostly portraits. Her self-portrait shows her at work at her easel and is inscribed *"Ego Caterina de Hemessen me pinxi 1548"* (I, C. v. H., painted me)—a self-representation of a twenty-year old who, with quiet self-reliance, depicts her own work process and thereby her profession: in the 16th century still an uncommon idea.

Court, Suzanne
The Last Supper

undated / enamel / 25.2 × 19.4 cm
Herzog Anton Ulrich-Museum, Brunswick

This "Last Supper" by the Frenchwoman Suzanne Court is one of the few known examples of 17th century enamel painting by a woman. She was the daughter of an enamel painter and was probably also trained by her father.

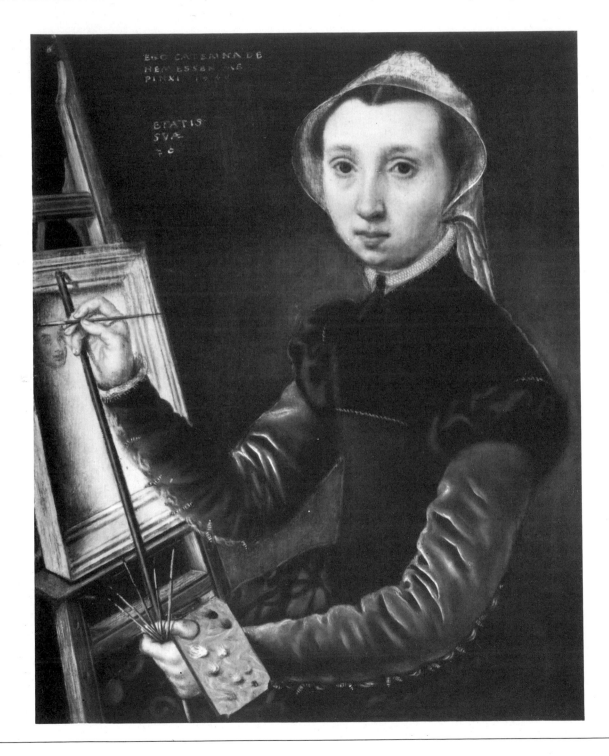

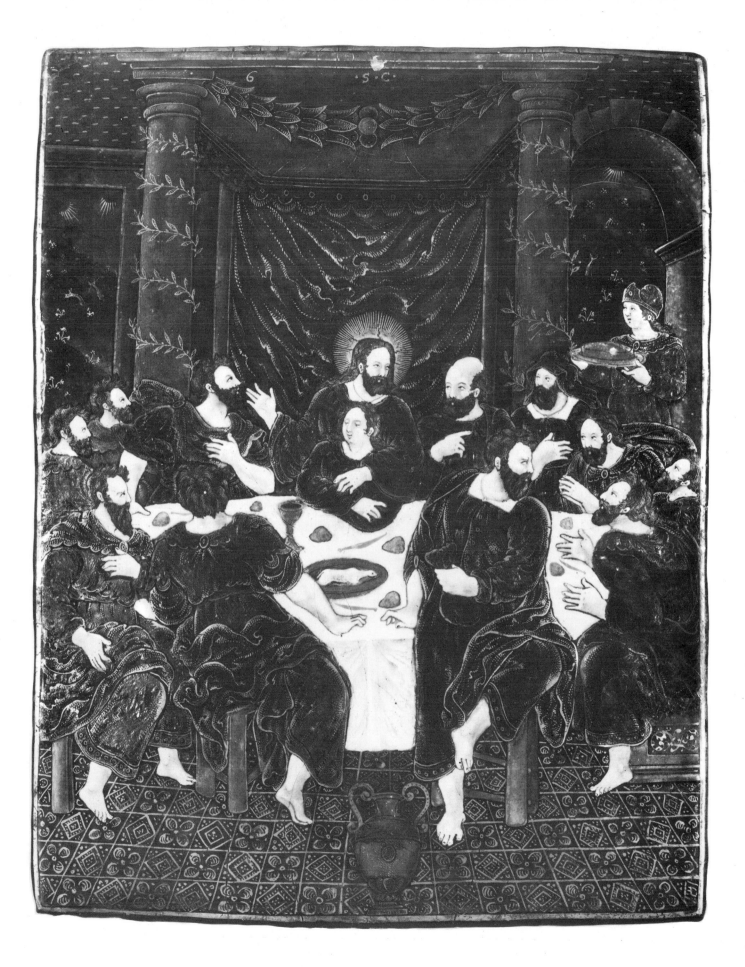

Fontana, Lavinia
Holy Family, with Saint Elizabeth and the Youthful Saint John

undated / 39 × 32 cm
Staatliche Kunstsammlungen Dresden,
Gemäldegalerie Alte Meister

Fashionable with the Roman aristocracy and high clergy, Lavinia Fontana was the daughter of the Bolognese painter Prospero Fontana, who taught her and whom she eventually excelled on portraiture. She married another pupil of her father's, Gian Paolo Zappi, of whom it is said that he forsook a career of his own in order to collaborate at his wife's picture. She received a call to Rome about 1600. A large number of portraits and religious scenes of her's are known, and she is generally thought to be the first female painter of the Baroque age of significance. Her paintings were often confused with works by Guido Reni because of her slick and sentimental manner of painting.

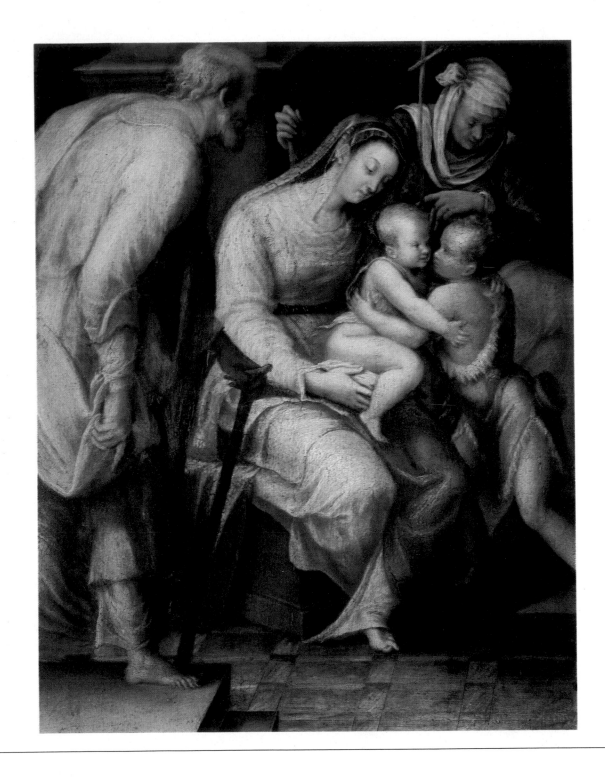

Woutiers, Michcline
Saint Joachim

c. 1650 / 75 × 64 cm
Kunsthistorisches Museum Vienna

Woutiers, Micheline
Saint Joseph

c. 1650 / 76 × 66 cm
Kunsthistorisches Museum Vienna

Woutiers, Micheline
The Progress of Bacchus

c. 1646 / 270 × 354 cm
Kunsthistorisches Museum Vienna

Little is known concerning the Flemish painter
Micheline Woutiers. Her painting of "The
Progress of Bacchus" is dynamically composed
with the figure of Bacchus accentuating the
turning of the bacchantic escort into space, and
shows a command of the male nude unusual for
a female painter of the period.

The two pendant pieces of the half-lengths of
the Saints are also vigorously conceived and
technically well worked out in the corresponding
functions of the book and flower, respectively,
and the clearly modelled heads.

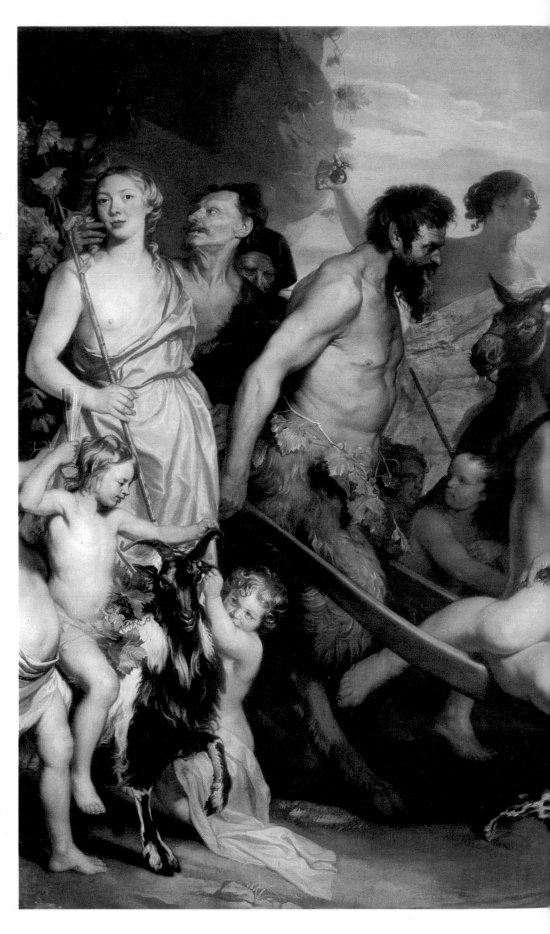

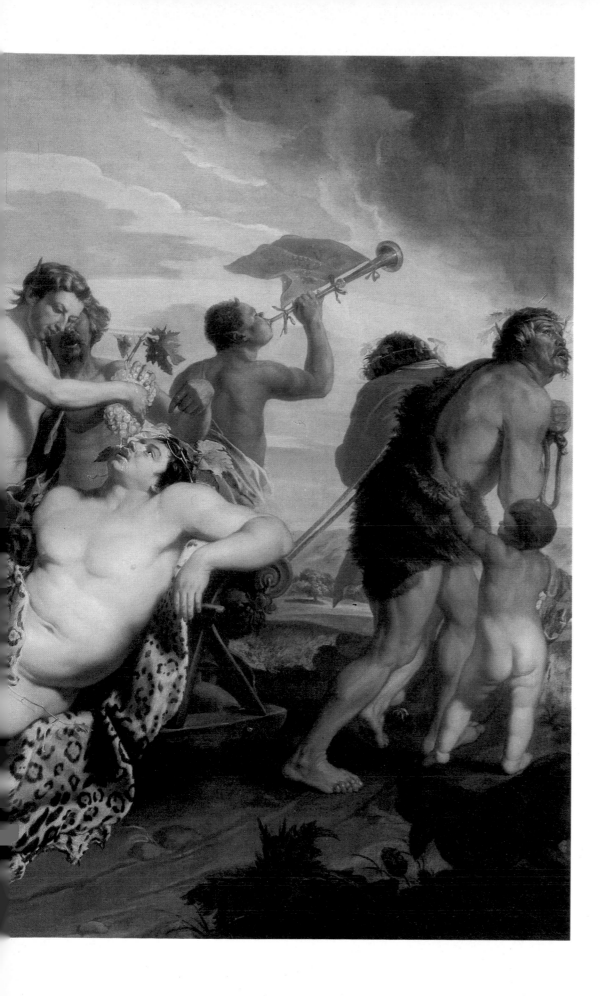

Wolters-van Pee, Henriette
Self-Portrait

c. 1700 / miniature / 6.8 × 5.5 cm
Rijksmuseum Amsterdam

This self-portrait of the Dutch miniaturist Henriette Wolters-van Pee is distinguished from many contemporary miniatures by its honestly realistic manner of representation. Her miniatures were often mounted on to bracelets and were in great demand during her lifetime.

POSITION IN SOCIETY, SOCIAL BACKGROUND
AND LIVING CONDITIONS

Generally speaking, the status of women artists during the past four centuries corresponded, of course, to the respect shown to the profession of fine artist at large, a condition modified by political, sociological and economic factors of the period. By and large it was high, although fluctuations in valuation did occur. For example, the status of a court painter was higher than that of a modest Dutch painter of genre scenes working for the public market, whose rank would be but little higher than the esteem accorded to a tradesman—naturally this applies to his female counterpart equally—but the valuation of the artist's calling depended also on the market price of his "merchandise."

As to their social origin, most professionals came from the middle and lower middle classes. To a certain degree, however, the profession of fine artist created a special community of interest distinct from other social strata; this is shown, for example, by the many inter-marriages amongst artists' families. The children issuing from such alliances frequently adopted the parental profession, which accounts for the remarkable number of artists' dynasties, especially toward the last decades of the 18th century, carried on by the female branch as well as by direct descent.

But artists also enjoyed for centuries better chances for elevating their social position than any other segment of the bourgeoisie. Many of them reached envied positions at various courts, and a relatively large proportion of such were women. Until the 19th century it was part of le bon ton, even at the minutest princely courts, not only to care for art, i.e., be a collector, but also to be able to hold one's own as a dilettante.

To impart the requisite instruction for such dabbling was one of the tasks assigned to both male and female court artists, the latter perhaps partly being chosen for the protection of young ladies of the court who wished to take art lessons; they would be safer from "affairs" such as had been known to occur between pupils and their men teachers. Beyond such considerations of prudence, however, the cultural tone of even the lesser courts was set largely by the prince's ladies, who liked to surround themselves by artistic and refined women.

By contrast, there were solicitous fathers, fearing for their daughters' morals at court, and accompanied them as chaperons; possibly also, not being very successful in their own calling, to reap their share of their more able daughters' fame and emoluments. One of these was the painter Ludwig Schneider, who always travelled with his daughter, Henriette (1747–1812), a very talented portraitist, when visiting the various German courts where she had been commissioned to do work. Similarly Levina Teerling of Bruges (1515–1576) insisted on her father and teacher, Simon Benning, accompanying her on her journey to England. She had collaborated with her father already prior to her engagement to work for King Henry VIII, whose conduct might excusably inspire uneasiness. Levina, by the way, won high fame as court painter in England under three successive rulers.

But there are also reports of other women refusing to accept highly paid court positions; of such was the Dutch miniaturist Henriette Wolters (1682–1741), daughter and pupil of the painter van Pee, who declined an offer of a position at the court of Peter the Great of Russia, despite a proposed salary of 6,000 guilders (in her home country she was paid 400 guilders per portrait).

It is said of the copper engraver Barbara Regina Dietzsch (1706–1783) from Nuremberg, reputed to have been "in request by persons of the highest rank because of her fame," that she would not "sell her liberty" as a court painter. No matter what kind of liberty she may

have called her own as a private citizen, this much is certain that court service was not for everybody, and many a court painter, regardless of professional standing or highly placed protectors, was treated no better than some favorite lackey. But despite this we must assume that female artists who had accepted court positions, whether short-term, or life-long, whether accompanied by husband or father, or on their own as a majority of them surely was—filled their appointed places as competently as any of their male colleagues, and were shown the same respect as productively creative persons. Available sources indicate that until the early 19th century there hardly was such a thing as "discrimination because of sex" of women in court service.

Thieme-Becker and other sources seem to agree, in regard to the social background of female artists, which is not always given, that most of them either were the direct descendants of other artists, or came from respectable bourgeois families and frequently married men of the same class, which was not often the case for stage artists for example. This leads us to deduce that professional women artists were, in general, well integrated in their social stratum, while the exceptionally famous ones had of course risen well above any bourgeois standard; however we should not forget that certain bourgeois circles maintained a distant reserve toward any and all artists, whether male or female, as a matter of principle. The recognition extended toward women artists was due to their belonging to a profession which was in itself respectable, a vocation highly esteemed for centuries by persons of quality including the "highest circles" and due also to their producing works not only of "ideal" but also of material value.

Compared with the quantities of artists' daughters and the sizeable contingent of girls from middle-class or even noble backgrounds, we find but few women from proletarian or small artisan origin who had been able to overcome the handicap of their birth. An example of this minority is the French Gabrielle Capet (1761–1817), daughter of a servant, who became a pupil of Adélaïde Labille-Guiard who also was believed to have had to struggle against the disadvantage of humble antecedents; Gabrielle Capet became one of the most favored miniaturists in Paris. The English Mary Grace (died in 1786 at an advanced age) was a shoemaker's daughter; she educated herself autodidactically by way of copying paintings, and gained a sizeable fortune as a portraitist. The Moravian painter Marie Gardovska (born 1871) came from peasant stock and had been doing farm work until she was able, at the age of 24, to enter the Arts and Crafts School at Prague, where she specialized in the representation of folk types in their native dress. The sculptor Katharina Felder (1816–1848) was likewise of rustic origin; she whittled crucifixes on the sly while attending the village school, thereby attracting the attention of the painter Maria Ellenrieder, who started her in her career by giving her drawing lessons at Constance. After subsequent studies at Munich, Felder was able to move to Berlin through the mediation of the Schinkel family; in the Capital, no less a celebrity than Christian Daniel Rauch arranged a studio for her. Here she created the equestrian statue of Saint George for General Knesebeck and carried out some commissions for churches.

The Austrian plumber's daughter Angela Stadtherr was born in 1899. When her father died, she continued his business, studying at the same time from 1917 until 1921 at the Arts and Crafts School at Vienna, after which she sculpted various statues in extruded metal. The Danish farm girl Helene Jacobsen (born 1888) went to the *Volkshochschule* (people's university) of Lyngby in 1909, and later distinguished herself as a landscapist.

In connection with origin, the sculptor Edmonia Lewis's case is a special one. Born in 1843 at Greenwich, Ohio, the daughter of an Indian mother and a Negro, she studied at Oberlin College, which was the first college in the United States to be open not merely to women, but to members of all races. She began to practice sculpting in Boston. Her portrait bust of Colonel Shaw, killed in the Civil War, became so popular that she had to make many replicas. This brought her money enough to enable her to engage in advanced study at Rome, where there was a small colony of American women sculptors. While at Rome, Edmonia Lewis modelled various sculptures expressive of the sufferings of the oppressed non-white Americans, especially of the Indians. These works met with very favorable recognition on the part of American liberal circles. She returned to the U.S. in 1873 where her statues and portrait busts were widely exhibited. This is

what the artist said about her marble statue of *Hagar*: "I feel a strong sympathy for all women who have had to fight and to suffer." It appears that Edmonia Lewis revisited Rome once more, but nothing more is known of her later life.

The French painter Marie Laurencin (1885–1956) had to overcome another handicap: she was an illegitimate child. Supported by Picasso, Braque and Apollinaire, she became one of the best-known French women artists of her time, not only as a painter and graphic artist, but also a designer of stage sets and costumes for the *Ballet Russe* of Diaghilev, the Comédie Française and others. The designer and painter Suzanne Valadon (1865–1938) had a somewhat similar career. Born in very humble circumstances, she left her native Limoges as a very young girl, to try her luck in Paris. She began as a *poseuse*, i.e., a painter's model, and posed for such celebrities as Renoir and Puvis de Chavannes. These connections gave her courage to begin drawing on her own, later on also to paint; she made good progress and no less a man than Degas recognized her talent. Her pictures sold so well that she was able to buy an old château in 1920. In her old age she stopped painting and spent her last years in taking care of her son, the famous Maurice Utrillo, whose life was endangered by illness and alcoholism.

Although it is perfectly possible that female artists of earlier periods, working perhaps in printers' and engravers' shops or similar semi-mechanical trades which flourished during the 17th and 18th centuries, may have elevated themselves from the "lower" social strata into professionalism, but none are documented.

This much is certain: that from Renaissance times onward, the practice of the arts made the practitioner "free" — freer, at least, than a great many other people. This freedom consisted not merely in liberation from corporate compulsion and the limitations connected with the guild system, wherein the women benefited equally with the men, but also in society granting a greater independence to the individual in choosing work conditions more in keeping with personal endowment and inclination. Even so, of course, the artist, regardless of sex, must still rely on commissions, which means that a degree of economic and ideological dependence on the ruling class and the wealthy bourgeoisie necessarily subsisted.

In this context it is noteworthy that a great many Jewish names appear on rosters of artists of the last centuries. It leads to the conclusion that many members of the oppressed strata of society who were longing for their emancipation sought, and often found, liberation from bourgeois trammels and prejudice in the profession of the free artist. The truth of this applies equally to women yearning for their independence as it does to the Jews, who suffered discrimination for so long a time, although the causes of the respective limitations and subjections are different. But the greatest difficulties in emancipating themselves from the disadvantages of their birth by way of adopting a free art career were those encountered by the offsprings of the working classes, especially their women. They faced obstacles more formidable than those who merely sought to free themselves from the handicap of either sex or race. What the poorest social classes were in most need of, next to spiritual-intellectual motivation and impetus, were funds—money which was indispensable for even the most modest professional instruction. And after the apprenticeship had ended, an artist whose sole means of support was his or her art, had to struggle long and hard to get and keep himself going. A famous example is Watteau, who in his youth made a precarious living by turning out cheap copies by the dozen for a picture dealer.

We have only scanty information of the average earnings of women artists, since the older sources commonly quote only exceptionally high sums earned, in order to underline the fame and success of prominent artists. For instance, we may read that Levina Teerling was paid higher fees at the English court than her contemporary, Hans Holbein the Younger, who was working at the court at the same time in 1543; or that Rachel Ruysch sold her pictures for 750 to 1,250 guilders, whereas Rembrandt rarely got more than 500 for any of his works.

A few more such samples may be given; the author discovered these more or less by accident and they cannot, therefore, be regarded as typical: Artemisia Gentileschi, it is claimed, was paid, for each figure represented in a group composition, 1,100 scudi; August II of Poland allegedly paid 2,400 guilders for two flower pieces commissioned from the Dutch painter Maria van Oosterwyck (1627–1692). The Italian Anna Maria Vaiani (died

1655) collected 348 scudi from the Papal exchequer for decorations executed in a chapel of the Vatican. Her countrywoman, Isabella del Pozzo (1660–1700), while serving as court painter to Adelheid, wife of the Elector of Bavaria, received a daily allowance of a measure of beer, wine and bread, on top of a yearly salary of 400 guilders. Later the Elector awarded her a gratification of 30 guilders, which was raised to an annual pension of 200 guilders after she became blind. Maria Felicita Tibaldi (born 1707), who was married to the painter Subleyras, was paid 1,000 scudi by Pope Benedict XIV for a water-color copy of a Last Supper painted by her husband. The German miniaturist, Elisabeth Mildorfer (1713–1792), active for a long time in Rome, regularly charged 70 squins "for even the smallest pieces." The miniaturist Château (active between 1701 and 1725) was employed at the court of the Regent, Philip of Orléans, and got 60 livres a piece for portrait medallions of the young King Louis XV, to be mounted on pieces of bric-a-brac.

Elisabeth Vigée-Lebrun was one of the best-paid women artists of her time; she relates in her memoir that by the year 1789 she had earned roughly one million francs, which her husband squandered. She had begun to paint at the age of fifteen. One of her average portraits netted her some 8,000 francs. This may be compared with the earnings of a prominent master of baroque portraiture in the reign of Louis XIV, Hyacinthe Rigaud (1659–1743), whose annual earnings during his best period averaged 30,000 francs. Of Angelika Kauffmann it is reported that she made enough money in a single year in England, where she painted from 1766 until 1781, to be able to buy a house in Golden Square, and to invite her father to live with her in London. Goethe wrote in 1787, in a letter from Rome: "She is tired of painting for a living but her old husband is just too charmed with the heavy sums paid for such easy work."

Data concerning honoraria in the 19th century are much scarcer, but one commonly hears that female artists were paid less than men, if for no other reason than because of their inferior training. About the mid-century when more and more women entered the field of the Fine Arts, a female art proletariat came into existence, whose members worked for fees which no one would have dared offer to a man. Outstanding women, of course, continued to be well paid, e.g., Rosa Bonheur (1822–1899) who received 28,000 francs for her "Norman Horse," the average prices for pictures ranging between 3,000 and 15,000 francs per canvas.

It is admittedly impossible to find a reliable denominator which would enable us to express the earnings of the subjects of this study in terms of contemporary equivalents. According to Dr. Heinz Fengler, Director of the *Münzkabinett* (coin collection) of the Staatliche Museen zu Berlin, who has worked at the problem of converting these amounts into comprehensible terms, some of the considerations which are to be taken into account are the following: dimensions and complexity of the subject matter of the respective work; a comparison of the amounts laid out in the various countries for similar objects (e.g., Spain, where gold was plentiful); the general tendency of a rising art market; the fluctuations of the esteem in which the various artists' works were held, etc., in other words quantities which cannot be brought into meaningful relation to one another. Dr. Fengler therefore chose to base his calculations on the annual salary of a town clerk of the city of Frankfort on the Main in the year 1600 (a position roughly corresponding to a contemporary division chief in public administration) or, for some special cases, on a gold conversion factor. The town clerk's salary was 100 florins (a florin was worth approximately one guilder) plus a rent-free official apartment, fuel and clothes allowance in the amount of 15 fl., totalling about 250 fl. or the equivalent of 817.5 grams of gold.

Reckoned on this basis, Lavinia Fontana would have been paid approximately four times the yearly salary of the town clerk for her picture "The Holy Family"; Artemisia Gentileschi two and a half times the salary, Anna Maria Vaiani for a fresco in the Vatican less than one annual salary, Maria van Oosterwyck for a flowerpiece about one quarter's salary, while the yearly earnings of Isabella del Pozzo may be roughly the same as the salary of a flower painter-decorator at the *Porzellanmanufaktur* (porcelain manufactory) at Höchst, i.e. 360 fl. or about 1,260 grams of gold per annum. Henriette Woutiers charged a rough fifth of the base amount for one of her portraits. A miniature portrait by M. Château was inexpensive at two and a half louis d'or, but gold was in great demand at the period. Maria Felicita Tibaldi's water-

color copy was worth about one and a half times the base amount of the annual pay of the town clerk, but Elisabeth Mildorfer's miniature only about one sixth of it. Elisabeth Vigée-Lebrun got roughly one year's pay of the town clerk for a portrait by her, but then, by the end of the 18th century, the clerk's salary had risen to 750 fl. Copies made by Caroline Bardua were poorly paid at the rate of four louis d'or (the "louis" had lost weight in the meantime), while her court portrait was worth 20 friedrich d'or (the equivalent of 100 taler). At that period in time a librarian in the city of Frankfort on the Main drew a yearly salary of 200 taler or 40 friedrich d'or, equalling 240 grams of gold. A miniature by Mary Ann Knight, assuming an average price of 30 guineas, would come to about 250 grams of gold.

This kind of comparison is of course modified by all sorts of variables like national and economic conditions and must therefore be viewed with reservations; but, crude as the scale of equivalences may be, it indicates nevertheless that women artists of the period ending about the turn of the 18th century earned honorariums that were not disproportionate to their productions.

Study of the living conditions under which female free artists had to prove their mettle in a four-century period shows that they were faced not only with the shifting conditions dictated by widely varying social and economic factors, which applied equally to male artists too, but that they were subject to the most fluctuating appreciation of the idea of female artistry in general. For example during the Renaissance women enjoyed living and working standards which they lost again later on, while in 18th and early 19th century France they once again were able to achieve an important degree of economic and artistic autonomy, although of course still more or less dependent on male goodwill. This dependence has existed since society began, and the women of all periods, a few female rulers excepted, have had to accommodate themselves to male standards, not only in the arts but in general. It is thus all the more remarkable that women artists have maintained themselves professionally for so many centuries, coping not only with masculine preponderance but also with the extensive burdens placed upon so many of them, by marriage, family often of many children, and household affairs. The Italian decorator of churches, Caterina Ginnasio (1590–1660), later an abbess at Rome, is said to have exclaimed that needle and distaff were the worst enemies of crayon and brush, and centuries later, Käthe Kollwitz complains in a letter: "I have not been near my work for weeks; it is the old story: as soon as one of the children is sick, work stops."

In addition to all this, many women artists have fed their families with the proceeds of their art, particularly if the breadwinner was sick or had died. Elisabetta Sirani is an early example who shared everything she earned with her family. Elisabeth Chéron (1648–1711) had the care of her mother and sisters (one of whom, Marie Anne (1649–1718) became a painter too), paid the debts left by her father (another painter) and directed the education of her brother Louis, who later became a successful artist in England. Maria Tibaldi provided for the entire family after the death of her husband, the painter Subleyras. The English engraver on copper, Elizabeth Blackwell (died in 1744), the wife of the Swedish court physician and physicist Blackwell who was later executed, supported her husband by making flower designs while he was imprisoned. The English painter Mary Ann Knight (1776–1851), one of the ten children of a merchant, provided for her own numerous family from 1802 on with the painting of miniatures; by 1836 she had produced nearly 700 miniature portraits for which she was paid between 2 and 40 guineas. Another English painter, Mary Harryson (1788–1875) provided for her family of twelve children with her art earnings after her husband lost his fortune and was struck by sickness, and the painter Louisa Costello (1799–1870), the daughter of an Irish officer, supported her mother with what she earned and enabled her brother to attend officers' school. Living since about 1820 in England, Costello was also known as a writer, one of her studies being devoted to eminent Englishwomen. I give these examples, drawn chiefly from documents dating from the period ending with the early 19th century, in order to show that women artists have often been able to provide for their families in a manner comparable to men.

Many female artists had a numerous progeny. Lavinia Fontana had eleven children, only three of whom outlived their mother; the highly-paid Rachel Ruysch, wife of the portraitist Pool, had ten; the Dutch Aleyda

Wolfsen (1648–after 1696) was mother of eight children; the Danish painter and writer Elisabeth Jerichau-Baumann (1819–1881) also had eight, of whom two sons became painters; the American painter Lilly Martin-Spencer (1822–1902) had no less than thirteen children. The degree to which these painter-mothers have provided bread for their families is not known. But the very fact that they were able to work at their vocation and achieve something of value under such handicaps is in itself astonishing and admirable.

Discounting the "liberated women" of the Renaissance, the professional lives of female artists seem to have been closely bound to family life, or at the least to a tradition of professional artists' dynasties. We have already seen this in the role that family members were playing in the operating of the craft shops, in which female artists or artisans worked side by side not only with father, husband or brothers, but also with mothers, sisters and daughters. This mode of production with a rational division of labor is known from the 16th century on. For instance Titian employed his daughters in his studio. It was common for whole generations of families to collaborate in such craft-related enterprises, which, in most cases, remained in family possession and where male and female apprentices were trained.

We may note in passing that male artists, even some well-known ones, took their early training from female masters within their family connections; for example the miniaturist Justine Ayrer (1704–about 1790) was not only Chodowiecki's aunt but his first teacher as well; the painter Marie Bessemers, known also under the name of Mayken Verhulst (1520–1600), the grandmother of Jan Breughel or the *Sammet* (velvet) Breughel filled the same place in her grandson's life.

No less than five daughters were trained by their mother, the French miniaturist Antoinette Hérault (1642–1695), whose first husband had been an engraver and who subsequently married a painter. These daughters were "every one of them beautiful and well versed in the manner of painting" as an old text states, and all five of them married artist colleagues. Louise Cochin (1686–1767) was another copper engraver who ran a family shop jointly with several of her brothers, sisters and sons. The French engraver on copper, J. F. Beauvarlet, employed his first wife, Francisca, born Deschamps (1737–1769), and later his third wife and pupil, Marie Catherine, born Riollet (1755–1788 ?) in his printshop and published their engravings from it, but nothing is known of his second wife.

Several female members of the Augsburg artists' family of Nilson worked amongst relatives: Rosina Barbara (1691–1763), Barbara (1758–1821), Rosina Catharina (1755–1785) and Susanna Christiane (born in 1786), possibly a granddaughter of Rosina Barbara. The functions of these women consisted in hand coloring of prints, or making drawings for the publishing firms of Engelbrechts successors and Ebner, who issued colored prospectuses, fashion designs and similar printed products. The three daughters and pupils of the French painter, Parrocel, were blessed with extreme longevity, if the records may be trusted: Jeanne Françoise, a flower and animal painter, died in 1829 at the age of 95; Marie, a portraitist and painter of historical scenes was 81 years old at the time of her demise in 1824; the third sister, Thérèse, a miniaturist, lived to be ninety. Taken overall, a rather high proportion of women artists have reached advanced ages in past centuries, when the average life expectancy was low compared to modern figures.

Four women, members of the Nuremberg family of Preissler, illustrators and engravers on copper, were active about the year 1750; two of them were engravers, one was a gem cutter and another a wax mould maker. And lastly we may mention the four sisters of the Scottish painter, Patrick Nasmyth, who were active as painters around the year 1800.

Leaving these more or less forgotten artists' families, we turn to more prominent dynasties which engendered a whole series of accomplished female artists, especially in 18th and 19th century Germany. During this period, twenty-one members of the Tischbein family were active in the arts. The best-known of them is Johann Heinrich Wilhelm, the so-called "Goethe Tischbein." Out of the twenty-one, five were female artists bearing the family name of Tischbein; two others became known under another name. The most important ones were Caroline (1783–1843), who was also a very talented singer by the way; a pupil of Apollonia Seydelmann (1767–1840), she supported in later years her seriously ill husband with

the proceeds of her portrait painting, and Wilhelmine Caroline Amalia (1757–1839), who was made an honorary member of the Cassel Academy in 1780.

Two of Daniel Chodowiecki's daughters, both trained by their father and, incidentally, both destined to marry clergymen, Jeanette (1761–1835) and Suzette (1763–1819), made names for themselves, particularly the latter. She created moralizing picture series in the style of her father, with titles like "Good and Bad Upbringing," "The Good Wife and the Shrew," etc. She was nominated in 1789 for regular membership in the Berlin Academy and received a number of honorary awards. A niece of Chodowiecki's, Nanette (about 1780), has been mentioned as a painter and draftswoman.

Initially trained by their parents, the sculptor J. P. Tassaert and the painter Marie de Moreau, subsequently students of the Berlin Academy, the sisters Felicitas (1766–1818) and Antonia (died 1787) Tassaert figured amongst the best-known women artists in Berlin. Felicitas, the more important of the sisters, was made honorary member of the Berlin Academy in 1787; after the death of her father she was granted a royal pension of 200 taler.

Another family of German artists whose female descendants achieved a certain renown was the Mengs family. The painter Ismael Mengs had one son and two daughters; the latter were brought up to be artists, the same as their brother, Anton Raphael, who in his day was counted amongst the outstanding European painters. His father walloped him into an artist; at the age of 14 he was forced by his father to draw every day from morning till dark, locked up in the stanzas of the Vatican, copying after his namesake Raphael. His sister Theresia Concordia (1725–1808) fared no better in her youth than her brother; living since 1741 in Rome, she became a miniaturist painter and eventually married the painter Anton von Maron, a pupil of her brother's. Mengs' other daughter, Juliane Charlotte (died after 1789) became a court painter at Dresden and ended her days in a convent. A grandchild, daughter of Anton Raphael, Anna Maria (1751–1793) also was a miniaturist and painter in pastels; she married the engraver Carmona at Rome; later they went to Madrid, where Anna Maria became a member of the Academia de San Fernando in 1790.

In contrast to these painters' daughters who rose to public recognition by the fame of their father or brothers, the two daughters of the Berlin painter Lisiewski made the paternal name known to a broader public by their merit. Two of their nieces have also been mentioned as able painters. The elder of the two Lisiewski girls, Anna Rosina (1716–1783), who later married the assessor von Gask, a friend of Lessing's, was made a court painter at Brunswick after she had completed a huge commission of 40 female portraits for the *Schönheitsgalerie* (gallery of beauty) for the palace in Zerbst to the satisfaction of the court. She became a member of the Dresden Academy in 1769. Anna Dorothea (1721–1782), the younger of the two sisters, was the more famous one; wife of the hotelkeeper and painting dilettante Therbusch, her marriage was not a very happy one. She came before the public only about 1760. Receiving a call to the court of the Duke Karl Eugen of Stuttgart in 1761 she obtained the title of court painter at Mannheim two years later. In 1765 she journeyed to Paris, where she became a member of the Académie Française the next year. She was also named a member of the Vienna Academy on the strength of her portrait of Philipp Hackert. After her return to Berlin she worked as portraitist for the court, the nobility and the upper bourgeoisie.

In her excellent foreword for the "Women Artists" exhibition Ann Sutherland Harris points out that, up to approximately 1800, the ages of exhibiting female artists are given as astonishingly youthful, much more so than the average male ages, which leads her to speculate whether the successes of the women might no be, in part, related to their youth and beauty. Doubtless, advantages of this nature must have had their effect, especially in the case of a novice, and, in particular, during the amorous rococo period many a woman artist may have had to thank her feminine charms for a good portion of her professional successes. But a case like that of Anna Dorothea Therbusch argues, to the contrary, that women were able, even in those days, to win acclaim on their own intrinsic merits. Fidière writes of her that, in Paris, she did not meet with the success which Rosalba Carriera (1675–1757) had obtained some decades earlier, as had been her hope, because "while she did not lack talent, she was deficient in youth, beauty and coquetry," which,

however, were advantages not owned by Carriera either, as she was described as "ugly but witty." Thus the artistic fame of these two women was not due to youth and beauty. But it is possible that their failure to attract the eyes of male critics may be laid to their alleged preference for the female over the male sex in their emotional lives, as was later the case for Rosa Bonheur.

On the other hand, second and even third marriages are recorded of many women artists, some even at an advanced age; some also had quite adventurous careers, which would be unthinkable without some kind of attractiveness, but there are scarcely any indications of physical and artistic successes reacting on one another. To the contrary perhaps, since a large proportion of women artists found professional recognition only in their later years. The biographies of some of the best-known of them bear this out: while isolated individuals amongst them may indeed have combined personal beauty with professional excellence, a majority owed their successes exclusively to artistic qualities.

We have referred repeatedly to women occupying positions as court artists at many major, as well as minor, European princely courts well into the 19th century. A more impressive yardstick for measuring the degree of public appreciation of female merit in the profession of the Fine Arts through the ages is their membership in many academies in almost all European centers that had one. The total count of women academicians in the various institutions may be small compared to the rosters of male members, but the proportion of academy women to the overall numbers of women artists is impressive. It becomes even more so when one takes into account the opposition to their being admitted, on the part of the diehards in the respective institution, who often reacted quite unpredictably. Fidière has recorded that the Académie Française (founded in 1648) in the period between 1763, when the first woman member, Catherine Duchemin (wife of the sculptor Girardon) was elected, and 1795, after which no more women were admitted, the academy rolls show twenty female artists. Napoleon was not in favor of feminine talent. Fidière comments: "The reason why the Académie des Beaux-Arts does not accept women?—Our fathers were less exclusive than we are. Whether out of gallantry, or whether they se-

riously admired respectable talent, somehow they did not fear that their grave assemblies might be disturbed by the presence of some charming women."

Compared with the Académie Française the British Royal Academy was very conservative. In the course of the 18th century it admitted only two female members; the next one to follow them was not elected until the year 1920. By contrast the Berlin Academy counted a whole series of women artists amongst the membership by the early 19th century, many of whom were honorary members. The Dresden Academy likewise included several women at this period; we have already referred to Munich in this connection. The women's share in the various Italian academies was also relatively generous even in the 19th century. Italian academies were also far more willing to accept foreign artists, from the earliest times on, than the institutions of other countries. It must be, that the excellence of the women artists of the Italian Renaissance had prepared the way for a general appreciation of female artistry for centuries in advance. The German author Fanny Lewald describes in her *Italienisches Bilderbuch* (Italian picture book) of 1847 the awarding of prizes at the Roman Accademia di San Luca: "The first prize in painting was awarded to a lady... no longer in her first youth, she represented the noble Roman type, which remains beautiful and imposing through all the ages of womankind, both in the proportion of the features and in the figure... when she arose, after her name had been called out, to receive the diploma and the gold medal fastened on to a purple ribbon and bow, a loud and universal 'Brava' was heard." Regrettably, Fanny Lewald omits to give the name of the artist, who also won a second prize.

During the 19th century the German, French and English academies lost much of their earlier prestige. Admission of new women members had virtually ceased, but reports of female academicians in Russian, Dutch and Scandinavian academies multiply from the mid-century on, and women also continued to be accepted by the Spanish academies. In 1869 the Irish-born painter and etcher, Eliza Greatorex (1820–1897) became the first woman associate of the National Academy of New York. Incidentally, she brought up both her daughters, Kathleen and Eleanor, to become artists.

Jerichau-Baumann, Elisabeth
The Wounded Soldier

1865 / 107 × 142.5 cm
National Museum Copenhagen

Elisabeth Jerichau-Baumann was born in Poland of German parents; widely travelled, she later settled in Denmark, where she was nominated for membership in the Copenhagen Academy in 1861. The painting here reproduced is a genre scene of a type popular at the period. Often somewhat sentimental, such representations were to the taste of the bourgeois middle class and many male painters also catered to it.

Therbusch, Anna Dorothea
Self-Portrait

c. 1780 / 150 × 115 cm
Staatliche Museen zu Berlin, Nationalgalerie

Amongst the many known self-portraits by
women, this one, by Anna Dorothea Therbusch,
is noteworthy because the artist, holding an open
book in her hand, clearly identifies herself as a
searching observer by means of the single
eyeglass directed at the spectator.

Lisiewska, Anna Rosina
Portrait of a Lady and Child

undated / 102.5 × 77.5 cm
National Museum Warsaw

Anna Rosina Lisiewska was a sister of the more
famous Anna Dorothea Therbusch; a court
painter at Brunswick and member of the Dresden
Academy, Lisiewska had acquired a good
reputation as a portraitist, especially for her
elegant likenesses of ladies.

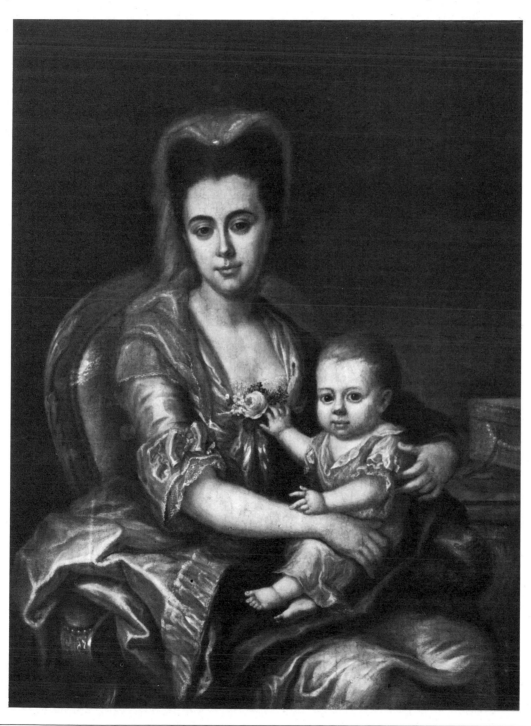

Labille-Guiard, Adélaïde
Portrait of the Painter Vincent

undated / 75 × 59 cm
Louvre, Paris

The Parisian painter Labille-Guiard portrays here her second husband, the painter F. A. Vincent, who had also been her teacher. Guiard was in constant rivalry with Elisabeth Vigée-Lebrun, with whom she was in competition for a portrait prize in 1782, which she won.

Labille-Guiard, Adélaïde
Self-Portrait with Two Pupils

undated / 211 × 151 cm
Metropolitan Museum of Art, New York

The artist has painted herself at her easel in fashionable dress, with boldly undulant plumed hat; not, perhaps, the most workmanlike attire for a painter. The two pupils are more simply clad. This is an out-and-out representative work of a successful artist, asserting her place in the profession with confidence; compare this with the sober, restrained and realistic self-portrayal of Anna Dorothea Therbusch of the same period!

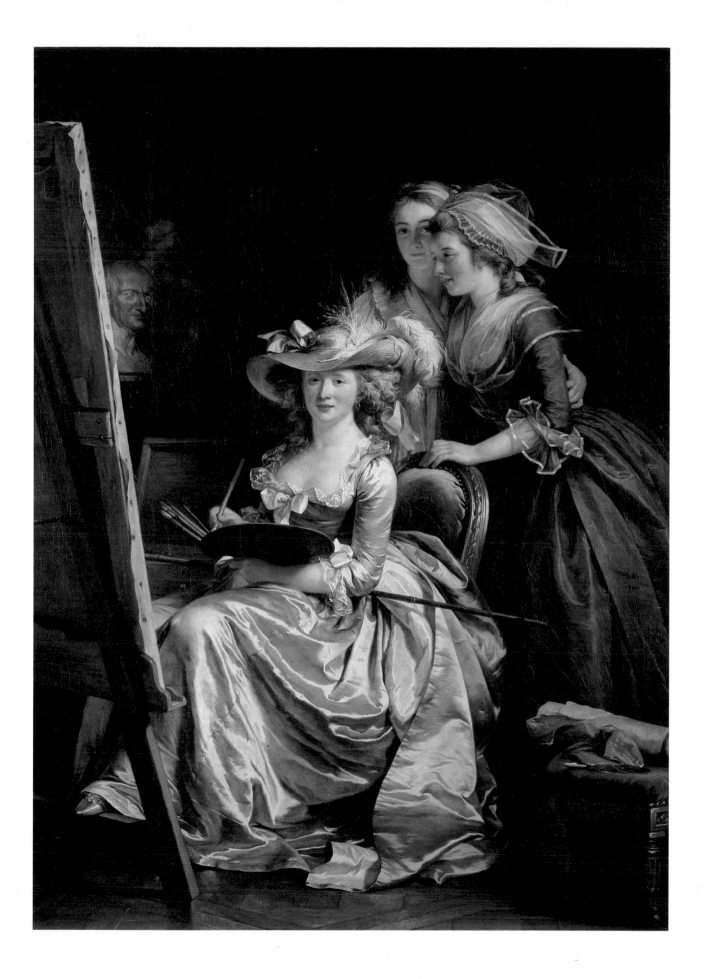

Ellenrieder, Maria
The Betrothal of Saint Catherine

1820 / etching / 21.2 × 17.2 cm
Museum der bildenden Künste, Leipzig

Maria Ellenrieder, the first female student ever accepted at the Munich Academy (1813), was regarded as the most important German woman painter of the early 19th century. Louise Seidler refers to her as a "church painter" in her memoirs and states that her zeal put most men to shame. She lived for some time in Italy and was influenced by the Nazarenes, as the illustration indicates.

Ellenrieder, Maria
The Artist's Mother
The Artist's Father
1809 / etchings / each print 11.5 × 9.8 cm
Museum der bildenden Künste, Leipzig

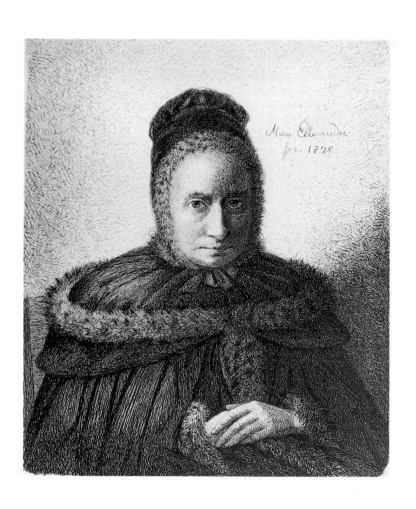

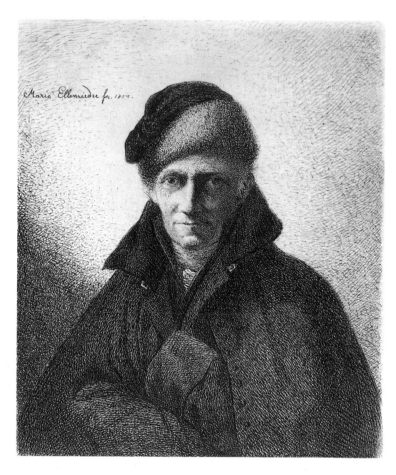

Mengs, Theresia Concordia
The Artist's Sister, Juliane Mengs

before 1765 / pastel / 42 × 34 cm
Staatliche Kunstsammlungen Dresden,
Gemäldegalerie Alte Meister

Theresia Concordia was a member of the artists'
dynasty of Mengs, famous in the 18th century;
she married the painter Anton von Maron in
Rome. Her sister, Juliane, was likewise a painter
and later entered a convent.

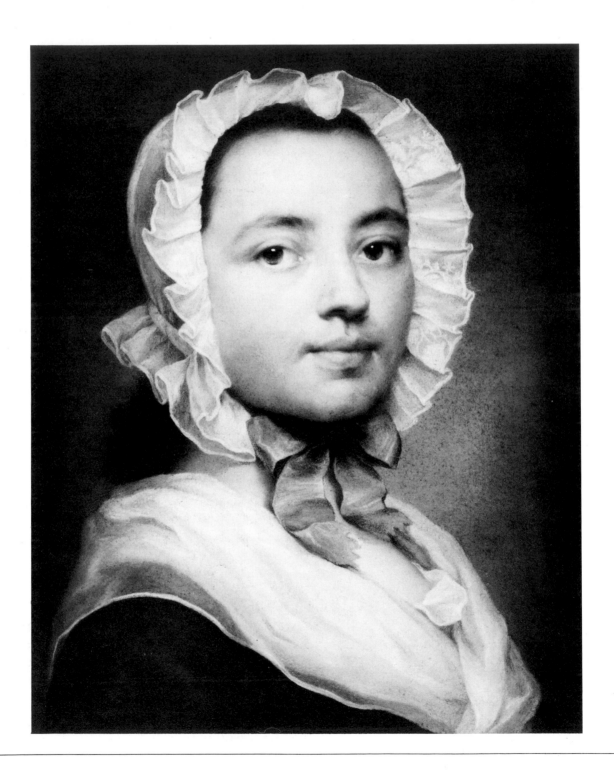

44

Tischbein, Caroline
Portrait of E. August Blümmer

undated / 64.5 × 54 cm
Museum der bildenden Künste, Leipzig

Caroline Tischbein, wife of the historian and orientalist Wilken, was the most gifted of the many women painters descending from the Tischbein family. She was also a talented singer. She took her professional training in the studio of Apollonia Seydelmann who later became a member of the Dresden Academy. Caroline's painting of young Blümmer is the sensitively conceived portrait of one of the romanticizing youths of the period.

Laurencin, Marie
Self-Portrait

undated / lithograph / 30 × 18 cm
Staatliche Museen zu Berlin, Kupferstichkabinett
und Sammlung der Zeichnungen

Marie Laurencin was part of the circle of Picasso,
Braque and Apollinaire, whose artistic influence
on her is just perceptible. Her lyrical and graceful
art, although perhaps too concerned with
decorative values, yet identifies her as a delicate
and sensitive artist.

Laurencin, Marie
Portrait of a Lady with Doves

undated / watercolor / 34 × 25 cm
Staatliche Museen zu Berlin, Kupferstichkabinett
und Sammlung der Zeichnungen

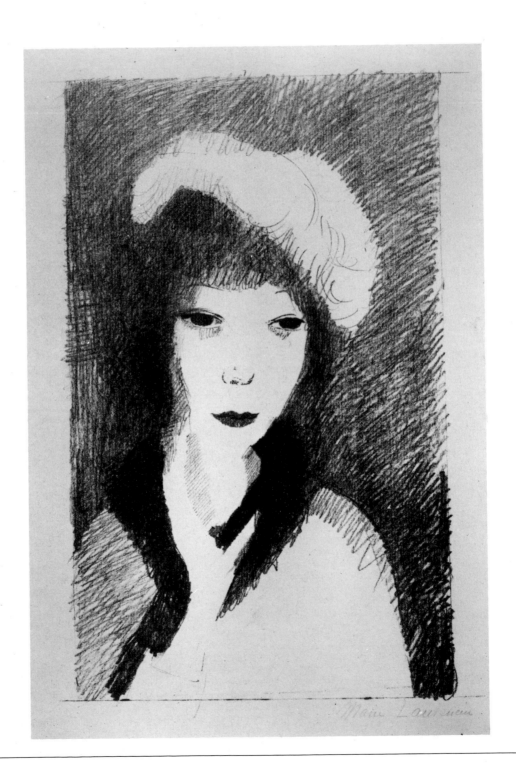

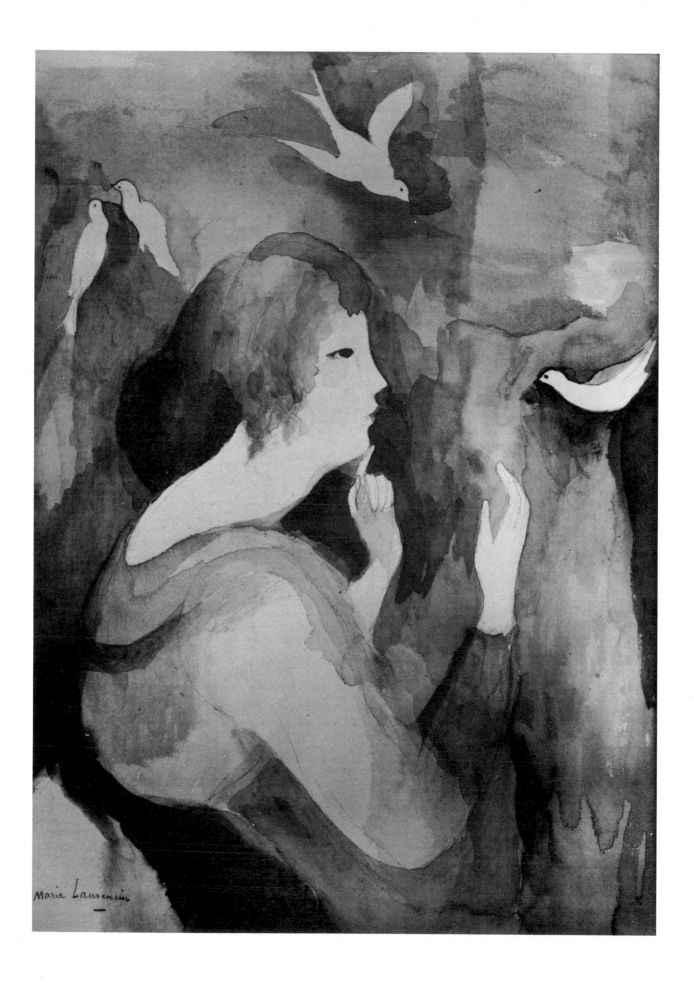

FIELDS OF ACTIVITY, CATEGORIES, THEMES, SUBJECT MATTER AND MEDIA

A great majority of women artists were painters and graphic artists; during the Renaissance, this was almost exclusively true. A very much smaller proportion devoted itself to sculpture before about 1800. Until approximately the same period, the number of miniaturists was especially high. Women had always been held the most suited for mini-art, but there were also countless men engaged in painting miniatures, because this genre was a high favorite with the public for centuries.

Many women, as well as men, derived a substantial part of their revenue from copying paintings. Regarding this, it should be remembered that, until well into the past century, the copying of masterworks was a perfectly respectable artistic branch, as well as a comparatively lucrative one. One may add in parenthesis that until our own time almost, picture copying was still taught as a required discipline at art academies, on the theory that it was bound to materially increase and fertilize painting techniques. The passion for collecting at courts, in aristocratic and wealthy bourgeois circles, included works which, if not otherwise available, were wanted at least in a replica, and provided a livelihood for quantities of copyists of a widely varying degree of proficiency. Some of

them specialized in copying only works by one master and often became famous for their skill in imitating his manner. Also, until the late 18th century, some of the famous painters whose works were in constant demand, employed their own copyists, who were quite often their wives and daughters; it was admiringly stated of such painting female relatives that frequently even connoisseurs could not distinguish their copies from the originals. A good example is the Dutch painter Anna de Deyster (1690–1747), daughter of the painter Ludwig de Deyster of Bruges, who besides being her father's copyist, composed landscapes of her own. The three daughters of Balthasar Denner, in particular Catharina (active between 1723 and 1744), not only produced copies of their father's pictures but were sometimes set to painting in details or even to finish his paintings.

Picture copies were also an overseas export article for a long time, a trade in which the art dealers had of course a rich share. Until about the 1770s whole ships' cargoes of copies and inexpensive devotional art were despatched from Spanish and Portuguese ports toward the colonies in the New World, there to decorate churches and convents and to stimulate contemplation on the part of the newly converted populations. One may presume that women painters, on account of their known predilection for religious themes, had their part in the production of such export goods.

Commissions for copies came from foreign princely courts, e.g., the Imperial Court of Moscow; but orders of this kind were reserved for highly qualified craftsmen and women, many of the latter rejoicing in an enviable reputation, such as the Austrian Theresa von Eissl (born 1792), who painted masterly copies of works in the Dresden gallery for the account of German, Russian and Scandinavian collectors.

Lewis, Edmonia
Old Indian Arrow Maker and his Daughter

c. 1876 / white marble / *c.* 57 cm
Museum of African Art, Washington

In her sculptures of themes taken from Indian life, Edmonia Lewis worked in an intimate area all her own, which had not previously been explored in this manner. Her figures are idealized, and the artist's intention is clearly to typify the human qualities of her race and thus to support the struggle for racial equality.

The art of picture copying was not confined to imitating them in their original technique. In the 17th and 18th centuries the pictures of artists sufficiently in demand to justify it were also rendered or reproduced in other media, engravings on copper being the most common. Many generations of male and female artists have made their living from such reproductive work, which was often carried on in rational workshop production. We choose as an example the three sisters Bouzonnet. Children of the well-known artists' family of Stella, all three of them had been trained by their uncle, Jacques Stella. The entire family occupied quarters in the Louvre. Claudine (1636–1697) specialized in engravings after Poussin and was reputed to be the best interpreter of this master's work on copper. Françoise (1638–1691) engraved mostly compositions by Jacques Stella for the editions of religious series, while Antoinette (1641–1676) made engravings for prayer books after pictures with religious subjects. Another favorite genre was the reproduction of paintings on porcelain: many of the porcelain painters employed at Sèvres were women. Even free artists occasionally accepted such work, which was commissioned mostly by princely courts.

Besides these, there was an astonishingly rich variety of other, craft-related reproduction techniques in which female artists were employed during the 17th and 18th centuries. Some worked as painters on glass, for instance Barbara Abesch (1706–1760?), a descendant of an ancient family of glass painters of Lucerne; some were etchers on glass, such as the Italian Anna Cecilia Hamerani (1642–approx. 1678), who made candelabra for St. Peter's Cathedral with biblical scenes in a glass etching technique. The bronze caster Agata Confarto (about 1702) cast with the assistance of two other artists the statue of Philip V at Naples, which was however demolished only five years afterwards. The *scagliola* (imitation of ornamental marble consisting of finely ground, tinted gypsum and glue) artist Vittoria Seyter (2nd half of 18th century) made two tabletops representing landscapes, for the residential palace of the Elector at Würzburg. A *musiv* (mosaic) artist, Barbara Thein (born 1775) has been mentioned as assistant of J. B. Blank in Würzburg.

In contrast to these relatively rare crafts, women artists were numerous in such branches as armorial painting, gem cutting, ivory carving and die making for signets and medals. Amongst the latter we may mention Angelika Facius (1806–1897), a portrait medalist favorably regarded by Goethe. Many women were skilled in the painting of ladies' fans: in 1749 Marianne Hibon was admitted to the Paris Académie de Saint-Luc on the strength of her painted fan "Shepherds and Shepherdesses"; likewise Marie Soucancy de Baricoux in 1763, also with a painted fan. Art embroidery, sometimes called *Nadelmalerei* (needle painting) was another outlet for female artistry, although not disdained by male artists either. The Venetian embroiderer and miniaturist, Dorothea Aromatari became famous in the 17th century for her creations of "marvels of needle painting." The nun, later abbess at Bamberg, Salesia von Lilgenau (died in 1808) is referred to as the "inventor" of *zeichnende Stickerei* (embroidery imitating drawing) and said to have been able to "imitate paintings most deceptively." The English embroiderer Mary Linwood (1755–1845), who was also a composer and writer, made embroidery copies after paintings by Reni, Dolci and Reynolds. The Danish Ottilie Hornemann (1764–1826), member of the Berlin Academy and a trainee of her stepmother, the embroiderer Bothilde Hornemann (1752–1792), showed a portrait of Frederick II, embroidered in wool after a painting by A. Graff, in an academy exhibition in 1791 which was greatly admired. Copies of paintings in embroidery were especially valued if obverse and reverse showed the same image and were rated as artistically valid works in those times; but many embroiderers created their own designs. The family of Huguet y Creixels became known in Spain: after the grandmother Maria Valls died in 1868, the mother, Rosa y Creixels (deceased in 1911) was specially employed by the courts at Madrid and at Lisbon. Two of her daughters gained high fame for their lace work and embroideries made especially for court dress: Josefa (born 1863) was commissioned by patrons in France, Belgium and England; Pillar (born 1868) was also a miniaturist. The sisters Dora and Mathilde Jörres (about 1860) as well as many of their pupils were employed by King Louis II of Bavaria to make embroideries for the castles of Herrenchiemsee, Linderhof and Neuschwanstein; samples of their works were shown at the Berlin Great Art Exposition of 1894.

Besides reproducing other works of art, the enamel and china painters executed portraits, landscapes, still lifes and other subjects from their own designs; artifacts in these techniques were in fair demand until the end of the last century. Some women became skilled picture restorers-conservators, for instance Madame Godefroy (about 1753), the widow of a painter and picture restorer who died in 1741. At the time of her husband's death she found herself with seven children to feed. She carried on the restoring shop, being given a studio in the Apollo Gallery of the Louvre in 1753. As late as 1773 she can be traced as a conservator of the Royal Picture Collection.

Many women were faience painters and some even ran their own potteries. The German faience artist Anna Maria Molin (about 1697) assumed the directorship of the oldest faience factory in Berlin, after the death of her husband, a faience artist of Dutch descent who had previously headed the business. The faience painter Seraphia von Löwenfinck (1728–1805), a descendant of a family of German artists, took over the management of her husband's Hagenau faience factory after his demise, as well as another establishment in Strasbourg from 1761–1762. In 1763 we find her as *Kondirektor* (codirector) at a faience pottery connected with the porcelain manufactory at Ludwigsburg, which she subsequently headed independently from 1777 until 1795. The Frenchwoman Perrin was another faience manufacturer who directed her workshops at Marseilles jointly with a partner under the name of *Veuve Perrin fils* (the widow Perrin and son) about the year 1785.

The interior of the Municipal Parish Church of St. Lorenz at Kempten was decorated with elaborate stucco inlay work (1666–1670), which was at least partly executed by a Viennese stucco worker listed in the Parish register as "the widow Barbara Hackl." It is said that she also created the excellent stucco sheathing of the corner pilaster of this church. Information of this kind leads us to deduce that women were employed in such and similar trades at least about the end of the 17th century, but probably also before as well as after, without their collaboration being specifically recorded.

Next to painting in the most various media the graphic arts were a main outlet for the talents of women artists; as already mentioned, their activity was by no means con-

Braun, Anna Maria, b. Pfründt
Medal of Frederick I of Saxe-Gotha

1705 / reproduction from W. E. Tentzel,
Saxonia Numismatica,
Ernestinische Linie Dresden 1705, pl. 65 I
Staatliche Museen zu Berlin, Münzkabinett

Highly regarded in her time, the wax moulder and medalist Anna Maria Braun was the daughter of the wax moulder Pfründt, and married to a medalist by the name of J. B. Braun. Her work was so famous that at two different times she received calls from the court of Vienna.

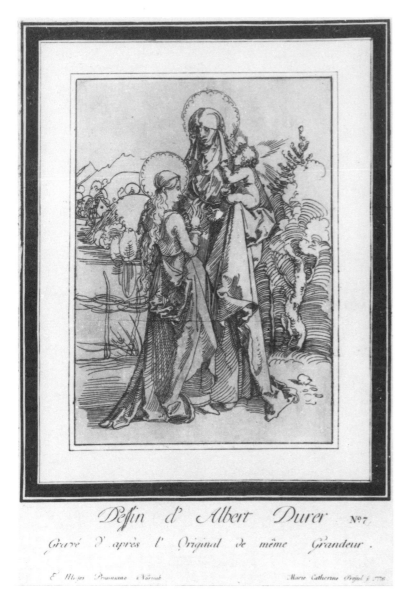

Deſſin d' Albert Durer N°7.

Gravé D'après l' Original de même Grandeur.

E. Illges Prassano Narvak Marie Catherine Prestel f. 1776

Prestel, Maria Catharina
Elizabeth and Mary
(after Albrecht Dürer)

1776 / aquatint / 24 × 17 cm
Kunstsammlungen Veste Coburg

This print is another illustration of the role
played by women artists in reproduction
techniques. It is an aquatint by Maria Catharina
Prestel, who was the wife and co-worker of a
reproduction engraver. Her daughter,
Catharina, was also a copper engraver and
worked with her mother.

fined to the purely reproductive use of engraving. The
high ratio of feminine participation in the graphic arts is
connected with the rising demand for book illustration in
general, and in particular for scientific illustration, in the
16th and 17th centuries. Many female graphic artists
worked in this area, straddling artistic and scientific con-
cerns, even later—we are reminded of the incomparable
Maria Sibylla Merian at once; and, like her, whole gener-
ations of women illustrators have known how to combine
scientific research with artistic formulations; only the
19th century arrogated to itself the right to deny women
the faculty for doing science work.

Engraving on copper was the preferred medium of a
majority of women artists for a long time. But they were
also proficient in other graphic processes. Many worked
as illuminists, that is to say, they hand-colored prints.
This was another branch of the arts often run as a fami-
ly enterprise, like that of the Flemish family of Merlen,
in which a mother, Constance (1609–1655) and two
daughters were active. Other women illustrated belle-
tristic literature and, in later times, periodicals, e.g., the
English Ellen Carter (died 1815) who made designs for
the *Gentlemen's Magazine* and *Archaeology* amongst others,
or the Frenchwoman Julie Ribault (born 1789) who en-
graved pages for the *Journaux des modes,* the *Petit courier des
dames* and the *Mercure des salons,* in other words, a forerun-
ner of the modern fashion designer. Some women worked
in the field of what we would call commercial art today,
like Thérèse Chenu (2nd half of 18th century), who made
etched landscapes and designed letterheads for wedding
and birth announcements, etc. During the period under
discussion there was hardly a branch of the graphic pro-
cesses in which women worked not only on a basis of
equality with men, but also, very often, quite indepen-
dently of them. Without doubt the most famous of them
all is Maria Sibylla Merian (1647–1717), to be fully dis-
cussed in another chapter; she certainly blazed a trail for
many a successor, but many other artists were already on
their own prior to her time of fame; we have space only to
name a few. Since the Renaissance the market for prints
of all kinds had steadily increased everywhere, a favor-
able conjunction from which women profited as well as
men, and by no means only as mere illustrators. The
trade was especially flourishing in the centers of Nurem-

berg and Augsburg, peaking in the 18th century, and the publishing companies could barely keep up with the demand. Folio works of engravings and vast quantities of single prints of the Saints were exported all over the world. So high was the market that women felt encouraged to become publishers in their own right, for instance the Augsburg engraver Maria Wieolat or Wieolatin, of about the year 1695, who is listed as a publisher of copper engravings, or the widow of the engraver and publisher, Christoph Weigel, who as his successor bought up the copper plates of the *Grosses Siebmachersches Wappenbuch* (collection of coats of arms) and brought the work out in a new edition from 1731 on. Her firm also published a variety of other picture books, amongst them encyclopedic works describing various trades and professions. In France, too, women artists became publishers of their own as well as of other artists' work, for example Francisca Basset (end of 18th century), who jointly with her brother ran a printshop in Paris, from which she issued her series of prints entitled *Les habillements modernes et galants* (modern elegant dress) in fascicles of six pages from 1785 to 1795. A family enterprise was headed by Louise Marie Cochin, already mentioned, the daughter of a Dutch bookseller, Horthemels, who had emigrated to Paris; her staff included her husband and three siblings, two of them her sisters. Together with her husband she appears as the publisher of an *Histoire et description de l'Hôtel des Invalides* and also finished etched works by her

son. Magdalena Fürst (1652–approx. 1717), a pupil of Maria Sibylla Merian's and illustrator of botanical books, was the youngest of three daughters of a Nuremberg publisher and art dealer, who were all active in the arts. Magdalena spent eight years on the illustrations for her chef d'œuvre, *Hortus Eystettensis* by Basilius Besler; her sister Rosina Helene edited the second, third and fourth parts of a *Modelbuch* (pattern collection), published by her father from 1666 on. Barbara Regina Dietzsch issued a folio work of fifty copper plates with representations of birds between 1772 and 1775, and her daughter Margarethe Barbara (1726–1795) devoted the greater part of her life to a monumental work on botany which began to appear in 1784; she made the pictures for a text by Schreber, for which she drew, engraved on copper and hand-colored illustrations of specimens of every fruitbearing herb, shrub or vine, and tree, growing in the vicinity of Nuremberg.

Geneviève Regnault (1746–1802), a Parisian printmaker, engraved her own and her husband's designs for the folio *La botanique* (1774), comprising 300 plates, and for the series *Les monstres ou les écarts de la nature* (1775). Laura Piranesi (1755–1785) was a member of the illustrious Italian family of graphic artists Piranesi; jointly with her brother Francesco she etched and published views of Roman monuments. The French Pauline Knip (1781–1851) specialized in ornithological drawings; during the years 1808–1814 she published a *Monographie*

Halstüchlein Riß.

14

Helm, Margaretha
Kunst- und fleissübende Nadelergötzungen

c. 1725 / engraving ón copper / 22 × 34 cm
Staatliche Museen / Preussischer Kulturbesitz,
Berlin (West), Kunstbibliothek

"Needle entertainments for practicing one's art and industry" is the title given to a sewing and embroidery book of patterns for cross- and satin stitch embroidery by the engraver Margaretha Helm, who worked in Nuremberg about the period of 1725. Her book was published by C. Weigel; many graphic artists earned their living by making such and similar design series in those times.

des pigeons et des tanagres, the designs for which she used later for porcelain paintings and exhibited those in the Salons. Her bird representations later earned her a gold medal. Her professional status was further increased by her drawings and hand-coloring of copper plates for two ornithological works by Desmarest. The Italian painter Rosalba Bernini (approx. 1778–1812) was also involved in ornithology: this daughter of the animal painter, Clemente Bernini, carried on his series of plates illustrating the birds of Southern Europe, which he had begun to issue in 1769.

Quite a different genre is represented by the Hogarth-inspired engraved series of *The Progress of Female Dissipation* and *The Progress of Female Virtue* by Maria Cosway (1759–1838). An Italian of English descent, she had settled in England on the advice of Angelika Kauffmann. In her time she enjoyed such fame that it was the rage to buy her works. She had lived a fairly adventurous life by the way; following the death of her husband, the miniaturist Cosway, who had been a supporter of the French Revolution, she returned to Italy, where she founded a "Collegio delle Dame Inglesi" at Lodi, for which the Emperor Francis I made her a baroness. Another Englishwoman, a native of London, Mary Lawrence (active between 1794 and 1830) began to issue in 1797 a de luxe edition of a series entitled *The Various Kinds of Roses Cultivated in England.* This roster might be continued almost indefinitely, for until about 1800 an extremely large number of women artists specialized in this branch of the visual arts. The art collection at the Veste Coburg, whose graphic cabinet contains over 300,000 prints assembled by the Duke Anton of Saxe-Coburg-Saalfeld toward the end of the 18th century, has an extraordinary quantity; of single prints as well as of series, in monochrome as well as colored, made by women whose names are for the greater part quite unfamiliar. From such profusion one may conclude that even more women have worked in this field than had previously been known or assumed. It is safe to guess that other graphic arts collections must equally harbor as yet unknown works by female artists. The sam-

M. Michelle Blondel Sculp.cit.

ples we have sketched in the foregoing should make it evident that, in the field of the graphic arts, women have pursued highly differentiated ends and have reached results often comparable to what was done by men. In the early years of the 19th century we see them running their own engraving shops and publishing houses, working as illustrators of scientific as well as belletristic literature on their own as well as for outside accounts, designing and issuing series of plates with the most diverse subject matter and, speaking generally, meeting with their publications the need for pictures especially of the less monied classes; their influence was peculiarly effective in reaching, forming the taste and raising the intellectual and esthetic standards of the important middle stratum of society.

From the earliest times to the period when women gained access to academic training institutions, and later still, women have often been very effective in teaching their profession, usually in conjunction with their own creative work. We have already referred to Elisabetta Si-

rani. Three hundred years after her, at the end of the 19th century, the Norwegian Harriet Backer (1845–1932), a well-known artist in her time, was the head of a school of painting in Christiania, the beneficial effect of which on the new generation of artists in Norway was publicly acknowledged. During the period marked by the above dates, more particularly toward its end in the course of the 18th and beginning of the 19th centuries, women teachers, especially of France, have taught countless male and female art adepts, dilettantes as well as aspiring professionals, commonly in their own ateliers but often also as teachers employed by the courts. Thérèse Baudry de Balzac (1774 – died after 1831) was a specialist in botanical illustration, and was for a long time a design teacher at the Royal Palaces of Ecouen and Saint-Denis; she also was recipient of a pension as a member of the Legion of Honor at least until 1830. Her daughter, Caroline (born 1799) was likewise a design teacher at Saint-Denis, gave lessons in oil and china painting, and worked for the porcelain manufactory at Sèvres. Another

Vase en plomb bronzé de la pièce de Neptune à Versailles.

M. Michelle Blondel sculp.

Blondel, Marie Michelle

Trophies of Crowns and Helmets after Reliefs from the Fontaine des Dômes in the Park of Versailles

between 1725 and 1735 / copper engraving / 10.5 × 19 cm
Staatliche Museen / Preussischer Kulturbesitz, Berlin (West), Kunstbibliothek

Blondel, Marie Michelle

Profiles and Ornamentations of Vases in the Gardens of Versailles, Trianon and Marly

between 1725 and 1750 / copper engraving / 19.8 × 18 cm
Staatliche Museen / Preussischer Kulturbesitz, Berlin (West), Kunstbibliothek

Engravings after crafts objects were often used by artisans as models and patterns in the 18th century. The Frenchwoman, Marie Michelle Blondel, published several such pattern series about 1730, like the "Trophies after Reliefs in the Park of Versailles," and "Profiles and Ornamentations of Vases in the Gardens of Versailles, Trianon and Marly."

female instructor at Saint-Denis was Louise Bouteiller (1783–1828). Justine Frère de Montizon (born 1792) was a drawing teacher at the Parisian Ecole Royale Gratuite in 1810 and subsequently conducted a drawing class for young people jointly with her sister Flore. The English miniaturist Emma Eleonora Kendrick (1788–1871) of London, court artist to the Princess Royal, Elizabeth, and, amongst other subjects, creator of classical-mythological and literary genre scenes, also instructed the daughters of the British aristocracy in miniature painting for many years. Clémentine de Bar (1807–1856) was design teacher at the Maison de la Légion d'Honneur at Saint-Denis, as was Elisabeth Swagers (died 1837) for a shorter period. The French painter Eugénie Hautier (about 1822–1909) became head of a municipal design school in 1860 and was appointed inspector of the drawing classes in the schools of Paris in 1870. The French painter and sculptor Adèle Gonyn de Lirieux (born 1865) was for a brief time painting teacher of the royal princesses at the court of England and also gave lessons at the South Kensington Art School. She was also a contributor of illustrated theatrical reviews to the magazine *Le monde artiste*.

Women artists proved themselves able also in related positions, e.g., the painter and engraver Magdalene Basseporte (1701–1780), who was appointed as draftswoman for flowers and plants at the Paris Botanical Gardens, or the sculptor Julie Charpentier (about 1800–1843), who held the post of zoological preparator at the Paris Museum of Natural History; she also designed some bas-reliefs for the Vendôme column in Paris.

Sometimes, to be sure, sex could be a disadvantage: the application for the post of drawing teacher at the Ecole Centrale at Chartres, of the painter Chézy-Quévanne in the year IV of the Revolution, was refused because she was a woman.

Although women sculptors were a distinct minority when compared to the number of women who were active in all the branches of painting and the graphic arts, there were yet more of them, from the early 16th century on, than had been known until recently. Whether the legendary Sabina von Steinbach (about 1300), the daughter of the eminent architect Erwin von Steinbach, was indeed the creator of the two statues *Synagogue* and *Ecclesia*

of the Strasbourg Cathedral, as some historians believe, is not certain at the present time and will probably remain doubtful; the attribution proves nevertheless, at least, that in those early times a woman was judged capable of so supreme an achievement. A painting by Moritz von Schwind of 1844 portrays this legend.

The only known female sculptor of the Renaissance is Properzia de Rossi (1491?–1530), who created the marble relief *Joseph and the Wife of Potiphar* for the church of San Petronio at Bologna. Vasari speculates that the figure of Potiphar's wife may be a self-portrait of the artist, who thereby hints at an episode of love despised. Properzia de Rossi began as a carver of miniatures; it has been claimed that she carved the entire passion of Christ out of a peach pit.

In later times many of the known women sculptors concentrated on wax modelling, a medium which has all but disappeared in our time, but which was highly popular until the late 18th century chiefly in the Roman Church and at courts. In her own day the medalist Anna Maria Braun (1642–1713) had a high reputation. She was the daughter of a wax model maker and medalist of Nuremberg; she later worked in Frankfort on the Main and was called at two different occasions to the court of Vienna. The nun, Placida Lamm (about 1665–1692) mostly modelled wax statues of Saints to be given as presents to illustrious visitors at her convent. Other wax sculptors too, such as the Italian Anna Manzolini-Morandi (1717–1774) and her countrywoman, Caterina de Julianis (about 1695–1742) did most of their work for churches; the last-named produced an abundance of brightly painted wax figures and relief plaques which

Göblin, A. B.
The Latest View of the Jubilee Celebration in Alt-Dresden on the 2nd of November in the Year 1717

1717 / engraving and etching / 40.9 × 32.2 cm
Kunstsammlungen Veste Coburg

This commemorative print of a jubilee celebration of the Reformation was made by A. Göblin, b. Hayd, wife of the engraver Göbel, after a drawing by her sister, the miniaturist Anna Maria Werner, who was a daughter and pupil of Andreas Hayd, a goldsmith.

Pachelbel, Amalia
Coat of Arms of M. C. Holzschuher

1710 / watercolor / 16.6 × 14.6 cm
Staatliche Museen zu Berlin, Kupferstichkabinett
und Sammlung der Zeichnungen

The Nuremberg watercolorist and engraver,
Amalia Pachelbel, also referred to as Pachelbein,
issued several series of engravings *c*. 1700; our
illustration may be of a design for a plate in one
of these series.

Troost, Sara
Male Portrait

1757 / pastel / 43 × 33 cm
Rijksmuseum Amsterdam

The Dutch draftswoman and painter Sara Troost
worked as a copyist both of older Dutch painters
and of works of her father's, Cornelis Troost;
besides she was a portraitist in her own right.
This likeness of a gentleman conforms to the
traditions of her time and of her native Holland:
it is unobtrusive and realistic.

Sintzenich, Elisabeth
Ladies in a Park

1795 / colored etching / 19.5 × 29.3 cm
Kunstsammlungen Veste Coburg

The draftswoman and painter Elisabeth Sintzenich, descendant of a family of artists, is totally forgotten today. She came to Berlin in 1790 with her father, a painter. Her composition is graceful and elegant and reminds of a fashion design; the coloring however is a little loud.

Godefroid, Marie Eléonore
The Sons of the Marshal Ney

1810 / 162 × 173 cm
Staatliche Museen / Preussischer Kulturbesitz,
Berlin (West), Gemäldegalerie

A high favorite of the *haut monde* for portraiture in her time was the French painter Godefroid. Between 1800 and 1847 she exhibited numerous portraits of the aristocracy in the Salons, earning many awards. She also taught at a boarding school for the daughters of nobles. In her charming group composition of three children, which also has remarkable painterly qualities, she portrays a society whose star was soon to sink, but which has kept certain cultural traditions alive.

Ellis, Elizabeth
View from the Vicinity of Hemstead

c. 1778 / etching / 56 × 78 cm
Kunstsammlungen Veste Coburg

The English engraver Elizabeth Ellis (active around 1775) was either the wife or the sister of William Ellis, with whom she worked jointly at print making; the pair published their plates under their own name. The figures were probably drawn by W. Woollett, the teacher of William Ellis.

Abercromby, Lady Julia
Queen Victoria (after a painting by
H. von Angeli)

1883 / watercolor copy / 140 × 93 cm
National Portrait Gallery, London

This copy of a portrait of Queen Victoria by von Angeli is the work of a dilettante member of the nobility. Lady Julia Abercromby was lady of honor of the Queen, whose partiality for women artists is well known. We have chosen this picture as a specimen of the copying work of many women painters of the period.

Backer, Harriet
A Country Cobbler

1887 / 66 × 90 cm
National Museum Stockholm

In the late 19th century, Harriet Backer was the best-known woman painter in Norway. Her private painting academy exercised considerable influence on the young generation of artists. Her way of seeing is close to Impressionism; besides having painterly qualities, her pictures are attractive because of their restraint, which does not exclude a sincere feeling for her subjects.

Backer, Harriet
Big Brother is Playing
1890 / 50 × 61 cm
Art Museum Göteborg

Radziwill, Maria Eleonora zu
Youthful Heroic Figure

1723 / graphite / 18.2 × 13.5 cm
Staatliche Museen zu Berlin, Kupferstichkabinett
und Sammlung der Zeichnungen

This drawing in graphite of a young hero is the
work of a dilettante, the princess Maria Eleonora
zu Radziwill; it is artistically without pretension,
but is executed with style.

Facius, Angelika
**Medal Johann Wolfgang
von Goethe**

1825 / bronze / 0.32 cm

**Medal Maria Pavlovna
of Saxe-Weimar**

1854 / silver / 0.55 cm

**Medal Charles Augustus
of Saxe-Weimar**

1829 / bronze / 0.42 cm
Staatliche Museen zu Berlin, Münzkabinett

The die maker and gem cutter Angelika Facius was one of the artists sponsored and supported by Goethe at the court of Weimar. After studying with Rauch, she also did sculptures. Our illustrations show that she was a skillful portrait medalist.

Rossi, Properzia de
The Wife of Potiphar

probably between 1525 and 1527 /
marble relief
S. Petronia in Bologna

The only female sculptor of the Renaissance of whom we have certain knowledge is Properzia de Rossi of Bologna, and the only authentic work of her's which has come down to our time is this marble relief of Potiphar's wife. Vasari maintains that this scene portrays an event in an unhappy love affair of the artist; the dramatically dynamic group reveals de Rossi's high art.

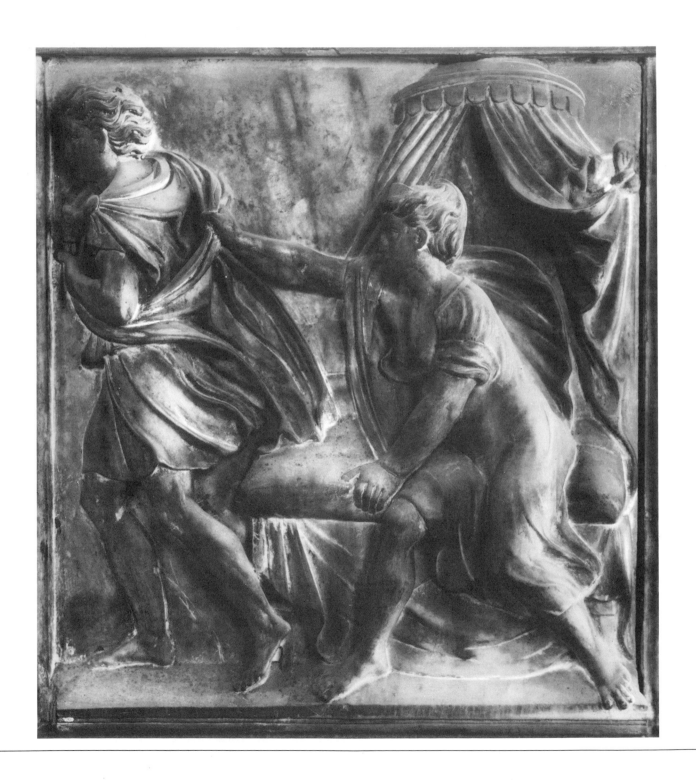

Dantzig, Rachel van
Portrait of Frau Emma Cornette

undated / bronze / height 35 cm
Koninklijk Museum voor
Schone Kunsten Antwerp

Rachel van Dantzig is one of the few women sculptors working at the turn of the last century in Holland. She had studied for a time at the Académie Colarossi in Paris. Her portrait head, despite a slightly sentimental touch, demonstrates the artist's ability to express something essential of her model in plastic terms.

Golubkina, Anna
Portrait of Alexei Tolstoi

1911 / wood / height 66 cm
State Tretyakov Gallery Moscow

Anna Golubkina was a pupil of Rodin and counts as one of the most important Russian women sculptors. She created several other wooden portrait sculptures besides this bust of the writer Alexei Tolstoi, which is characteristic for her bold and expressive style of woodcarving.

Sintenis, Renée
Kneeling Fawn

between 1914–1920 / bronze / height 7.5 cm
Staatliche Museen zu Berlin, Nationalgalerie

This kneeling fawn is an early work of the animal sculptor who reached her personal style only afterwards, but the little piece illustrated shows already the sensitive perceptiveness and pronounced feeling for form which was to characterize her work later; it was purchased for the National Gallery in 1921 by Ludwig Justi.

were widely admired, chiefly for churches at Naples. The English wax sculptor Catharina Andras (born about 1775) held an appointment as wax portraitist to Queen Charlotte in 1801 and received, in the same year, an honorable mention from the Society for the Encouragement of the Arts, for two portrait busts of her's. There is no doubt that the most famous of them all was Marie Tussaud (1761–1850) who will be described in more detail further on in this book.

But females were also at home in the "classical" sculpture modes. Indeed some gained high acclaim, e.g., the Spanish Luise Roldán (1656–1704), who was from 1695 on court sculptor of Charles II—the only woman, by the way, to occupy such a post so far as is known. Commissioned thereto by the king, she designed and constructed a colossal crucifix, and a large statue of St. Michael for the Escorial, which was much marvelled at. The French Marie-Anne Collot-Falconet (1748–1821) also became famous; we shall have more to say about her work in another chapter. Her countrywoman Clémence Daudignac (1767–1850) portrayed many celebrities of her pe-

riod and also created original thematic sculptures with the type of titles so characteristic for the time: *Plato Meditating on the Immortality of the Soul*, *Sappho Deserted by Phaon*, or *The Duchess of Berry in the Arms of the Duchess of Angoulême Lamenting her Late Husband*.

The Italian Caterina Caniana (2nd half of 18th century) worked as a sculptor in woodworking and inlay work; Anna Berini (about 1830), also known as a painter on ivory, was praised for her bold busts, while yet another Italian, Theresa Benincampi (1778–1830), a pupil of Canova, even became professor of sculpture at the Florence Academy. The ranking English woman sculptor of the period is thought to be the Scottish-born Anne Seymour Damer (1748–1828) who created a colossal statue of George III for the Registry Office at Edinburgh.

During the 19th century we see the numbers of women sculptors increasing considerably; besides America, the Scandinavian countries, Russia, England and France, become the predominant nationalities; German sculptors remain a rarity until at least the middle of the century. It may be presumed that the intensified sculpturing

Caffi, Margherita
Still Life

undated / 75 × 61 cm
Kunsthistorisches Museum Vienna

The Italian Margherita Caffi worked in Vienna during the 17th century. Her flower pictures were once much in demand. They may have been made in a Viennese studio, the products of which show the imprint of her personal style.

Stella, Claudine
The Betrothal

(No. 14 in the series "Pastorales" after paintings by Jacques Stella)
1667 / copper engraving / 24.9 × 31.9 cm
Kunstsammlungen Veste Coburg

The engraving and printing shop of the family of Bouzonnet-Stella in the Louvre published amongst other works a series of engravings with the title "Pastorales" after paintings by J. Stella. The artist's niece, Claudine, proudly marked her name as the engraver on the title page and on each plate, not forgetting to mention the royal privilege.

activity of women in the countries named is connected with the proportionately greater degree of freedom allowed to the sex in their respective homelands, while in conservative Germany the taint of "emancipation" was attached to the sculptors still more than to the other female fine artists. The bad name which sculpture by women had with the public was, in the first place, due to the indispensable training including the study, and eventual representation, of the nude, without which nothing could be achieved, but which was deemed to be improper for females; in the second place, the expenditure of physical force is much greater for sculpting than it is for painting, and this, it was thought, made the plastic art a male preserve; for a long time women in Germany were, at best, conceded to be passably adequate in the areas of portraiture, genre scenes and devotional statuary. Seen from the perspective of Europeans, not accustomed to such sights, the groups of American sculpture students in the Rome of the 1850s had the appearance of veritable "Amazons," such as Edmonia Lewis, already mentioned here, and the spectacular Harriet Hosmer (1830–1908) who pained bourgeois propriety for nothing worse than her custom of riding on horseback unaccompanied through the Roman Campagna. The English writer Elizabeth Barrett-Browning wrote of Harriet Hosmer's lifestyle in 1854: "She lives here by herself (at the age of 22!), breakfasts and dines in the cafés like any young man, and works from six in the morning until dark, as every great artist must do." In later years Harriet Hosmer executed sundry major commissions in America for monuments, fountains, etc.; her *Puck* alone brought her a fortune: thirty replicas were ordered and sold. We may name some other well-known American women sculptors of the 19th century: Caroline Ball (born 1869), who created amongst others the statue *Victory* for the U.S. pavilion at the Paris World Exposition of 1900; Alice Kitson (born 1876), a prolific worker who sculpted war memorials for many American cities and towns, as well as statues, portrait busts, and medals; and Anna Vaugh Hyatt (1876–1973), whose chef d'œuvre was the equestrian statue of Joan of Arc, unveiled on Riverside Drive in New York in 1915, one of the most impressive monuments in the city. She was made a Knight of the Legion of Honor in 1921.

Nineteenth-century Russian women sculptors enjoyed a considerable headstart over their Western colleagues, as we have said; some of the best known are Maria Nikolayevna Annenkoff (about 1850–1889), a member of the Saint Petersburg Academy since 1868, who excelled in portrait busts and relief sculptures; Maria Lvovna Dillon (born 1858), who had many commissions, and won prize medals, for her portrait busts and public monuments; next, a pupil of Rodin's, Anna Semyonovna Golubkina (1864–1927), who is represented in the Tretyakov Gallery in Moscow with outstanding wooden portrait carvings; and lastly Vera Mukhina (1889–1953) who is counted one of the best-known Soviet woman artists since the October Revolution.

In England, Mary Thornycroft (1814–1895) was one of the first prominent female sculptors of the 19th century. She had studied with Thorvaldsen in Rome, and worked mostly in collaboration with her husband, whose pupil she had been as well; one of those jointly executed works is an equestrian statue of Queen Victoria. She also modelled statues of the Queen's children at Windsor Castle. One of her own three daughters became a sculptor and the others, painters. Queen Victoria often commissioned women artists: amongst them was Susan Durant (about 1820–1873), born and educated in France; she made various plastic works for English chapels, and also gave lessons to the British princesses. The English sculptor Edith Downing (born 1857) became known through her creation of a marble altarpiece showing 32 figures in relief sculpture, and other plastic décor in col-

Piranesi, Laura

View of the Campidoglio

undated / etching / 16.1 × 23.1 cm
Kunstsammlungen Veste Coburg

Piranesi, Laura

View of the Arch of Septimus Severus

undated / etching / 15 × 21.7 cm
Kunstsammlungen Veste Coburg

Laura Piranesi was a member of the famous family of artists, Piranesi, daughter of Giambattista Piranesi. Together with her brother Francesco, Laura worked in the manner of her father, publishing views of Roman monuments.

Veduta del Romano Campidoglio Laura Piranesi incise.

Lavora Piranesi inc. *Veduta dell'Arco di Settimio Severo.*

ored alabaster for the church at Worinbridge, Herefordshire.

Scandinavian women sculptors appear on the scene from the mid-nineteenth century on: we may mention the Swedish Karoline Benedicks-Bruce (born 1856), mostly exhibiting portrait busts, statuettes and prints in the Paris Salons; the Finnish Sigrid Maria Forselles (born 1860), a Rodin pupil who assisted the master in the execution of his group *The Citizens of Calais*; her chef d'œuvre are five large relief sculptures conceived in a painterly style, representing *The Evolution of the Human Race* for a church in Helsinki. We should also mention the Swedish Sigrid Blomberg (born 1863) who made altar groups for churches and is the author of a statue *The Little Mermaid* (not to be confused with the more famous *Little Mermaid* of the Langelinie in Copenhagen by Edvard Eriksen), and the Danish Elna Inger Borch (born 1869), to whom we thank such groups as *Death and the Maiden* after Schubert, *Hagar and Ishmael*, etc.

Most of the important women sculptors of the 18th century had come from France, with England and Italy closely behind; this trend continued in the 19th century with many talented plastic artists emerging: Marguerite Dubois-Davesne (1832–1900), who is represented with portrait busts in several of the Paris theaters, e.g., the Théâtre de Vaudeville, and the Nouvelle Opéra of the Théâtre Français, and who also regularly sent sculptures to the Paris Salons to the end of her life; and Camille Claudel (born 1865), the sister of the author, Paul Claudel, who worked for a year in Rodin's atelier both as his friend and assistant. She had adopted his ideal of "creating types of life in motion." Some of her groups, for instance *Les bavardes*, *Les baigneuses*, etc., were purchased by French art museums. Lucienne Antoinette Heuvelmans (born 1885) was the first woman to be awarded the Grand Prix de Rome; Marie Demagnez (about 1890) exhibited sculptures with titles such as *Poésie*, *In memoriam*, *La fortune et le jeune enfant* or *Source d'amour* in the Paris Salons.

From the sparse ranks of German women sculptors one may cite Eugénie Kaufmann (1867–1924), who had been a painter before she studied sculpture; she had her own studio in Weimar, and also wrote on art matters. A *Semmelweis* relief of her's was to be seen at one time in a ly-

ing-in hospital at Mannheim; she also designed posters. The first German woman sculptor to reach major rank was without doubt Renée Sintenis (1888–1965), whose animal sculptures gained European fame for her.

Note may also be made of a good many women who wrote on the arts. While their publications were often connected with their teaching activities, in the shape of art manuals and technical directions, there were others who wrote independently on subjects not related to what they were doing themselves. Cases of dual or multiple talents are surprisingly common amongst women artists, not only in related, expressive modes, i.e., acting, poetry or music, but also in disparate fields, such as languages, the sciences, etc. Anna Maria van Schurman (1607–1678) was a famous example in her time: She spoke and wrote Latin and Greek, had a command of several modern European and Oriental languages and was, besides, a musician, poet and a painter; one finds her referred to as "a wonder of Creation" by contemporaries. Perhaps not far behind such worth was Elisabeth Chéron, a French painter who became a member of the Académie Française at the age of 26. She, too, was a poet and musician, and had a command of Hebrew and Latin. She was also an engraver, and a voluminous folio of her's was published at Paris in 1706, entitled *Livre des principes à dessiner*. King Louis XIV gave her a pension of 500 livres. Conversely we find women gathering laurels in the Fine Arts whose chief interest lay in other fields. Of such was the world-famous tragedienne Sarah Bernhardt (1844–1923) who took lessons from Alfred Stevens and the sculptors Mathieu Meunier and Franceschi, and subsequently exhibited in the Paris Salon of 1876, where her plaster group *Après la tempête* won an honorable mention. In the 1880 Salon she showed a painting with the title "La jeune fille et la mort"; she also produced bronze busts, marble reliefs and self-portraits.

If we examine the various categories, themes, subject matter and techniques, whether they are conspicuously prevalent in female art or only an exception, with a view of ascertaining what may be peculiarly typical, we find that, generally speaking, there is no sexual difference, i.e., a majority of women have worked in the same genres of fine art which a majority of men also favored. If we discount the reproduction techniques like picture copy-

ing, rendering of paintings in copper engraving, etc., the chief area is portraiture. A great many women painters worked as miniaturists, but they were thoroughly at home in oil and pastel painting too, and many a female portraitist was in greater demand in her day than her male competitors. To illustrate the point we need only to remind of such figures as Carriera or Vigée-Lebrun. Whole generations of women artists have earned their bread with portrait painting, mostly of course before the introduction of photography, but to some extent even after. A branch in which women artists excelled was the representation of flowers and plants: the most famous names in this branch are Maria Sibylla Merian, Rachel Ruysch, Maria van Oosterwyck and Margherita Caffi, already mentioned. Many other flower painters who are less well-known today illustrated works on botany, or even published them on their own, as for example the English Mary Delany (1700–1788), who edited and published in the years between 1770 and 1780 a botanical work in nine volumes, with illustrations worked in paper mosaic of 980 flowering plants. Women painters were also at home with animal representations; in the 18th century, birds were very popular. The Dutch painter Cornelia de Rijk (born 1656), like many of her male contemporaries, was an expert in portraying domestic fowls; other women composed still lifes with flowers, fruits, birds and insects in the style which the 17th century public found so appealing.

During the 19th century, pictures of quadrupeds became the preferred animal art, male and female painters both profiting from the new genre. Horses, dogs, cats and other domestic animals became the subjects for pictures equally fancied by the bourgeoisie and the upper class. The animal painter Maud Earl (active about 1884) was a great favorite in her native England; she portrayed the pet dogs of Queen Victoria and of the Prince of Wales, as well as other prize-winning canines. Many of her most popular works were reproduced and sold as prints. The English painter Lucy Kemp-Welch (1860–1958) is generally allowed to be the leading animal artist of the period, especially of horses. She served for a while as President of the Association of English Animal Painters. A countrywoman of her's, Julia Chance (about 1884) achieved some prominence as a painter of cats, a favorite

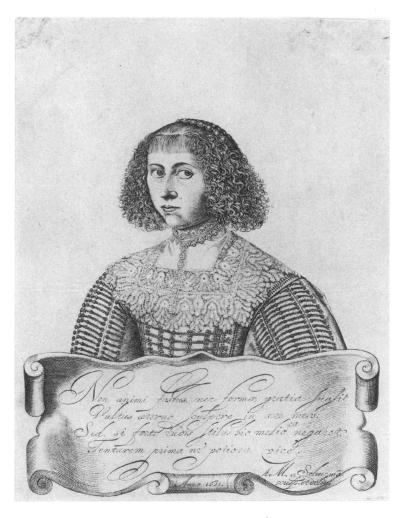

Schurman, Anna Maria van
Self-Portrait

1633 / engraving on copper / 20.2 × 15.2 cm
Kunstsammlungen Veste Coburg

One of the most famous women in the 17th century was Anna Maria van Schurman, the "Sappho of Holland"; she mastered more than ten languages, wrote poems in Latin and was well-read in many of the sciences; she was equally at home in music, painting, calligraphy and art-embroidery. Several self-portraits by her hand have been preserved. The copper engraving shows her as a young woman with a charming, artfully curled short haircut.

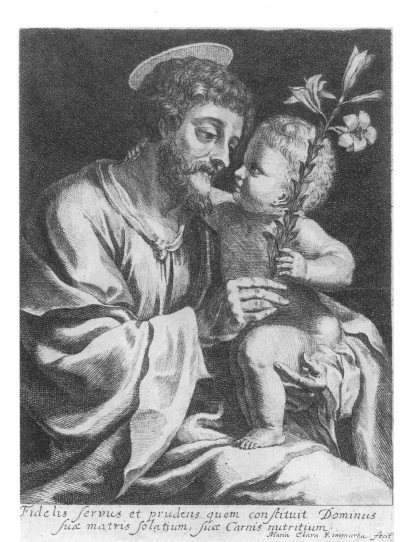

Fidelis servus et prudens quem constituit Dominus
suæ matris solatium, suæ Carnis nutritium.
Maria Clara Eimmartæ fecit

Eimmart, Maria Clara
Saint John with the Infant Jesus

undated / etching / 37.4 × 27.5 cm
Kunstsammlungen Veste Coburg

Maria Clara Eimmart, daughter and pupil of
the German painter, scholar and astronomer
G. Chr. Eimmart, who also taught her languages,
mathematics and astronomy, assisted her father
in his astronomical observations from an early
age on. For her own part, she painted flowers,
fruits, birds and other subjects, and also did some
engraving. Married to the important physicist
Heinrich Müller, she died during childbirth at
the age of 31 years in 1707.

topic of many female artists; in 1898 she published a *Book
of Cats*, made up of reproductions of her paintings. But
beyond dispute the outstanding animal artist of the cen-
tury was Rosa Bonheur, whose life and work we shall dis-
cuss in a future chapter. Her huge canvases were of
world-wide fame.

Since so many women artists of the earlier times were
strongly oriented toward church decoration, religious
subjects, pictures of the Saints, etc., it may be presumed
that churches and convents, especially in Italy and
Spain, are harboring more works by women than have
been identified up to the present. It used to be said of the
pictures of some of the female painters of religious sub-
jects that they were indistinguishable from those painted
by their male relatives, fathers, brothers or husbands,
and that oftentimes such pictures were displayed with
the signatures of some male artist in the family. A good
example in this connection is Agnese Maria Dolci (died
1686), the daughter and pupil of Carlo Dolci; she copied
many of her father's paintings and it is possible that the
picture "Christ Blessing the Bread" in the Louvre may
be by her hand.

Of the several requirements for the composition of ma-
jor religious works none is more essential than mastery of
figural groups, as dictated by iconography. Women
painters have tried their mettle in this difficult genre, too,
and have not been unsuccessful; it must be admitted,
however, that later generations hardly rose to the heights
of figure composition which were reached by the vigor-
ous female artists of the Renaissance.

Many women have handled mythological and histori-
cal subjects in the late 17th, the 18th and the early 19th
centuries, but their works cannot be compared to that of
their predecessors, either in outward dimensions or in
spiritual content.

We give some sample titles as an extract of what was
being done, which will be characteristic for the taste of
the times, to which a large proportion of male painters
has bowed likewise. For instance Angelika Kauffmann
painted scenes like "Abelard and Héloïse," "Ariadne in
Naxos," "Hector Perceives Paris in the Battle," or
"Ganymede as Cup-Bearer to Jupiter's Eagle"—none
of which can rate as her best. The French painter Pauline
Auzou (1775–1835) came out with historical themes

entitled "Marie-Louise Arriving at Compiègne" or "The Parting of Marie-Louise from her Family." Marie Guilhelmine, Comtesse Benoist (1768–1826) was a pupil of Vigée-Lebrun and the favorite pupil of David, and is best known for her "Portrait of a Negro Woman." But she also invented an allegorical composition entitled "Innocence between Virtue and Vice," which is interesting for portraying Vice as a beautiful young man, instead of the traditional female figure usually incorporating Vice in contemporary allegories. Her countrywoman Constance Mayer La Martinière (1775–1821) took up the theme, modified as "Innocence between Love and Riches." She had studied first with Greuze, later becoming a pupil of Prud'hon, whose common-law wife she became after she had been awarded a studio at the Sorbonne next-door to his. When she was given notice to vacate the studio, she killed herself. She had addressed herself to the taste of the period with sentimental subjects, such as "The Dream of Happiness," "The Happy Mother," "The Mother Abandoned" or "The Sleep of Venus." Another French painter, Augustine Cochet de Saint-Omer (1788–1832) appeared at the Salon from 1812 on with genre scenes: "St. John Praying in the Desert," "Death of Queen Camilla of the Volscians" or "Ceres Lighting her Torch at Mt. Etna." The French painter Belfort (about 1812), appearing under the listing of historical painter in the catalog exhibited at the Salon from 1812 on scenes with titles like "Ariadne and Theseus," "Eurydice Bitten by the Serpent" and "The Farewell of Hector." Another French artist, Eugénie Honorée Servières (born 1786), habitually did medieval subjects, but she won a gold medal for her painting "Hagar in the Wilderness." In 1817 she was honored with another gold medal for a portrait with the title "Louis XVIII and Madame Lafayette." Yet another Frenchwoman, Aimée Brune (1803–1866), exhibited works showing "The Sentencing of Anne Boleyn" and "Leonardo da Vinci Painting the Gioconda."

The moralizing genre, a great favorite of the times, also had its female interpreters. We have already mentioned Mary Cosway's series on this theme. Chodowiecki's daughter, Suzette Henry, devised similar series but it must be admitted that they are a little too pedestrian for the modern eye; she did a series of eight designs: "Good and Bad Upbringing of Daughters" of 1800, and in 1810 a cycle called "The Manner of Living of Married and Unmarried Men." The French artist Antoinette Haudebourt-Lescot (1784–1845) discovered a new subject for the period when she introduced scenes from the everyday life of Italian people into high art, being the first woman painter to take advantage of this theme.

A Belgian, Adèle Kindt (1804–1884), pupil of David, won the first prize for historical painting at the Academy of Ghent at the age of 22 with her canvas "Count Egmont's Last Good-Bye to his Spouse Isabella of Bavaria"; later she was made a member of the academy. She continued to win prizes and honorable mentions for many of her works, for instance for a composition with the lengthy title "Elizabeth of England Gives Orders to her Secretary Lord Burleigh to Arrange for the Execution of Mary Stuart who has been Sentenced to Death." Her countrywoman Isabelle de Keyser (1815–1879) painted episodes like "Jane Grey's Parting from her Father" and "Margarethe, Daughter of the Chancellor Morus, Visits her Father in Prison"; the French artist Marguerite Chénu (born 1829) sent historical genre pictures to the Salon from 1852 on, themes like "Bonaparte as Prisoner at the General Headquarters at Nice," or "Cromwell's Daughter Reproaches her Father with the Death of Charles I." The German painter Hermione von Preuschen (1854–1918) invented a new manner of representing historical themes: she combined flower still lifes with historical or allegorical subjects, and produced images such as "Cleopatra's Couch" or "Irene von Spilimberg in the Death Gondola." As recently as the early 20th century a picture with the title "The Killed Amazon" by the Danish painter Elna Ingeburg Andreasen (born 1875) was awarded the gold medal at the Copenhagen Academy of Art.

These and similar pictures are nowadays buried in the storage vaults of museums, mostly deservedly so. One does not have to know them all to hazard the guess that, even in their own time, they did not exceed a degree of mediocrity in the totality of painting according to the taste of the time, the same as most of the analogous pictures made by men. Nor have any of these or related works been exhibited anywhere, once their brief span of

popularity had run out, at last not so far as is known. The best we can say about them is, that these titles indicate that women have tried to tackle nearly all artistic problems of their period, regardless of the results. Another corollary offered by the list of titles is, that female artists had a predilection for grouping their historical or allegorical scenes around some central female figure: a favored theme is the slave woman, Hagar with her child, guiltlessly expelled from society, with whose harsh fate these artists have doubtlessly identified emotionally.

Countless women painters have dealt with scenes from women's lives in later days, too; not so much as historical genre pictures as situations of everyday existence. The theme of motherhood, for instance, is an exceedingly frequent one; but it was reserved for the unique Käthe Kollwitz to elevate mother and child to the level of a vigorous, social statement.

Landscapes by women artists appear only about the time of early Romanticism, when it became a theme for creative invention; in the 18th century, landscapes by women are almost exclusively engravings, copies or vignettes. But in the last three decades of the 19th century landscape came into its own as a major theme with the arrival of Impressionism, when outdoor painting became the principal mode of creation with painters. Hundreds of doughty women landscapists have enriched the pictorial world since that time; we need to remind only of such figures as the French Berthe Morisot (1841–1895) or the Austrian Tina Blau (1845–1937).

Beyond all that has been enumerated thus far we may observe that women painters have ventured in exceptional cases to handle themes which were regarded as the exclusive domain of men.

Even the so very "unwomanly" subject of war and battle scenes was attacked by female painters in the 19th century. The French Zoë Chatillon (1826–1902) became very popular in 1870 and after with her pictures referring to the Franco-Prussian war with titles like "L'esclave," "L'option" or "Revanche." But her success did not equal that of Lady Elizabeth Butler (about 1850–1933) a battle painter whose enormous compositions had sensational appeal. Her painting "The Roll Call," an episode from the Crimean war, shown in the 1874 Royal Academy exhibition, made her famous overnight. Her works were often reproduced and almost every year she came out with a new battle composition, many of which won prizes. She was prosperous enough to be able to hire extras to re-enact the battles she intended to portray.

The Scottish Mary Cameron became somewhat famous about the year 1900, although her pictures were criticized by contemporaries as too "robust and not very womanly." She began with paintings of soldiers, later doing hunting pictures and scenes from the turf, and also Spanish bull fights with many figures. The Greek Thalia Flora-Caravias (born 1875) used her drawing pen as a front-line reporter, sketching in the combat area of the Greco-Turkish Balkan war of 1913; the Austrian Stephanie Hollenstein (born 1886) also became a battle artist with front-line experience, having first served as a medical soldier wearing men's uniform in 1914.

It is not widely known that, beginning with the mid-19th century, women artists have been entrusted with some frequency with commissions for wall decorations and similar large figurative compositions. In the early times, nuns had handled decorative projects for the churches and chapels of their convents, including the design of large tapestries; but in the 18th century with its declared preference for small pictures women had few opportunities to exercise their talents for large-scale works, which were not thought to be their line, anyway. At best one sees them collaborating in those times with husband or father on larger projects: e.g., the French Marguerite Bunel (died about 1630), who was commissioned jointly with her husband by King Henry IV to decorate the Apollo Gallery of the Louvre, where she painted portraits of queens and other female celebrities, while her husband did the kings and military heroes.

In the first half of the 19th century the French porcelain artist Eléonore Escallier (1827–1888) executed sev-

Oosterwyck, Maria van
Flower Piece

undated / 77 × 60 cm
Staatliches Museum Schwerin

In her flower still life this important Dutch flower painter displays her peculiar ability to render each one of the different blossoms composing her bouquet as an individual "personality."

Block, Anna Catharina
Flower Piece

undated / 42 × 27 cm
Staatliches Museum Schwerin

This flower piece belongs in the tradition of
Dutch baroque flower painting, such as the
artist's contemporaries Maria van Oosterwyck
and Rachel Ruysch practiced, and shows
qualities quite comparable to their best work.

Marchioni, Elisabetta
Flower Basket

undated / 45 × 57 cm
Kunsthistorisches Museum Vienna

The Italian Elisabetta Marchioni, active *c.* 1700,
was one of the most celebrated flower painters
of her time, whose works were in many art
collections. The Viennese flower piece, with its
exuberant shapes and dramatic illumination
characterizes baroque flower painting.

Treu, Katharina
**Fruit Still Life with Peaches, Grapes
and a Goblet**
1773 / 60 × 48 cm
Staatsgalerie Stuttgart

The painter Katharina Treu came from a family
of artists and her sister, Maria Anna, was also a
painter. Katharina, since 1769 cabinet painter
to the Elector at Mannheim, became a titular
professor at the Düsseldorf Academy in 1776.
Her decorative fruit still lifes were much admired
in her day.

Vallayer-Coster, Anne
Still Life with Round-Bellied Flask

c. 1770 / 27 × 32 cm
Staatliche Museen / Preussischer Kulturbesitz,
Berlin (West), Gemäldegalerie

The French painter Anne Vallayer-Coster
ranked with the most prominent women artists
of her period and became a member of the
Académie Française at the young age of 26; a
little later she became *peintre du roi*. Her
harmoniously composed still life of common
household objects derives its peculiar charm from
the highlights on the glass surfaces.

Rijk, Cornelia de
A Barnyard

c. 1710 / 133 × 172 cm
Museum of Fine Arts, Budapest

This picture by the Amsterdam artist Cornelia de Rijk ties in with the Dutch tradition of scenes of barnyard life, of which the Amsterdam animal painter Melchior de Hondecoeter is a famous representative. Our illustration shows an early example of an animal picture by a woman.

Richter, Therese Caroline
Still Life with Deer Antler and Squirrels

c. 1810 / 63 × 87 cm
Staatliche Kunstsammlungen Dresden,
Gemäldegalerie Alte Meister

Not much is known of the painter Therese Caroline Richter, except that she worked in Dresden in the early 19th century. Although she had some artistic training she was probably not a full-scale professional painter. Her still life is typical for the general way of painting of the period.

Longhi, Barbara
Mary with the Child and Saint John

undated / 88 × 71 cm
Staatliche Kunstsammlungen Dresden,
Gemäldegalerie Alte Meister

Barbara Longhi, the daughter and pupil of Luca
Longhi, was a contemporary of the more famous
Lavinia Fontana. Her work belongs in the
category of baroque women painters appearing
on the scene in fair numbers about this time,
whose popularity was due to their religious
subjects.

Steenwyck, Susanna van
Interior of a Gothic Church

1639 / 26 × 30 cm
Staatliche Galerie Dessau

Our illustration of the interior of a Gothic church
by the Flemish-Dutch painter Susanna van
Steenwyck (active *c.* 1640) represents one of the
few architectural views by a woman artist of the
period.

Latour-Simons, Marie de
Breakfast at the Farm

undated / chalk drawing with wash /
45 × 54.8 cm
Koninklijk Museum voor Schone Kunsten
Antwerp

The Belgian painter-engraver Marie de Latour-Simons never became very widely known. She worked both in Brussels and in Paris, partly as a reproduction engraver. Her wash drawing "Breakfast at the Farm" uses elements of Flemish-Dutch schools and is a good example of the idyllic genre scenes which the public of her period favored.

Laeck, Maria van der
Prince Leopold of Anhalt-Dessau as
a Boy

c. 1680 / 123 × 88 cm
Staatliche Galerie Dessau

The Dessau portraits of princes were thought
for a long time to be the work of the Flemish
painter Reynier van der Laeck, but have been
lately identified as the work of his daughter
Maria. Our youthful portrait shows the "Alter
Dessauer" (Old man of Dessau) (1676–1747) as
a boy in the garb of baroque childhood, against
a background with a hunting scene.

Waser, Anna
Self-Portrait at the Age of Twelve

1691 / 12.5 × 10 cm
Kunsthaus Zürich

Anna Waser is the earliest Swiss woman painter
of whom we have knowledge. She painted this
widely admired self-portrait at the young age of
twelve. Her later work was highly paid and was
sold mostly abroad. In 1699 she was appointed
court painter at the court of Count Solms. The
report is, that she became melancholic in 1708
and that she lost her life in an accident at the
age of thirty-three.

Her drawing of an ideal head of a woman has
the inscription in French: "As health is the
Paradise of the body, the love of God is the
Paradise of the soul."

Waser, Anna
Ideal Head of a Woman

1711 / silverpoint / 11.7 × 8.8 cm
Staatliche Museen zu Berlin, Kupferstichkabinett
und Sammlung der Zeichnungen

Simanowitz, Ludovica
Portrait of the Painter Wächter

1792 / 59 × 47 cm
Staatsgalerie Stuttgart

The artist was on friendly terms with Schiller, whose portrait, as well as portraits of members of his family, she had painted. She was married to a friend of the poet, Schubart, and had connections with circles who were influenced by the ideologies set in motion by the French Revolution. She did this portrait of the painter Wächter in Paris; Wächter, like Schiller, had been a pupil in the Karlsschule in Stuttgart. These various connections are symbolized by the tricolor cockade on Wächter's hat.

Lusurier, Cathérine
Portrait of Germain-Jean Drouais
at the Age of Fifteen

1778 / 80 × 65 cm
Louvre, Paris

The French painter Cathérine Lusurier died young; she was a relative of the painter H. Drouais, under whose supervision she trained herself for her profession. Her painting of Germain-Jean Drouais may not be a masterpiece, but it shows the affectionate understanding with which she regarded the son of her benefactor, who likewise became a painter but died also at a young age.

Ledoux, Philiberte
Girl with an Open Book

c. 1793 / 45 × 37.5 cm
Museum of Fine Arts, Budapest

The illustration shows clearly that this painter, who exhibited at the Paris Salons, was a faithful pupil of Greuze, whose sentimental and often sugary genre pictures were in high favor at the time, especially when these qualities were combined with erotic elements. His pupil, who also did portraits, adapted herself cleverly to his style without adding anything of her own.

Pasch, Ulrica
Portrait of Frau Schmiedeberg

1783 / 74 × 59 cm
National Museum Stockholm

The Swedish painter Ulrica Pasch came from a family of artists. She became a member of the Stockholm Academy in 1773. She worked at times together with her brother, the painter Lorenz Pasch. Her portrait of Frau Schmiedeberg is an amiable example of the portrait art of an 18th century Nordic female painter.

Curran, Amelia
Portrait of Percy Bysshe Shelley

1819 / 59 × 47 cm
National Portrait Gallery, London

Amelia Curran was probably a dilettante because she is virtually unknown. She portrayed the English poet Percy Bysshe Shelley, the foremost representative of revolutionary romanticism in England. Her interpretation of Shelley as a gentle and dreamy youth emphasizes the lyricist rather than the author of *Prometheus Unbound*.

Carpenter, Margaret
Portrait of the Painter Bonington

1827 / 98 × 60 cm
National Portrait Gallery, London

The English portraitist Margaret Carpenter was in high favor in the middle years of the 19th century. She had married an art historian and both her son and her daughter were trained by her to become painters. Her picture of Bonington demonstrates the remarkable level of achievement of female portraitists in the England of the period.

Krafft, Barbara
Anton Marx and Family

1803 / 149 × 208 cm
Oesterreichische Galerie Vienna

Barbara Krafft was much in demand as a
portraitist of persons of high rank. She was famed
for "her bold manner, such as was never seen
before in a female."

Her group of nine figures recommends itself
for its balanced and elegant composition, besides
the good characterization of all models, children
included.

Bray, Mrs. Charles
Portrait of Mary Ann Evans
(George Eliot)

1842 / drawing / 18 × 15 cm
National Portrait Gallery, London

A member of the circle around the English author
Ann Evans, who wrote under the name of George
Eliot, was Mrs. Charles Bray, of whom only this
drawing is known. Mary Ann Evans married the
banker, Cross, in 1880 (the year of her death).

Wagner, Maria Dorothea
The Millpond

c. 1750 / 27 × 37 cm
Staatliche Kunstsammlungen Dresden,
Gemäldegalerie Alte Meister

This is one of the few known landscapes by 18th century women artists. Maria Dorothea Wagner was a painter's daughter and received her first lessons from her father; later her brother became her teacher.

Mayer La Martinière, Constance
The Unhappy Mother

before 1810 / 192 × 145 cm
Louvre, Paris

Mayer La Martinière, Constance
The Happy Mother

before 1810 / 192 × 145 cm
Louvre, Paris

Constance Mayer La Martinière was the favorite pupil of Prud'hon; she painted sentimental genre pictures around the turn of the 18th century, such as the two pendants which are shown in the illustrations. Such works show the influence which Greuze had on the taste of the public of the time.

Hitz, Dora
Girl in a Field of Poppies
1891 / 48 × 108 cm
Museum der bildenden Künste, Leipzig

With its highly developed color culture the "Girl in a Field of Poppies" follows the neo-romantic style of the turn of the century. Dora Hitz has created a sensitive and at the same time, decorative, portrait of a girl, the mood of which is less determined by the personality of the model than by the coloristic environment.

Abbema, Louise
Amazon

1880 / 229 × 137 cm
Museen der Stadt Gotha, Schlossmuseum

The French painter Louise Abbema became chiefly known through her decorative ceiling paintings. Her elegant "Amazon" also has decorative value, primarily in the contrast of the black riding habit with the coloristic setting, and in the central position of the figure in proportion to the neatly rendered environment.

Morisot, Berthe
Le Trocadéro

1872 / 45 × 80 cm
The Santa Barbara Museum of Art,
Santa Barbara, California

Berthe Morisot, a friend of Manet and wife of his younger brother, is one of the most important women Impressionists in France. Her sister Edmée was also a painter.

Blau, Tina
Spring in the Prater

1882 / 214 × 291 cm
Oesterreichische Galerie Vienna

Many German women landscapist painters exhibited around the late 19th century; Tina Blau is one of the best known of them. She was married to the animal and battle painter Lang. From 1891 on she had the use of a studio in the Prater. Here she produced one of her most important pictures, the "Spring in the Prater." This canvas shows her reaction to French impressionist painting.

eral large decorative orders, besides continuing in her regular post as china painter at Sèvres. Two of her panels are in the Palais of the Legion of Honor, and her monumental design "Le printemps" was used for a tapestry wall hanging in the staircase of the Luxembourg Palais. A contemporary of her's, the American Adele Fassett (1831–1898) composed about 1878 a gigantic group portrait of some 200 figures for the Capitol in Washington, representing the Election Commission at a public meeting listening to the opening sentences of a speech by W. H. Evarts. The German Dora Hitz (1856–1924) who was also a known portraitist, painted some large murals for the Rumanian Queen Elisabeth for the music chamber of her château Pélès at Sinaia between 1883 and 1886, with subjects taken from the poetry of Carmen Sylva. This was the pen name of the queen-poetess. The French Louise Abbema (1858–1927) received the cross of the Legion of Honor for her artistic creations in 1906; she carried out important commissions in the décor of public buildings, for instance murals and ceiling paintings for the Théâtre Sarah Bernhardt. Her countrywoman Clémentine Hélène Dufau (born 1869) created monumental-heroic panels for the Sorbonne, showing allegorical representations of various branches of science; later she also designed wall hangings for the house of the poet, Edmond Rostand.

The American Violet Oakley (born 1874) also did extensive public decorations. She painted a frieze of eighteen panels in the Governor's Reception Room in the State Capitol of Harrisburg, Pennsylvania, representing the "Founding of the State of Spiritual Liberty"; further, sixteen murals in the Supreme Court Chamber, with the subject "The Opening of the Book of Law"; in the Senate Chamber nine murals depicting "Creation and Preservation of the Union." Oakley also painted altar decorations for various churches. Likewise, the French Marguerite Cornillac (approx. 1865–after 1908) of Lyons created important large murals for the Medical Faculty of the University of Lyons, as well as for the Hall of Sessions of the City Council in the townhall of Lyons.

These names have been chosen from a sizeable roster of female artists who have been engaged in large-scale, decorative work, but this area requires further research. Doubtlessly the increase of opportunities for women art-

Roghman, Geertruydt
The Kitchen Maid

undated / copper engraving / 21.6 × 17 cm
Kunstsammlungen Veste Coburg

The Netherlandish draftswoman and engraver Geertruydt Roghman was active about the middle of the 17th century; she made engravings after own compositions and after works by other artists as reproductions. Our illustration of the "Kitchen Maid" is certainly one of her own creations, as indicated also by the signature "Geertruydt Roghman invenit." She has portrayed the servant in an unusual back view, fully engrossed in her work sphere. The style is reminiscent of Dutch realist painting of her period, which emphasizes interior scenes of everyday life, as seen in Vermeer van Delft's work. Our picture is interesting because it is one of the few instances of a 17th century woman artist choosing the theme of a human creature actually working at something.

Küsel, Johanna Sibylla
The Battle of Barcan
(after a painting by Le Clerk)

undated / etching / 31.4 × 23.3 cm
Kunstsammlungen Veste Coburg

Four descendants of the Augsburg family of
engravers Küsel were active in Augsburg about
the year 1700. Two of these are known to be
sisters, and were granddaughters of Matthäus
Merian: Magdalena and Johanna Sibylla; two
other women, Johanna Christiana and Maria
Philippina, stand in an unclear degree of kinship
to the first-named. The etching of the Battle of
Barcan, after the painting by Sebastian Le Clerk,
is by the hand of Johanna Sibylla, also known
as "Kräusin" because she was married to the
copper engraver Kraus, whom she assisted in
his print shop. It is a good specimen of the
countless reproductions of works by well-known
masters which were engraved at, and exported
from, Augsburg. The red chalk drawing of the
oriental warrior is a study from life.

Küsel, Johanna Sibylla
Oriental Warrior

1671 / red chalk drawing / 14.2 × 9.4 cm
Staatliche Museen zu Berlin, Kupferstichkabinett
und Sammlung der Zeichnungen

ists to do public projects toward the end of the 19th century is related to the overall growth of the demand for monumental-decorative art in bourgeois society; nevertheless the question, why the portion falling to the share of women artists in particular should have augmented by so much remains unanswered.

Comparatively few women seem to have involved themselves artistically in political and social themes, proportionately fewer than men, from whose ranks significant personalities have stood out in this field.

Until the French Revolution, women artists had shown virtually no sign of an awareness of political problems of the day. But the events of 1789 affected everyone in a population, and many who under less stirring conditions would perhaps not have joined in singing "the political, the loathsome song" (Goethe, *Faust*, Part I) did so now. One ought not to forget either, that during the Revolution many proposals for advancing the condition of women were submitted: in 1791, Olympe de Gouges propounded a "Declaration of the Rights of Woman," which had stirred up animated discussions for a while.

Occasionally, female free artists, whether politically alerted or not, found themselves faced with the consequences in having failed in political flair: thus the painter Anne Rosalie Filleul (1752–1794) who was accused of being a royalist and *amie de la Messaline Antoinette*; she was found guilty and was sent to the scaffold together with her mother and a woman friend. In some contrast thereto, Adélaïde Labille-Guiard, who was not only a member of the Académie Française since 1783 but also a "painter of princesses," became exceedingly popular in 1791 with a portrait of Robespierre, of which a replica was ordered, and other leading figures in the National Assembly came to her for portraits. But something went wrong with her political flair, too: despite these successes she was misguided enough to undertake a monumental composition with the subject of "The Reception of a Knight of the Order of Saint-Lazare by the King," which was seized and destroyed for political reasons in 1793, whereupon she withdrew from the profession of the arts.

Marie Champion de Cernel (1753–1834) was more successful. She was the wife of the engraver Sergent (a second marriage), who held various offices during the Revolution, and was able to exhibit in 1793 under the name of Citoyenne Cernel a collection of her etchings and colored engravings after paintings. The painter and sculptor Antoinette Desfonts-Gensoul (active about 1790) exhibited a model for a triumphal column celebrating the storming of the Bastille in the Salon of 1793; she also composed a painting entitled "Siège des Tuileries par les braves sans-culottes." Angélique Allais, an engraver, collaborated at a series of likenesses of deputies in the National Assembly at Levachez in 1789, and made portraits of prominent leaders during the Revolution, for example of Mirabeau and Marat. Another engraver, Elisabeth Herhan was likewise a collaborator in 1797 at two series of portraits of French generals of the Republic. It would be too much to elevate the preceding examples into manifestations of a political attitude, inasmuch as they were probably just so many orders filled by the respective artists; but one may accept them as a sign that some women artists at least did not withhold themselves from the Spirit of the Age.

Next to no instances of taking a political stand are known in women's art of the 19th century. The theme of the emancipation of women has motivated some female artists to express their opinion, e.g., the Norwegian painter Asta Hansteen (1824–1908), although she battled for the rights of women chiefly with the written word; the Danish artist Marie Luplau (1848–1925) painted a series of 24 portraits for a hall in the National Diet a Copenhagen, with the title "From the First Days of the Battle for the Rights of Women"; and the English Florence Claxton (about 1850), who made an exhibit of approximately 100 drawings under the heading *The Adventures of a Woman in Search of her Rights* at London in 1871.

A more common theme in the later 19th century was the dialogue with social problems, its expression in visual art reflecting the rise to power of the labor movement with its attendant questioning of social conditions. The cycle of motives generated by the labor movement, while gaining ground in all countries throughout the remainder of the century, caused varying responses in the different European countries, corresponding to the prevailing social conditions and attitudes; for example the involvement was less intensive in Germany than in France or Spain. In the former country the stance taken by artists of both sexes frequently came out as a kind of painting of

compassion, a compromise which, however, at least aligned the respective artist on the side of the socially disadvantaged, and to that extent may pass as a statement of social consciousness. Broadly speaking, treating the theme as a genre scene, which is what most of these painters did, presented the social problem from an overly romantic point of view, especially during the early stage of this phase, although here and there one encounters also more aggressive and consciousness-raising formulations.

A forerunner of the 19th-century women who took up the social theme, was the Frenchwoman Françoise Duparc (1726–1778) who for the last two years of her life was a member of the Academy of Marseilles, her native city. She represented men and women at work, which was a reason why her pictures were often mistaken for works by a man. Her choice of subject matter was too uncommon in those last pre-revolutionary years for her art to have become popular.

At a later period the English Mary Osborn (born 1834) composed works with the general subject of "the consequences of death and poverty in the lives of young women."

Some significance attaches to the works of the Russian painter Helene von Wrangell (1835–1906), because she portrayed scenes from the lives of Russian peasants, before her more famous contemporary, Repin, had created his important paintings representing the lives and history of the Russian people. Somewhat sentimentalizing "scenes of human misery," at least from our present-day viewpoint, were the products of the French Madeleine Carpentier (born 1865), for instance her composition "Jeune misère" of 1904. The Belgian painter Cécile Douard (born 1866) took up subjects from the Belgian coal mining districts about the same time as Vincent van Gogh.

Working people were also of interest to the French painter and etcher, Angèle Delasalle (born 1867), whose "Earthworker" is typical of her work, and to her compatriot Emilie Desjeux (about 1887), whose chief canvases are "The Scissorgrinder" and "At the Poor-Doctor's." The Austrian Hermine Heller-Ostersetzer (1874–1909) made her public début with genre scenes appealing "to the modern perception of social misery." The English Edith Farmiloe (about 1895), who was married to a vicar in a London slum district, represented the doings of the children of the poor, left to themselves all day long, with a critical humor remindful of Heinrich Zille. Dewing-Woodward, an American, preferred scenes showing the lives of working people to all other subjects, rendering them with "as much truth as if she had lived amongst these people herself, and with a vigor which often caused her pictures to be mistaken for the work of a man." A French artist, Léonie Humbert-Vignot (approx. 1905) took up a related social theme when she devised compositions with titles like "Consequences of a Strike" or "A Strike Morning." Up to the present, however, by far the most important interpreter of the fate of the poor and the defenceless, especially of their women and children, is Käthe Kollwitz.

This survey shows that women artists have shared, to the extent of their ability to involve themselves, in nearly all aspects of the visual arts of their respective epochs. They have varied their approach between joining the mainstream, where they had to contend with the names of the great and the masses of second-string competitors, and finding their own personal paths and byways.

TYPICAL CAREERS

Standing out from the many careers of women artists of the past four centuries which we have examined for our professional image, some of which we have already briefly sketched in the foregoing, there are certain cases that deserve particular attention, because they are symptomatic for the living, working and professional conditions of women in the free arts in general. We have chosen careers which were satisfactorily documented with the necessary data and which possessed sufficient professional merit in themselves to warrant a detailed presentation, even though the art of the chosen artist may have lost much of its significance with the passing of a period.

We begin with the Italian painter Artemisia Gentileschi, the pupil of her father, the Roman painter Orazio Gentileschi. Her biography is full of adventures and intrigues. As a very young person she was raped by one of her teachers, the painter Agostino Tasso; her father bringing the charge against him, Tasso paid for his deed with imprisonment. The openness with which so delicate an affair could be negotiated speaks for the broadminded outlook which dominated this epoch. Two hundred years later, things were treated differently: In Schiller's drama *The Conspiracy of the Fiesco of Genoa*, which takes place in the year 1547, Verrina's daughter, Bertha, who has been raped, undergoes not only her father's curse but is offhand locked up "in the nethermost vault of the palace" until such time as the miscreant ravisher has breathed his last; which, luckily for her, happens soon after. In contrast, Artemisia was married to a Florentine gentleman in order to cover things up. It is probable that her personal experience has a relation to her earliest known works, in which she takes up the theme of Judith and Holofernes; the battle of woman against man is rendered in a fairly drastic way. These paintings brought her much fame in Rome. About the year 1630 we see her in Naples, mostly doing religious pictures. Soon after she severed the union with her husband, with whom she had a daughter who also became a painter, and journeyed in 1638 to England to join her father, who was employed in that country. She remained with her father until his death, creating amongst other works her familiar "Self-portrait as La Pittura." Later she returned to Naples, concentrating on painting famous and heroic women figures from the Old Testament and from the Apocrypha: Esther, Bathsheba, Susanna. She died about 1652 and remained probably an active painter to the last.

The characteristic points to mark in this career are to be found also in the careers of women artists of the Renaissance in general, and are, before anything else, the freedom and independence of movement of professional women: She travelled wherever she wanted to go, settling to work where it was most profitable; she corresponded with prominent persons of her time whom she occasionally also portrayed, and earned a sizeable fortune with her art.

The Dutch Judith Leyster was a contemporary of Artemisia; her work has been rediscovered only in recent times, when her signature was found on a painting previously believed to be by Frans Hals. From the date of the uncovering of the signature (1893) on, several other works once attributed to Frans Hals have been identified as her's. Such instances where works by women have for long periods of time been ascribed to men are not uncommon in the history of art. It is likely that further errors of attribution will be detected, as the knowledge of the nature of feminine creativity progresses; if nothing more, cases of this kind demonstrate that the 19th century theories respecting "typically male" and "typically female" qualities of art, such as have been emitted by Scheffler for example, must be accepted with the utmost reservations.

Unlike so many of the women painters of the period, who were artists' daughters, Judith Leyster's father was a brewer in Haarlem, apparently not a very successful one. Her name is an assumed one and derives from the paternal business sign: Leyster means Lodestar. How, and by what means, she got into art, is not known; the earliest document is from 1630 and makes mention of an apprenticeship with Frans Hals. In 1633 she was received into the Haarlem Painters' Corporation, the guild of St. Luke: in 1635 it is mentioned that she had some pupils, which indicates that women were recognized to be qualified to hold master's rank in the Netherlands. She married Jan Miense Molenaer in 1633, a painter considerably her junior, with whom she occasionally collaborated. A year after their marriage, the couple moved to Amsterdam, apparently in the hope of better earnings in this art center. Molenaer was plagued by lawsuits, mostly for his debts, as is shown by the records. In 1648 we find them in Heemstede. Some time between 1645 and 1650, i.e., relatively late in life, Judith Leyster gave birth to a daughter. No pictures of her's after 1652 have been found so far, perhaps because of worsening health. In 1659 she made her Will, in which mention is made of a son, who may have been born around this time, and could possibly be the cause of her death. Her period of greatest productivity falls between the years 1629 and 1635, when she painted her most important works, such as "The Serenade," "The Merry Drinker," "The Flute Player" and "The Tempting Offer." The subject matter of these compositions represents the so-called Intimate Genre, which she was one of the first to help to create in the Netherlands.

Maria Sibylla Merian belongs to the generation of women artists following Judith Leyster. Still known today as the painter of flowers, plants and insect life, she is mentioned as early as 1675 in Joachim von Sandrart's *Teutsche Academie der Edlen Bau-, Bild- und Mahlerey-Künste* (German academy of the noble arts of architecture, sculpture and painting). Her merit is due to a combination of scientific research studies and a high perfection of artistic imagination; her passion for entomology led her to take a highly unconventional journey to Surinam (Dutch Guyana) at the age of fifty, a considerable adventure for a woman of the period.

Maria Sibylla was the daughter of Matthäus Merian, the well-known engraver and publisher of topographical views of cities and towns. After his death in 1650, the girl received her first instruction from her stepfather, the Dutch flower painter Jacob Marell, later to be followed by his pupil Abraham Mignon, under whose tutelage she studied for seven years, learning techniques of oil and watercolor painting, copper engraving and etching. In 1665 she married a pupil of Marell, the printmaker Andreas Graff, the pair settling in Nuremberg. While in this city, she eventually became the chief breadwinner of the family, because her husband's expectations of prospering in his art dealing did not materialize; by this time she had given birth to two daughters. Maria Sibylla's earnings came at first from craft-related products like painted tablecloths and silk scarves and shawls; these sold so well that she could soon employ and train some female assistants, some of whom were daughters of patrician families. Besides this, she drove a vigorous trade with artists' colors and varnishes, from which she also supplied her pupils. Subsequently one of her trainees carried on the color business for her. But she also worked at the graphic representation of the indigenous flora: the result of this was published by 1680 under the title *Neues Blumenbuch* (New flower book) in three volumes. Prior to this, she had been pursuing studies of caterpillars and butterflies, which consolidated in 1679 in the publication of *Der Raupen wunderbare Verwandlung und sonderbare Blumennahrung* (The marvellous metamorphosis of caterpillars and their peculiar flower food), for which she wrote the text herself.

The marriage with Graff was not particularly happy; in 1681 Maria Sibylla returned to her mother's house in Frankfort on the Main, taking her daughters with her; they later became her assistants in her scientific and artistic activities; in Frankfort she continued her studies and published a volume on European insects in 1683. In 1686 her brother, Caspar, invited Maria Sibylla to stay with him in Holland. He belonged to the sect of the Labadists, a religious community founded by Jean de Labadi, a famous member of which was Anna Maria van Schurman; the sect maintained some missionary stations in Surinam. Thus Maria Sibylla and her two daughters journeyed to Holland, where they lived for a while as Caspar's guests in the château Thelinga State which be-

longed to the sect. After Caspar's death and the dissolving of the community of Labadists she moved on to Amsterdam in 1691, still continuing and intensifying her scientific research. In 1699 the dream of her life came true, when friends of the Labadist times made it possible for her and her daughter Dorothea, to travel to Surinam, where she had always wanted to study tropical plant and insect life in their natural habitat. A sojourn of about two years followed, filled with intensive work and observations. After her return to Amsterdam, where an impressive display of the fruits of her labors was made at the town hall in 1701, she set about preparing her chief work *Metamorphosis Insectorum Surinamensium* for publication; the text was in Dutch and in Latin, which she had learned in the meantime by way of private lessons. The book appeared in 1705 and has since been translated into several languages. She had planned a follow-up volume, but could not complete it, because she suffered a stroke a year later, which paralyzed her almost totally. Death came in 1717; it is said that her death certificate was signed by a registrar of the poor.

In the same year her daughter Dorothea Maria accompanied her husband, the Swiss painter Georg Gsell, to Petersburg, in response to an invitation by Peter I. Here Gsell was appointed court painter in 1719; he and his wife jointly gave drawing lessons at the Académie des Beaux-Arts of Saint Petersburg. In her day, Dorothea Maria was one of the most important representatives of European art in Russia.

Probably the most famous woman artist of the first half of the 18th century was the Venetian Rosalba Carriera, who gained the highest international successes; her peculiar achievement was, to have brought the art of pastel painting into high favor. Rosalba came from a humble setting; her father was a clerk in a Venetian business firm, although he also painted some altar pictures, and one of her grandfathers was also a painter. While still a child, she contributed to the family income with making Venetian lace. After this fashion passed, she set herself, under the direction of an artist, to paint miniatures for decorating snuff boxes, which were then a favorite gift article. Together with her two sisters, she was given lessons in music and foreign languages. She also studied miniature painting, later also pastel painting, with different

Venetian artists; as early as 1705 she had won enough fame as a painter of miniatures to be made an honorary member of the Roman Accademia di San Luca. Her artistic breakthrough is due to her pastel work, which proved to be a turning point in the opening years of the 18th century, although she was already so well-known before this as to be in demand for portraying virtually every person of renown either living in, or passing through, Venice. Her studio was a meeting place for domestic and foreign prominent visitors. The banker Grozat, of Paris, invited her to the capital, where she arrived in 1720, in company with her sister and brother-in-law, the painter Pellegrini. In Paris she was celebrated as *La Reine du Pastel* and was received into the Académie Française. Her studio in the Rue de Richelieu was beleaguered by the carriages of the great, who desired to have their portraits painted and who were willing to pay whatever was asked. It is said that she also had secret commissions, the speculation being that ladies of the court wanted to be painted "in the costume of Eve."

After a year of this she returned to Venice, where she remained, with the exception of a visit to Vienna, where she had been invited by the Emperor Charles VI, until her death. At the age of 61 she went blind and, despite several surgical operations, did not regain her sight. We may note in passing that blindness in older age is reported of a relatively large number of artists. Severe eyestrain was an occupational hazard taking its toll especially in the early days, when artificial lighting was poor and the science of aids to vision at a low state of development. Rosalba's sister and coworker, Giovanna, died in 1738, and the artist, who was already earlier inclined to depressions, became mentally deranged. Her second sister remained with her to take care of her to the end, which came in her 82nd year. Rosalba's fame must have lured on many other female painters of the later 18th century, although not many of those who followed her attained similar heights of acclaim.

In contrast to Carriera, who was closely attached to her native city and could never be happy for long when away from Venice, many of her successors in the profession led wandering lives, albeit mostly not without the company of a family member or other protector. Angelika Kauffmann, a painter's daughter and native of Swit-

zerland, was equally at home in London as, later on, in Rome. While her contemporaries, amongst whom was Goethe, greatly appreciated her art, Ludwig Justi more recently has expressed himself differently: "It required the great ebbtide in the arts to make it possible that talents like her's, which in more inspired times would have been quite submerged by more tone-setting authorities, were able to stand on their own feet and to create a style and an ideal world of their own." While still a child, Angelika traversed Europe in company of her father, especially Italy, and in her later life spent years in London. She was one of those painters of whom we have spoken, who combined personal grace and good looks with visual talent. Her beauty was often praised and she attracted many men, although neither one of her two marriages can be called a success. Uncertain for a long time whether to become a musician or a painter, she decided at last in favor of the Beaux Arts. She began her studies by copying masterworks in the great galleries, subsequently took up portraiture and, already in 1764, painted a likeness of Johann Joachim Winckelmann which is still known today. A year after she became a member of the Accademia di San Luca in Rome. Her friend, Lady Wentworth, invited her to come to England in 1766; in this country too, she quickly achieved both professional success and social recognition. In 1768 she was even to be seen amongst the founding members of the Royal Academy, together with Sir Joshua Reynolds.

She declined Reynolds' offer of marriage and accepted, instead, an adventurer and swindler, whose identity was uncovered only after the wedding. As a Roman catholic she was not permitted to remarry until the death of her husband in 1780. She then became the wife of the Italian painter Antonio Zucchi, a man fifteen years her senior. The pair settled in Rome, where she was again swamped with portrait commissions. Her house, as the home of an artist universally acclaimed as witty, refined and amiable, became a center of the artistic and social life in Rome and many prominent personages made a point of calling on her. Amongst them was Goethe, who became a constant guest; he asked her advice in artistic matters and has pronounced himself repeatedly very favorably in regard to her painting. She died in 1807 and, a year later, the artists in Rome placed a bust of her in the Pantheon to make her one of those deemed to be immortal in the arts. She, however, was not content with what she had accomplished in her life, and knew well what it was that had been lacking to make her really great. In one of his letters Goethe wrote: "She is not as happy as she deserves to be with her truly great talent ... she would now like to paint for her own enjoyment, taking more time and care, and more study—and she ought to do it." One reason for the artist's dissatisfaction with her life's work very probably lies in her awareness of the insufficiency of training, both basic and advanced, which she had to content herself with in her formative years, like so many of her female colleagues. Such shortcomings could be made good only by the most determined self-education if the highest goals were to be attempted. On the other hand, portraiture was easier and lucrative as well; no wonder that many a woman artist contented herself with it. Angelika did attempt mythological and classical subjects, but in those compositions she barely exceeds mediocrity, when compared with other contemporaries, whereas her less pretentious but honest drawings, for example, and also her portraits, indicate gifts well above the contemporary average.

Only one sculptor appears noteworthy amongst the many women who have achieved some international reputation in the 18th and early 19th centuries: Marie Anne Collot-Falconet. Nothing is known of her antecedents. She became a pupil of the sculptor Etienne Maurice Falconet in 1764; this artist was much *en vogue* in his time.

Gentileschi, Artemisia
Saint Mary Magdalen

c. 1630–1635 / 97 × 78.5 cm
Kunsthistorisches Museum Vienna

While the early paintings by Artemisia Gentileschi are composed in a turbulent and dramatic manner influenced by Caravaggio, she turned in her later work toward more serene attitudes, also showing an interest in idealizing her figures more than formerly. Preference is still shown for female themes, with whom she could empathize to a greater or lesser degree. Thus she does not represent Mary Magdalen as a penitent, as other artists have done, but depicts her as a beautiful sinner, whose pensive expression suggests that she counts on being forgiven.

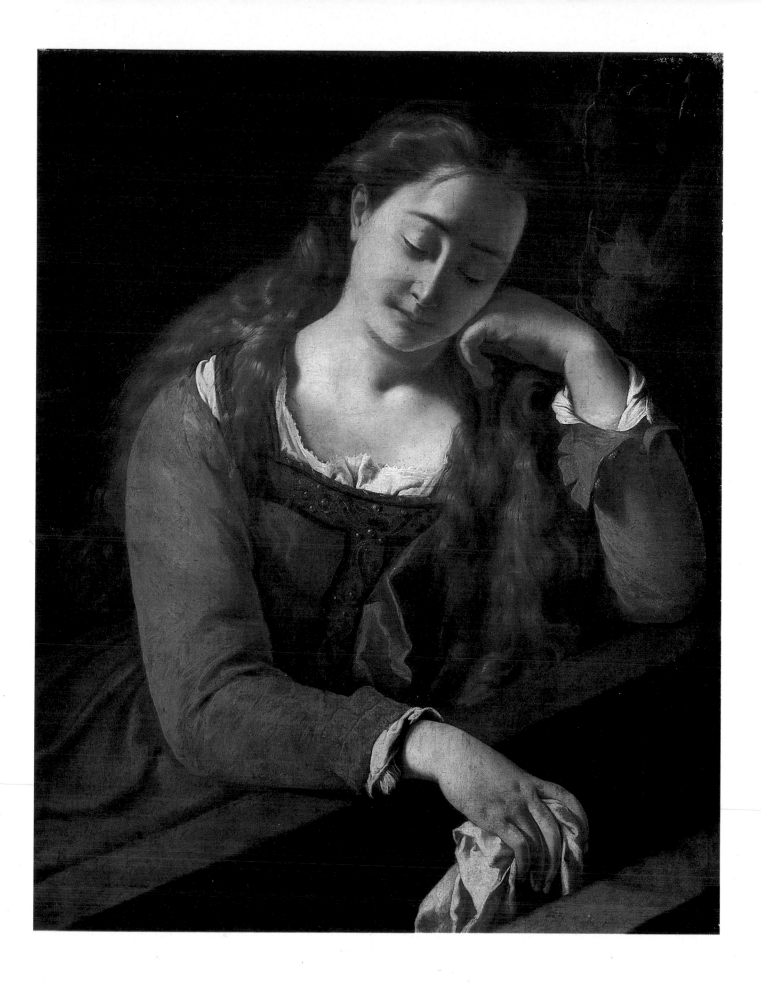

Leyster, Judith
Young Fluteplayer

undated / 73 × 62 cm
National Museum Stockholm

Judith Leyster's paintings were for a long time mistaken for works of her teacher's, Frans Hals, and indeed she has adapted her manner of painting as well as her choice of subjects to the style of her master. The erroneous attribution of her pictures to Frans Hals is a sign, in any case, that artistically she was hardly his inferior.

Leyster, Judith
The Serenade

1629 / 45 × 35 cm
Rijksmuseum Amsterdam

Leyster, Judith
A Merry Drinker with Pewter Mug
and Clay Pipe

c. 1629 / 74 × 59 cm
Staatliche Museen zu Berlin, Gemäldegalerie

Merian, Maria Sibylla
Coral Bean Tree and Saturniid

Design for plate XI of the *Metamorphosis*
Opaque watercolor on vellum / 40 × 30 cm
Library of the Academy of Sciences
of the USSR, Leningrad

These watercolors testify to the perfect synthesis of design qualities and scientific information which is such a distinguished feature of the art of Maria Sibylla Merian. Note the elegance of composition, combining truth of representation with the swelling forms and undulant line which are the epitome of the high baroque style.

Merian, Maria Sibylla
Creeping-stones Turbo

Design for plate XIX of Rumphius,
Rariteitkammer
Opaque watercolor on vellum / 37 × 28 cm
Library of the Academy of Sciences
of the USSR, Leningrad

Carriera, Rosalba
A Turk

1739 / pastel / 56.5 × 44 cm
Staatliche Kunstsammlungen Dresden,
Gemäldegalerie Alte Meister

Rosalba Carriera's pastel portraits prove amply
that she had earned her fame as *la Reine du Pastel*.
Most of her pictures easily hold their own with
works by famous male colleagues.

Carriera, Rosalba
Portrait of the Countess
Anna Katharina Orzelska

undated / pastel / 64 × 51 cm
Staatliche Kunstsammlungen Dresden,
Gemäldegalerie Alte Meister

Carriera, Rosalba
Self-Portrait as "Winter"

1731 / pastel / 46.5 × 34 cm
Staatliche Kunstsammlungen Dresden,
Gemäldegalerie Alte Meister

Hoffmann, Felicita
Portrait of the Orchestra Conductor
Johann Adolf Hasse

c. 1745 / miniature on vellum / 11 × 8 cm
Staatliche Kunstsammlungen Dresden,
Gemäldegalerie Alte Meister

Felicita Sartori was a pupil of Rosalba Carriera;
she became the wife of the Saxonian Councillor,
Hoffmann, and came to Dresden in 1741, where
she obtained many commissions from the court.
After Hoffmann's death she married his nephew
and went to live in Bamberg. Her sister,
Angioletta, likewise worked as a pupil and
assistant in Rosalba's atelier. The portrait of
Hasse clearly shows Felicita as a trainee of
Rosalba Carriera's, but in distinction her work
falls short of that of her teacher.

Collot-Falconet, Marie-Anne
Monumental Head of Peter the Great
for the Equestrian Statue by
E. M. Falconet

1776–1778
Hermitage, Leningrad

The replica of the monumental head of the statue of Peter the Great, modelled by Marie-Anne Collot for her teacher Falconet, demonstrates her ability to understand and express the character of a great personality.

Kauffmann, Angelika
Mrs. Volpato and Mrs. Morghan
as Muses

1791 / 125 × 158 cm
National Museum Warsaw

Kauffmann, Angelika
Cornelia, Mother of the Gracchi

undated / pen drawing / 29.5 × 37.7 cm
Staatliche Museen zu Berlin, Kupferstichkabinett
und Sammlung der Zeichnungen

Responding to the taste of her time which delighted in the conjunction of portraiture and allegorical-mythical disguises, Angelika Kauffmann gives an example of the sensitive classicism which was her favorite style, in her double portrait.

Much closer to the Here and Now than her paintings are her drawings, which, although she regarded them only as a sideline, betray very

considerable talent for realism. One is tempted to speculate that, if she had not overtaxed herself with those monumental mythological scenes for which she lacked the intellectual and technical preparation, and had turned toward a realistic approach instead, she would have created more artistically significant work, although her public might not have agreed with this.

Kauffmann, Angelika
Female Portrait

undated / colored chalk drawing /
22.7 × 18.7 cm
Staatliche Museen zu Berlin, Kupferstichkabinett
und Sammlung der Zeichnungen

Kauffmann, Angelika
Self-Portrait at her Easel

1797 / drawing / 18 × 12 cm
Staatliche Museen zu Berlin, Kupferstichkabinett
und Sammlung der Zeichnungen

Vigée-Lebrun, Elisabeth
Portrait of Prince Heinrich Lubomirski as the Genius of Fame

1789 / 105 × 83 cm
Staatliche Museen / Preussischer Kulturbesitz,
Berlin (West), Gemäldegalerie

The portraits of A. Czartoryski, and of the young prince as the genius of fame, illustrate two radically opposed methods of Vigée-Lebrun's: on the one hand, the factual rendering of the model; in contrast to this, on the other hand, the concession the artist makes to the contemporary passion for exaggeration, here a young Polish prince disguised as something allegorical.

Lemoine, Marie Victoire
The Rape of Europa

State Museum of Fine Arts, A. S. Pushkin,
Moscow

The painting of "The Rape of Europa" appeals to the taste of the period for reviving mythological themes of the antique; it proves that this artist considered herself competent to tackle a large composition with many figures.

Lemoine, Marie Victoire
Mme. Vigée-Lebrun and her Pupil,
Mlle. Lemoine

undated / 112 × 87 cm
Metropolitan Museum of Art, New York

The double portrait tells a great deal of the teaching method of Elisabeth Vigée-Lebrun, with the imposing, full-length figure of the teacher in the center of the composition, while the artist has represented herself as meekly sitting at her feet. The picture is carefully constructed and worked out, from the figured carpet to the still life-like flower arrangements. It is one of the few known pictures by a female artist showing an interior of an artist's studio.

Vigée-Lebrun, Elisabeth
Portrait of Adam Kazimierz Czartoryski

undated / 26 × 19.5 cm
National Museum Warsaw

Tussaud, Marie
**Group of wax figures representing
the French royal family** *c.* **1787**
Madame Tussaud's Waxworks, London

Among the few remaining original examples of
Madame Tussaud's work in the London
Waxworks is this group portraying members of
the French royal family, modelled during their
life-time; from left to right: the Dauphin, Marie
Antoinette, Louis XVI, Madame Royal.

Bonheur, Rosa
The Horse Fair

1853, 245 × 506 cm
Metropolitan Museum of Art, New York

One of Rosa Bonheur's most important works, the "Horse Fair" today hangs in the Metropolitan Museum in New York. It gives an insight into the artist's exceptional ability to depict a large group of people and animals dynamically, with the line of movement progressing from left to right, while creating a composition which, despite apparently reflecting a hectic moment, is carefully and rhythmically conceived.

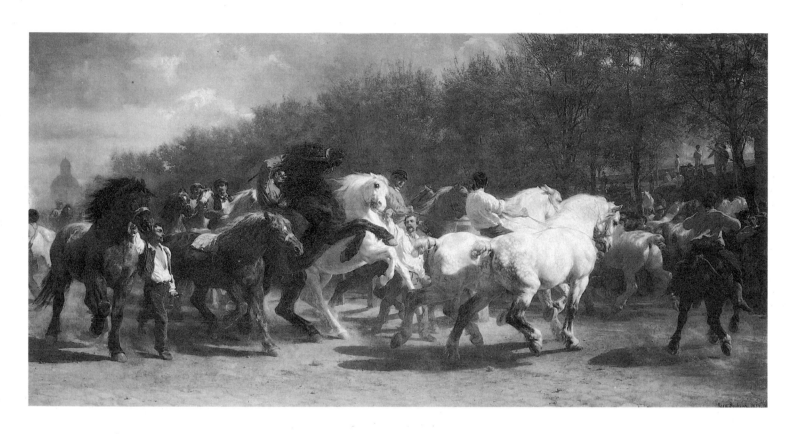

Jaquotot, Marie Victoire
Cup with Portrait of
Josephine de Beauharnais

1804 / painting on porcelain
Musée de Céramique de Sèvres

The paintings on porcelain of the Frenchwoman
Marie Victoire Jaquotot, reflecting the
sentimental taste of the period, nevertheless
demonstrate the high degree of perfection this
artist had attained in controlling the qualities of
chinaware for a painting ground.

Jaquotot, Marie Victoire
Virgin and Child (after Raphael)

1817 / painting on porcelain
Musée de Céramique de Sèvres

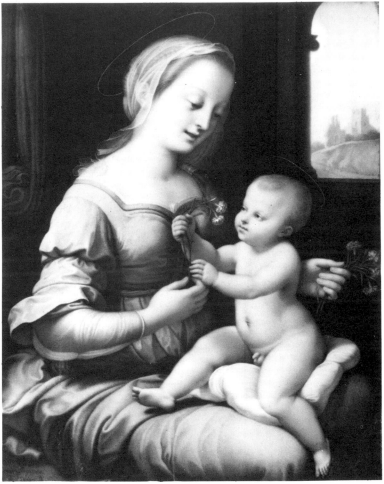

Jaquotot, Marie Victoire
Amor and Psyche (after Gérard)

1824 / painting on porcelain
Musée de Céramique de Sèvres

Peale, Sarah Miriam
Portrait Henry A. Wise

1843 / 74.9 × 62.2 cm
Virginia Museum of Fine Arts, Richmond,
Virginia

This portrait of the politician Henry A. Wise,
painted in Washington, ranks with the finest
achievements in portraiture by Sarah Miriam
Peale; its effect may be still heightened by the
uncommonly handsome model.

Kollwitz, Käthe
Cemetery of the March Dead

1914 / color lithograph, 2nd version /
46 × 36 cm
Akademie der Künste, Berlin

These graphic works are characteristic for Käthe Kollwitz's artistic credo, which in a visual language of revolutionary force and austere simplicity expresses her deep concern for the oppressed and suffering. Her designs have placed her in the frontmost ranks of printmakers of her time.

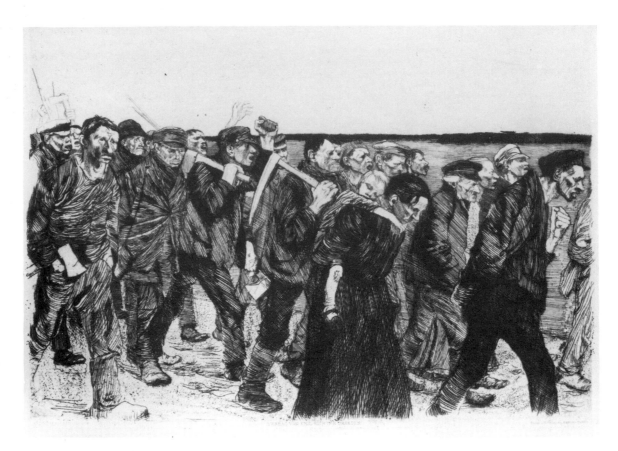

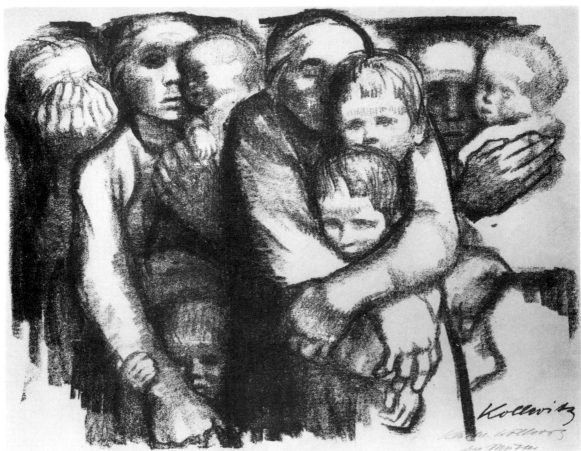

She specialized in portrait busts. At the age of eighteen she was taken to Saint Petersburg by her teacher, with whom she was living in intimate relations, who had been commissioned to do a monument of Peter the Great. In the capital, Marie Anne Collot became very quickly popular on account of the portrait commissions which she received from the court, amongst others a bust of Catherine II and another of her favorite, Count Orloff.

Falconet had a very high regard for the talent of his pupil; Diderot relates that he once smashed his own work when comparing it to a bust of Diderot by Marie Anne. Another instance of his appreciation is his decision not to sculpt the head of the Czar of the equestrian statue himself but to commission her to do it in his stead. In 1767 Marie Anne Collot was nominated for membership in the Académie des Beaux-Arts in Saint Petersburg and was given a gratuity of 12,000 livres in addition to her salary, which was 1,600 livres, raised, in 1768, to 1,000 rubles. In 1777 she married Falconet's son, but this union was dissolved a few years later. After her return from Russia she worked from 1779 on conjointly with her father-in-law for the court of the stadtholder in The Hague. Falconet later suffered a stroke and Marie Anne became his devoted nurse, taking care of him until his death in 1791. She then retired to a country estate which she had acquired in Lorraine and died in 1821 at Nancy.

Similarly to Collot's experience, a few decades after her, Elisabeth Vigée-Lebrun's art made the conquest of the court of the Czar. She arrived in 1795 and lived in Russia for nearly seven years; prior to this, she had travelled and worked in various other European countries. So far as is known, she is the only woman artist of her period to have published a memoir of her life and career (1835–1837). This work, although not free from self-admiration, is nevertheless an interesting professional sketch of the artist, who, together with Angelika Kauffmann, was the most famous female painter of the period, and we shall quote from it somewhat extensively.

Like so many other painters we have described, Elisabeth Vigée was the child of an artist; her father was a painter in pastels and taught his daughter drawing and painting from an early age on. Later she had some instruction from a married pair of painters who were friends of her father's—"they were pitifully poor," she says. After her father's demise, at the age of 14 or 15, she also worked with other painters, but "properly speaking, I never had a teacher." With her mother, she visited the art galleries in order to copy the works of the masters. Later, too, after she had begun to accept commissions for pictures, her mother was constantly present. When she was twenty, Elisabeth Vigée married the art dealer Lebrun, following in this her mother's counsel, who believed him to be wealthy. However, he proved himself to be both a gambler and a woman chaser, and totally ruined Elisabeth, who was already earning much money at this time, but he had the control of her fortune. She obtained a divorce in 1794. Beginning in 1779, she did several different portraits of the Queen Marie Antoinette, who treated her like a friend; the two women were almost exactly the same age. In general, Vigée likes to boast in her memoirs of her grand connections. She was received into the Académie Française in 1783, not without opposition on the part of some members on account of her sex. Like many of her colleagues she was a great music lover: her house was a meeting place for prominent musicians and she says that her concerts were the best that could be heard in the Paris of the period. She also enjoyed acting in comedies and often arranged home theatricals for her intimates.

A confirmed royalist, she fled from the Revolution, taking her daughter and a governess to Rome. Her husband having devoured her fortune—in her memoir she says that it was a million francs—she was entirely dependent on portrait commissions in Italy, but these were not slowly to materialize. She describes meeting with Angelika Kauffmann while at Rome; it appears that these two "First Ladies" of the palette understood each other

Kollwitz, Käthe
Cycle "Rebellion of the Weavers,"
print No. 4

1897 / etching / 21.9 × 23.5 cm
Akademie der Künste, Berlin

Kollwitz, Käthe
Mothers

1919 / lithograph / 45 × 59 cm
Akademie der Künste, Berlin

pretty well. Elisabeth seems to have been mostly attracted by Angelika's education and wit, but she also wrote: "She showed me quite a few of her works; I liked her sketches better than the finished paintings because their coloring is in the mode of Titian."

She recounts an anecdote of interest, because it illustrates her working method: "I painted Lord Camelfort's daughter, Miss Pitt. She was sixteen, and exceedingly pretty. I represented her as Hebe, floating on clouds, with a cup in hand from which an eagle is drinking. This eagle I painted from life but he almost tore me to bits. I had borrowed him from a cardinal who kept him chained in his courtyard; the damned animal was used to being outdoors and finding himself in a house, became furious and tried to attack me. I confess that I was quite terrified."

The next episode is characteristic for the complications which a woman painter might have to deal with; she reports that the Pope wanted to be painted by her, but under the condition that she should wear a veil. Fearing that, to do so, would handicap her vision, she declined the honor. "It was a great pity," she writes, "because Pius VI was still one of the handsomest men to be seen anywhere." She went on to Naples to do a portrait of Lady Hamilton—she represented her as a sibyl—and reaped so many additional commissions that she had to remain at Naples six months instead of six weeks, as originally envisaged. She also did a likeness of the Queen of Naples, receiving "an abundant honorarium and a snuff box studded with diamonds, worth 10,000 francs."

Despite her having become a member of every academy in Italy, it is evident that Elisabeth Vigée was dissatisfied with being nothing but a portraitist. Her discontent resembles Angelika Kauffmann's feelings: she writes that she would have liked to wrestle with more meaningful themes, but that all her strength was consumed by portrait painting. "I could not show four works of mine that are wholly satisfying to me."

Once again she lost her money, which was deposited at a Venetian bank but which she had failed to withdraw in time; when Bonaparte seized Venice, he confiscated the treasury and consequently her account as well. By way of Turin, Elisabeth made her way to Vienna, where she remained for two years and a half. As previously at Naples,

she again exhibited her picture "Lady Hamilton as a Sibyl," this time by invitation in the salon of Prince Kaunitz. The portrait commissions began to flow in again. Taking in, one after another, Prague, Dresden and Berlin, she worked on to Saint Petersburg. The luxurious life in the Russian capital delighted her, as did also the generous and hospitable reception extended to her by society. Her hopes of mending her fortunes were delayed by another bank failure, but by and by she could repair her losses with the income from court orders, for many eminent persons wanted to be painted by her. "I worked without interruption from morning to evening, but I lost two hours every Sunday, because it was necessary to keep open house at my studio for the sake of my clients who wanted to see it." In June 1800 she became a member of the Saint Petersburg Academy. "I had ordered the costume prescribed for academy functions: a kind of an Amazon outfit, with a small purple vest with short tails, a yellow skirt and black-plumed hat."

Soon afterwards, mainly for health reasons but also because her daughter's choice of a husband of whom her mother did not approve, Elisabeth Vigée said goodbye to Saint Petersburg. It was hard for her to leave Russia— "I still think of it as my new home country," as she wrote.

Stopping at Berlin, where she became member of yet another academy, and at Paris, which she did not like any more, she went to England. Although she found the country boring, she stayed for three years because of many orders; visiting Rotterdam, Amsterdam and Switzerland, she finally returned to Paris again, acquiring a country house at Louveciennes. Her divorced husband, her daughter and her brother all died during the next year, and Elisabeth quit the pursuit of her art. She died in solitude, her estate comprising, according to her notes, some 800 canvases as well as numerous drawings. The directions and advice to portrait painters with which her memoirs conclude, incidentally, make it still a readable work.

If Elisabeth Vigée-Lebrun is the embodiment of the prestigious delineator of the "quality" of her period, her contemporary, the legendary Madame Tussaud, has created a genre all her own from very different material. Marie Tussaud was a wax moulder, a branch of the plastic arts which was entirely respectable in her day, al-

though later it sank to the level of show business and was branded as "diorama art."

Madame Tussaud's mother was a descendant of a Swiss family of executioners by the name of Grossholz; her father was a Parisian painter and portraitist in wax, P. W. Curtius by name; mother and daughter followed him to Paris. Curtius was the proprietor of a popular wax figure cabinet; he taught his daughter the wax molding processes, she proving an apt pupil; she soon acquired a good reputation in the trade and, it is said, even gave modelling lessons at the court. It is also reported that she belonged to an Association of Women Artists, and that this body collected its members' jewelry and donated it to the Constituent Assembly. The tradition according to which she was allegedly compelled, during the Terror, to take off the death masks of prominent victims of the guillotine, amongst others those of Louis XVI, Marie Antoinette and Robespierre, is not reliably documented. So much is certain, nonetheless, that these heads were in her cabinet, as was also a death mask of Marat. Curtius died in 1794, leaving Marie as sole inheritor. In 1795 she married François Tussaud; a daughter, born a year later, died soon after birth; she had a son, Joseph, in 1798, and in 1800 another son, Francis. Marie Tussaud separated from her husband in 1802 and took her wax figures to London; the cabinet had grown constantly and contained effigies of many celebrities of the day. Incidentally she modelled her figures from life where possible, and from engravings when necessary.

In London she occupied at first a shop in Fleet Street; afterwards there were many removals, until she came to a temporary halt in Blackheath, Greenwich. In order to increase her income, she went on lecture tours with part of her cabinet, and also arranged for exhibitions of the figures.

A shipwreck, in which many of the figures sent out on exhibition perished, was a heavy blow from which she recovered with difficulty, as all the lost pieces had to be worked up again. Afterwards she resumed the lecturing tours, until she finally found a suitable, permanent establishment in Baker Street in London. As it was her constant preoccupation to keep abreast of current events, she did not shun modelling her likenesses even in the prisons, if they happened to house a criminal who had, in one way or another, captured uncommon public attention. In her last days she modelled from daguerreotypes. She worked for her cabinet until the end of her life in 1850, her last figure being her self-portrait. The cabinet was later administered by one of her sons; a large portion of it was destroyed during an aerial bombardment in World War II.

Porcelain painting was another side-line of the Beaux Arts, although in high favor until the latter half of the 19th century. Marie Victoire Jaquotot (1772–1855), a Frenchwoman, achieved much merit in this art. Incidentally she was also a virtuoso on the pianoforte, like many of her professional colleagues. Before she appeared, porcelain painting had not been considered as an artistic discipline in its own right. Marie Jaquotot however, a pupil of the porcelain painter Guay, penetrated so deeply into the secrets of color preparation and methods of color application on china, and achieved such unaccustomed freshness and harmoniousness of effects in the painting of porcelain ware, that it came to be recognized as a field of legitimate artistic creativity. Napoleon I, not otherwise much given to the encouragement of feminine talent, appointed her as cabinet painter and gave her the Great Gold Medal for porcelain painting in 1808, the first time such a prize was ever awarded in this branch. It has even been claimed that she was made a member of the Legion of Honor. She maintained a studio for ladies in Paris, besides working for the porcelain manufactory of Sèvres, where she trained numerous and able successors. She visited a great exhibition at Munich in 1837, where she saw her own products side by side with the china coming from the Royal Bavarian Porcelain Manufactory of Nymphenburg, and where she was much fêted besides. Some of her best-known works are several déjeuner sets with the portraits of celebrities and of members of Napoleon's family, which were commissioned by the Emperor.

After the July Revolution of 1830 her fortunes declined. The new government discontinued her annual allowance of 1,000 francs and other privileges. From this time on, she went on frequent study trips, but continued to work for the Sèvres factory.

Marie Jaquotot was married twice; after divorcing her former teacher, Guay, she married the painter Pinet. She also had an illegitimate son, who likewise became a

painter; his father was the architect, Comaires. She died at Toulouse at the age of eighty-three.

In the early years of the 19th century, a growing number of American women embraced the profession of the Fine Arts. And of these, Sarah Miriam Peale (1800–1885) is interesting, because she is the first female American artist to support herself solely by her art. Born in Philadelphia, the daughter of a painter of miniatures, she received, together with her siblings, her first instruction from her father. One of her sisters, Anna, also became a miniaturist; but Sarah felt more attracted by oil painting and sought instruction in this technique from one of her cousins. Her uncle was the portrait painter Charles Willson Peale, whose entire family devoted itself to the painter's art, Charles being the first outstanding member of this remarkable dynasty of American artists. Sarah Peale removed to Baltimore in 1825 and remained in this city for the next twenty years. She soon gained recognition as a portraitist and had many commissions. Leading contemporaries had their likenesses taken by her, and in Washington, where she visited from time to time, she made a whole series of portraits of prominent men and women in public life. In 1846 she accepted an invitation to go to St. Louis, where she felt so much at home that she remained in this city for three decades. In the new milieu she again became the preferred portraitist of the quality, but she also did still lifes which repeatedly brought her honorary awards. At the end of her days we see her in Philadelphia again, where she died at a ripe old age as a famous and honored painter.

In contrast to the career and the position in art today of Sarah Peale, whose works have had to be rediscovered by recent American researchers after a long period of oblivion, the French Rosa Bonheur, approximately twenty years the junior of Peale, rose to steadily increasing fame which has lasted into our present time without interruption. She came before the public for the first time in the Salon of 1841, where indeed she attracted little attention, but her reputation began to grow in the following seasons, until at last her name became known throughout the civilized world. She was born in Bordeaux, her father being a drawing teacher who moved with his family to Paris in 1828. Contrary to his hopes for a better income, he had to struggle along, giving private drawing lessons to make a living. He also taught his two daughters—Rosa's sister Julie became a painter as well—and set Rosa to copying in the Louvre, and to working from plaster casts, after he had perceived her talent. Besides these exercises she did intensive studies of animal anatomy, as she had discovered in herself an early predilection for animal representation. Her studies included drawing in slaughter houses and at horse fairs; to forestall being molested she went abroad in men's clothes, for which she received official permission in 1852. In order to understand form and movement, she modelled animal figures in clay; some of these studies were cast in bronze and were at one time very popular with collectors.

At the Salon of 1845, Rosa Bonheur won a prize for her animal paintings and was able to sell them at suitable prices. A few years later, her father became director of a girls' drawing class; upon his death, in 1848, Rosa took over the direction of the class with her sister Julie as assistant. In the same year her composition "Ploughing at Nièvre" won a gold medal for her and was purchased by the state for the Louvre. But her chef d'œuvre is the "Horse Fair" of 1853, which was the big attraction at the Salon of that year, and rated her an invitation to come to England. Her earnings soon permitted her to acquire the château of By near Fontainebleau, where she retreated with her friend, Nathalie Micas, to be able to work without being disturbed, the only company allowed being all kinds of pet animals. In 1865 she received the cross of the Legion of Honor from the hands of the empress Eugénie. Kept constantly busy with orders for pictures, especially from England and America, her work was rarely seen at exhibitions after 1853 except at several World's Fairs. Only one more composition by her was shown at the Salon—as it happened, in the year of her death—the famous "Cow and Bull of the Auvergne," perhaps her greatest triumph.

While Bonheur's fame was at its peak, Käthe Kollwitz, graphic artist, painter and sculptor, was born at Königsberg. Together with Paula Modersohn-Becker, who was about ten years younger, Käthe Kollwitz (1867–1945) ranks as the outstanding German woman artist of her time. She was the first woman to devote herself in her art almost exclusively to the poor, the despised and rejected, being motivated by a profound sympathy

for the suffering of humanity. She formulated her themes with a vigor and artistic passion exceeding by far everything previously seen under the contemporary sentimental heading of "painting of compassion" and has thereby created works of universal significance.

Seen superficially, and particularly when it is compared to the meteoric careers of some of her predecessors, Kollwitz's life presents a bourgeois pattern, but underneath the appearance it is all the more marked and burdened by suffering and uncompromising artistic self-critique, as her diaries and letters show. While wars and revolutions have affected the lives of other women artists in earlier times, none of them had to endure physical and spiritual coercion in their own persons on the score of political involvement.

It was reserved for the unholy methods of Fascism to encroach on artistic territory. The single exception in the 18th century is Rosalie Filleul of whom we have spoken, who was guillotined as a royalist, but it has remained doubtful whether she gave her life as a luckless victim or as a deliberate partisan of an antiquated and rejected system. If we consider all we know of the average attitudes of women artists during the Revolution, the latter explanation is not very convincing. More typical is the behavior of the admitted royalist Vigée-Lebrun, who voluntarily emigrated before the Terror, as did also some two or three others, without encountering any material disadvantages in consequence. Käthe Kollwitz, on the other hand, was cruelly penalized for her advanced political convictions.

She was the daughter of a master mason, and granddaughter of a minister of a free religious community in Königsberg. After taking private lessons from various artists, and a year's study with Stauffer-Bern in Berlin, she enrolled at the Munich School for Female Artists for two years. She married Karl Kollwitz, a physician, at the age of twenty-three, and the pair settled in one of the slum sections of Berlin, where she lived until the death of her husband in 1940, a period of almost fifty years. Two sons issued from this marriage.

Both world wars affected Käthe Kollwitz's life most cruelly: she lost her son, Peter, in the first war; he was killed in 1914; in the Second World War her equally beloved grandson Peter was killed in 1942. Her deep sorrow for the death of her son she has expressed in the commemorative sculpture group *Die Eltern* (The parents), which was placed in the Belgian Soldiers' Cemetery of Roggevelde near Dixmuiden in 1932.

The Prussian Academy of the Arts nominated Käthe Kollwitz to membership in 1919 and, against her will, honored her with the professor title. Her social-political involvement in the following years, expressed again and again in her graphic prints, attracted the persecutions of the Fascists after the *Machtergreifung* (scizing of power): expulsion from the academy and loss of her studio forced her to seek a livelihood as a "free" artist; beyond this she had to endure constant defamations, including an indirect prohibition of exhibiting. She continued to work, however, in the face of all this, until the mounting aerial attacks on Berlin, which in due course destroyed her house, compelled her to leave the city. She found a first refuge in Nordhausen (Thuringia), later another in Moritzburg near Dresden, where she died in the last days of the war.

Käthe Kollwitz's œuvre, so far unsurpassed, began in the years 1895–1898 with six graphic compositions, forming a cycle which is known as the *Weberaufstand* (Rebellion of the weavers) and consisting of three lithographs and three etchings, the subject-matter being inspired by Gerhart Hauptmann's drama *Die Weber*. This was followed by the cycle of etchings with subjects from the Peasants' War of 1903–1908: dramatically revolutionary compositions, which at once earned her the disapproval of the ruling class. Subsequently she abandoned historical themes and concentrated nearly exclusively on the portrayal of the social problems of her own era, and of the anti-war theme, not only in many graphic prints and posters, but also in several grandly conceived sculptures.

Our succession of twelve typical careers of women artists spanning approximately three and a half centuries, which we have tried to present as though they were joining hands across their respective generations, describes almost exclusively the destinies of individuals who established themselves by virtue of their own merits and who were economically able to spend their time on their own work as artists. This does not mean that they did not have to combat opposition of the most varied nature, and

that, in their quality as women, they did not have to accept severe handicaps: we call to mind only their exclusion from nude studies, to say nothing of the more personal difficulties ruling their daily lives, such as the demands made on them by motherhood and households. That courageous and independent artist, Rosalba Carriera, has stated that the only thing which made her envy men, was their freedom of movement, whereby they could see the world at their pleasure. In this respect the 18th century was more restrictive, especially in Italy, than the Renaissance had been. Even Elisabeth Vigée-Lebrun, who seemed to conduct her life entirely without restraint, has written of "the misfortune of being a woman."—There is food for thought, too, in the marital conflicts which quite half of the artists whom we have enumerated have had to endure, ending in separation from, or divorcing, their husbands. This cannot be accidental; it seems self-evident that an artistic career of a woman cannot be readily reconcilable with a "normal" married existence; least of all if the husband was himself an artist and to find himself outpaced by his wife. Of the nine artists of our series who were married, only the one Käthe Kollwitz had a long and happy marriage, and her husband was a doctor.

WORKING CONDITIONS IN
THE 19TH AND 20TH CENTURIES

The biographies of the three 19th-century representatives of our typical series do not clearly reflect the many and great changes which had come into the professional world of the free arts during the latter half of the century, because these women were sufficiently prominent in their vocation by virtue of their exceptional gifts, to be largely unaffected by the limiting conditions which hemmed in their less illustrious colleagues of both sexes. The revolution of social, technological and economical living conditions is the great characteristic of the 19th century, and the changes which it brought did not spare the exercising of the beaux-arts. Under the conditions which the industrial revolution imposed, the women faced additional difficulties, and nowhere more so than in Germany, where the bourgeois standards had a peculiarly restrictive attitude toward the sex. Renate Berger cites numerous examples to show just how much girls from bourgeois and aristocratic backgrounds, particularly from the middle of the 19th century onward, were held back in their artistic development by family notions of how a "respectable" girl should behave. Typically, hardly any woman artist became a member of an academy in the nineteenth century.

Women artists in France enjoyed a proportionately greater freedom of movement, and in some other European countries, for example in England, the practicing of their vocation was not much hampered by conventions, but in the Germany of the Biedermeier period (the period following the downfall of Napoleon and ending with the revolutions of 1830) they were hedged around with taboos which even a talented woman must find hard to cope with. Johanna Schopenhauer—who was, incidentally, herself an art dilettante—in a letter of 1805 to her son tells an anecdote which may illustrate our meaning. In those times her house was frequented by the promi-

nent Weimar circle headed by Goethe, who was much inclined to help hopeful young women artists. Amongst others he had been very encouraging toward Caroline Bardua (1781–1864), at the time of the anecdote an art student, although she became later a fairly accomplished portraitist. She also was often a guest in the Schopenhauer house. One day a group of friends were assembled in Johanna's salon, in which the hostess and Christiane von Goethe were the only ladies present. Goethe had begun to read aloud from a letter which told of a young unmarried woman who had become pregnant. Caroline Bardua appearing at the doorway at this moment was asked to stay outside until Goethe had finished reading the story. She expressed her protest by playing the piano as loudly as possible in the adjoining parlor (she was a talented pianist). Despite her being twenty-five years old she was not deemed fit, not being a married woman, to learn that a young unmarried woman could become pregnant. One asks: How was a girl to acquire the degree of human maturity which must always be a precondition for serious and well-founded artistic creativity, including portraiture, if she was to be kept artificially in such isolation and inexperience of human affairs? In the same year, Goethe wrote this about Caroline: "She does not lack various handsome talents; the question is, whether she will succeed to make the transition from the pretty promenades of dilettantism to the King's Highway of Serious Art, and whether she will grow to be a zealous pilgrim striving toward the Supreme Goal." But he did not say how she was to achieve this, if the "highway" was to be kept piled full with taboos of every kind.

Material changes in the working conditions of all artists, male or female, spread through all European countries around the middle of the century. The newly invented reproduction techniques of lithography and photogra-

phy rendered the work of reproduction engravers and picture copyists superfluous, when they had previously been a source of modest but certain profit. Many of the workshops devoted to the engraving and printing of pictorial material (establishments which were, if not outright artistic, at least art-related) lost much of their clientele; women employées, where there had been any, were dismissed first, and had to find new outlets for their talents. This was often difficult. A German artist, Emmeline Humblot (1816–1895) had tried to adapt to the new conditions, but she was nearly ruined by them. She had acquired a good reputation in Dresden as a copyist and painter of flowers—Lenau was so charmed with her pictures that he dedicated his poem *Die Blumenmalerin* (The flower painter) to her—when she decided to found a photographic studio, with which she moved to Paris. However the venture cost her nearly all her savings, and she had to work hard, first in England, later in Munich, to regain a new basis for existence. Likewise the Swedish painter and draftswoman Maria Christina Roehl (1810–1875) had been very prosperous as a portrait artist and miniaturist, but the report is that with the arrival of photography she lost virtually all means of making a livelihood, and that she ceased art work altogether about 1860. However, we may take comfort from the fact that she died as a member of the Stockholm Academy and painter to the royal court. These are but two officially documented cases—how many may there have been who fared no better. Although several female painters on enamel, on porcelain and in miniature art are still listed at the end of the century as independent, i.e., not employed in craft shops or factories, these branches had ceased to count as a certain source of income for women professionals.

Of course some individuals adapted to the changed situation and took advantage of new techniques. The Swedish engraver on wood, Ida Falander (born 1842), directed the xylographic atelier of the periodical *Ny Illusterad Tidning* from 1874–1877, for which she had previously worked in another capacity. But such cases are the exception in the staffing of the new reproduction shops for lithographic, photographic and similar processes which were opening everywhere, because these were mostly in charge of male professionals.

Some women saw possibilities for artistic expression in photography and worked early in this medium. A famous example is Julia Margaret Cameron (1815–1879), a daughter of an English army officer who was born in India; she became a portrait photographer of considerable repute, and also delighted in posing family members and friends in romantic costumes to impersonate mythological and literary scenes for her camera. But the overall number of women who used the camera as an artistic means of expression is minimal in proportion to the countless copyists, miniaturists or reproduction engravers who lost their livelihood in consequence of the new inventions in reproduction technology, which fate they shared of course with many of the men.

But technical evolution was not the only cause which was forcing women out of positions of professional productivity in which they had been at home. Peter Feist has stated the problem as follows: "The products of 19th century art bear the marks of the period in which capitalist production methods became dominant, because in the process of transition from manufacturing artisanship to industrial capitalism the making of art objects once and for all came under the laws of commodity production, precursors of which had already existed during the Italian Renaissance, and in 17th century Holland" (and, we should like to add, in the engraving enterprises of Nuremberg and Augsburg). "The quality of commodity of works of art, created by free-lance artists as small-scale entrepreneurs for sale in an evolving art market situation in which they were expected to meet with keen competition, necessarily influenced all aspects of art during this epoch."

The truth of this applies not only to Germany but equally to all countries in which art was being produced on a large scale. What had happened in the times when the corporations, under the pressure of the growing economic interdependencies and insecurity, had squeezed the female labor force, as the economically weaker contestants, out of guild membership, was happening again under the impulsion of the intensifying competition amongst the free art professionals. It was harder for the women to sustain the contest, because they were by tradition less well trained for their vocation than their male colleague-competitors.

The trend which becomes more and more pronounced after the middle of the century, of larger numbers of women straining toward an art vocation, further aggravated the situation. While the 19th century saw a general expansion of the demand for works of art—it had become evident that art collections constituted an attractive capital investment, i.e., art objects could and did become objects of market speculation—the female contingent of free artists gained but little from a "boom" conjunction. Not only must they labor enormously to hold their own, say, as portraitists against the portrait photographers (portraiture being, as we have shown, a chief source of income for women painters and sculptors) but also in order to prevail against male practitioners who were traditionally better paid.

We have already spoken of Caroline Bardua. Her experiences as a female free portraitist making a living out of her vocation fall in the first half of the 19th century. She had to supply not only for her own needs but also for her relatives. At the outset of her career, it had proven to be necessary to abandon the intensely longed-for project of an Italian journey, despite its being considered in those times as an almost indispensable investment for an aspiring young artist. Her professional life may be taken as symptomatic for the lives of many other women artists of the period, in particular of Germans, and we shall delineate it in some detail.

Upon completing her studies in Weimar and Dresden about 1810 she had begun to make a living by copying for collectors, but the returns were not satisfactory. A fad of the time came to her rescue: it had become the fashion to mount miniature portraits of the human eye on various kinds of small bijouteries used as gift articles. Caroline had to paint the eyes of the princess of Zerbst for many such pieces; wherever she happened to be working, the princely eye-sample was forwarded to her, with orders for yet half a dozen more copies. But by and by she succeeded to obtain some portrait commissions netting her a modest sum, enough to enable her to take some advanced lessons with Kügelgen at Dresden. Now and then a casual copy, for which she got four louis d'or a piece, helped to eke out the allowance. After Dresden she went on a journey visiting sundry German cities in search of portrait orders, with varying success. At that time her fees were eight louis d'or for a half-length without hands, ten for the same with hands; a three-quarters length was worth sixteen louis d'or. At last she settled in Berlin around 1819, where she did better, even becoming the fashion: she had commissions from the Prussian court, which were paid at the rate of twenty friedrich d'or. But subsistence of self and relatives was never reliably assured, as her earnings remained unpredictable. Eight years later (1827) she wrote from Heidelberg: "... is it not a hard lot to have to go abroad in search of some human being in need of having a likeness taken?" Travels had to be resumed, because (as she wrote) "in Berlin the army of painters is ever growing larger."

Once again she was able to scrape together a nest egg sufficient to let her accept an invitation for herself and her sister for a brief sojourn in Paris. When the visit was over she travelled again, reaped a modest salary from the Berlin Academy of Arts, where she also exhibited, earning sometimes more, sometimes less, and was still working at the age of 78 years. The wife of her former master, von Kügelgen, described her in 1810 as "a wild cat from the Brocken mountain—a frantic, untameable, almost masculine being." No doubt this kind of temper helped Caroline to endure such a "free artist's life"—many others, perhaps not less talented, might have been broken by it or sought refuge in marriage.

The professional profile of Bardua resembles, in a more limited way, that of Elisabeth Vigée, who was also in constant motion from one place to the next in search of patrons. Both painters paid for their bread with this restless itinerancy, but the doughtier Vigée reaped more laurels than the less gifted Bardua.

The career of Louise Seidler (1786–1866) is somewhat less obstructed than that of Caroline. This painter too had friendly relations with Goethe through which she is chiefly known today, although a modest memoir by her has contributed to her being remembered, while her artistic achievements are less conspicuous. Aided by princely patronage she spent a five-year study period in Italy; afterwards she gave lessons at the Weimar court and was promoted in 1837 to the rank of court painter at the court of the Grand Duke of Saxony, after she had been exercising the function of inspector of the Weimar picture gallery since 1824. Taken all in all, her financial

situation too was modest, although more secure than Bardua's.

Very few women painters of the 19th century show the éclat with which a Rosalba Carriera, an Angelika Kauffmann or an Elisabeth Vigée-Lebrun achieved their fortunes. If, as we have said, more and more women strained toward a free art career, the motivation was emancipation rather than hope of riches and fame.

We need not describe here under what conditions, and in what manner, the women of the bourgeois middle classes aspired with ever greater insistence toward equality with men during the later 19th century. While proletarian women had to work, due to steadily worsening living conditions, whether they wanted to or not, the women of the middle class wanted to take advantage of opportunities for educational betterment and vocational training which had begun to open up to their sex. They became constantly more articulate in their demands. But the choice of liberal professions which young women might hope to be able to master was small. Amongst the few for which training was available to qualified applicants, the vocation of the free arts was, for many daughters of bourgeois households, particularly attractive. To begin with, the training phase was a comparatively free process and was not tied to prohibitive prerequisites or rules.

Another advantage was that, since Renaissance times, the profession of the Beaux-Arts was traditionally rated as an acceptable way of life for a woman on the part of "good" society; even conservatively-minded parents need not fear derogation. Possibly more compelling than both these advantages together, in the eyes of young women of the period, was their yearning to break away from bourgeois restrictions and from the tutelage of fathers and brothers. An artistic calling offered good opportunities for this. It was a good reason why many girls, even if not especially talented and merely helping to enrich private art schools with the tuition fees they paid, tried to enter the art field. Their primary hope was to find personal freedom and independence, without yet having to forego necessarily their normal chances for marriage; for, although in certain bourgeois circles a female painter, or worse yet, a woman sculptor, was suspected of an improper hankering after emancipation, the general consensus more or less accepted a beaux-arts education as not derogatory to middle-class status.

The natural consequence of this feminine thrust was that a prejudice formed, especially amongst professional male artists, against all women who cast their lot with the fine arts for whatever reasons. The depreciatory label of *Malweib* (painter woman), much heard toward the turn of the century, was aimed in the first line at the dilettantes graduating from the art schools, whose half-baked artifacts discredited the serious efforts of more highly motivated professional women artists.

The glutted art market was nourished also by women and girls who turned their more or less trained mini-talents into a sideline for some pin money. At the end of the century the proportion of part-time female artists to the overall total of them is striking; the explanation here is, that an art occupation was chosen because it interfered less than other part-time employment with domestic duties, motherhood, etc. This applies of course mostly to married women. But amongst the full-time art workers a sort of an art proletariat came into being. Many or most of the women artists were forced to sell at less than adequate prices, if they would sell at all; the men were annoyed by this and often turned hostile toward professional women, and the competitive strife grew steadily worse.

Here are some statistics: Munsterberg says that, up to the middle of the 19th century, one quarter of the total number of practicing artists in France were women. Lily Braun gives the following figures for the year 1900 of the proportion of male and female painters and sculptors: in Germany—190,827 men, 839 women; in Austria—61,382 men, 327 women; in France—220,042 men, 3,818 women; in England—269,454 men, 3,132 women; in the U.S.A.—484,580 men, 10,815 women.

The German art historian Friedrich Jansa published in 1912 a compilation entitled *Deutsche Bildende Künstler in Wort und Bild* (Illustrated profiles of German fine artists), in which only those artists are described who had made a certain name for themselves, whether by way of exhibitions, publications, inclusion in art collections, etc. Of some 1,100 names given, some 100 are women, including 12 sculptors and a few craftswomen who did something also either in painting or in the graphic arts. The career profiles of the women artists evince in all cases that the

women in this compilation must have come from tolerably prosperous circles, as the majority of them had studied in various cities, mostly in Paris, and this kind of training was not cheap. Similarly, whatever details of their backgrounds are given, indicate that the respective person originated in a well-situated family. The compilation does not include a single name of a woman stemming from modest or poor circumstances, while amongst the profiles of men, it is noted occasionally that they had risen from humble origins. Therefore one may assume that, at least in Germany, only the daughters of relatively comfortably fixed families reached a measure of training that would allow them, talents permitting, to rise through the practice of their craft to the levels of those who "had made it." In France, by contrast, women of under-privileged descent, such as Suzanne Valadon or Berthe Morisot, have been able to achieve artistic acclaim and economic independence.

The mushroom growth of the number of practicing women artists contributed to make the situation of every individual amongst them much more complicated than it had been a century earlier. The chief difficulty, as always, was economical. Not only did the artist have to prove herself as a creative person—a task which in the 18th century, often called "the Century of the Woman," was still a comparatively simple matter where energy was paired with talent, although then as now a little luck was also required—but, in the 20th century, many or most artists found themselves engaged in a tough economical battle, which for the women was further complicated by their exclusion from the professional privileges and the advantages connected with them, which every male artist enjoyed as a matter of course. Up to the year 1913 this discrimination still existed in Germany, while other countries had abandoned such practices by the turn of the century. Women were kept out of membership in professional organizations, jury membership for the major art exhibitions, membership in prize committees, etc. In Jansa's *Deutsche Bildende Künstler* one may also note that a large number of male artists carries the title of professor, but not a single woman is designated as such.

In view of this dismal situation it is surprising that so very few women artists, in almost all European countries, came out openly in favor of the goals of the Women's Movement which was then gathering such vigorous momentum. This applies to individuals as well as to the professional associations of female artists which came into existence in many of the cultural centers in Europe toward the end of the 19th century. In their indifference, the women artists were in conspicuous contrast to women writers and journalists, who often were strongly identified with women's rights. It may be advanced that most male artists likewise were slow to involve themselves in political partisanship (which, for the women, would include the Women's Movement), again in contrast to their literary and journalist sex-mates. This detached attitude is partly explained by the prevailing sentiment at the turn of the century, that art and artist should be above the events of the day, and that themes of everyday political life were not art-worthy subjects. Irrespective of this, one would think that artists might have engaged in politics as "civilians," i.e., in a nonprofessional way. But such instances remained exceptions, in particular with the women, who in general abstained in those days from political activity, if for no better reason than that it required a more forceful personality than most female artists could lay claim to, to venture into the political arena. They expended their strength in wrestling with their art, which they, shortsightedly enough, deemed to be an ineluctable something outside of the sphere of socio-political discussion. Too commonly the organizations of professional women artists limited their debates to the solution of occupational problems, e.g., instituting education facilities for women, organizing exhibitions of women's art, etc. While such concerns were natural and useful enough, they had the disadvantage that public opinion concluded that the women themselves were taking on the responsibility of looking after these matters, and no state or municipal organization saw a need for doing anything.

The obstacles faced by women professionals in the Germany of the time, a backward country in other matters as well, on their way toward a recognition of their right to education on an equal basis with men, are outlined in a lecture given in 1913 at Frankfort on the Main by Henni Lehmann, on the subject of "Das Kunststudium der Frauen" (Art education for women). The lecturer demanded in the name of the recently founded

Women's Art Union, under the directorship of Käthe Kollwitz, the rights for women to study and teach at all public art schools, as well as other rights. These demands had been presented to the Reichstag (national diet) in the form of a petition; discussions of the petition had brought violent debates, but no results. On the other hand, since 1908 some German universities had begun to admit female students. Henni Lehmann made reference to a previously rejected petition on the part of the Union of North German Women Associations, to open the academies of Berlin and Düsseldorf to women students; she spelled out the reasons for refusing the petition, which today, at the distance of 77 years, are really grotesque, especially when one bears in mind that the problem had been solved in other European countries long before. For instance, in England women had had their own art schools since about 1860, but demanded nevertheless admission also to the classes at the Royal Academy. While this had first been refused on the plea that it would require fitting up of additional teaching space, only a year later a woman, the painter Laura Hereford, got into the Royal Academy as the first female student, although it has to be admitted that she had used a male name for submitting her sample work to the Admission Committee. Ten years later there were already forty women enrolled at the Academy. Women in France had gained access to the Ecole des Beaux-Arts only in 1897, but that was still fifteen years before Lehmann's lecture. The private academies of Julian and of Colarossi, both of high standing, had been accepting female students even earlier and were overrun by applicants.

In these private institutions men and women were taught separately, and some of the women's classes had as many as 70 or even 100 pupils, but still—their training was possible and assured.

How different in Germany! The first argument against granting the demand was, to voice doubts about the worth of academical training in general: it was antiquated, useless, etc. Lehmann countered this with the question why, in that case, men were subjected to such unsuitable methods? Another argument was founded on the nature of women, who were not sufficiently original and creative to promise enrichment of art. In refuting this argument, Lehmann pointed out that creative genius is rare everywhere, both in men and in women; she wanted to be shown why the large number of demonstrably valid talents amongst women should not be worthy of furtherance, even though up to now no female Rembrandt or Michelangelo had come to light. Another "reason" for objecting to granting the petition was, that if access to art studies were to be made too easy, still more women would flood the art academies because of the lack of other suitable occupation for educated females. Against this Henni Lehmann objected that the oversupply of applicants at art schools was just as high on the part of male students and that they, too, would have to be decimated before admission. After sundry other arguments, all equally specious, admission of females at art academies was finally refused on the ancient and familiar grounds that, for esthetic and moral reasons, the joint presence of men and women before the nude male model was unacceptable, while the introduction of special ladies' life classes at the academies was impossible because of lack of space. Lehmann begged to state that, up to now, no ill effects had been reported from the few art schools where males and females had jointly studied the nude model; she also averred that the "risk of coming in contact with the male bohème" allegedly threatening women if they were allowed in coeducational classes was notably greater at unsupervised private schools than it would be at state-controlled institutions; and finally stated that, to overly and hermetically seal off and protect the female sex was harmful to the free unfolding of personality.

We have quoted Henni Lehmann's lecture in detail because it illuminates the prejudices against official admission of women at art academies which was not to cease in Germany until 1918, and because it outlines their defense against such subterfuges as a matter of principle, for in practice it could be said that the way to institutions of art education was open to them. The lecture is also interesting because it is one of the few examples where a spokeswoman of the Women's Movement takes an official position in regard to free artists.

In connection with this question we quote the following passage from a letter by Hans von Marées to a young woman painter, written in 1873, which gives something of the male point of view in regard to the situation of female artists. He wrote: "...for the rest, I, too, am not of

opinion that the possession of a mustache is the only key to creative work; but women do face greater obstacles. The foremost of them is their insistence that they must remain ladies no matter what ... the great difficulty is always social respectability; to remain always *comme il faut* requires about the intelligence of a nutcracker, but the wretched considerations demanded by one's class deprive an intelligent being of his best ideas and take up most of his time. A man may deal more readily with such absurdities, but it is bound to be harder for a young lady, although not impossible..."

The wish to remain ladies, partly, at least, in the hope of escaping the stigma of being a "painter woman," obviously kept many women artists from personally joining in the demands for recognition of their rights, because women's rights advocates or liberated women were not "ladies." Since the bread of women painters was mostly portraits, bespoken by the comfortably situated middle class, care must be taken to preserve a lady-like effect, lest a self-respecting bourgeois should find it impossible to patronize a "painter woman." By and large the female artists of this period remained outside of the Women's Movement, whether they were successful or failures, seeking their way and *raison d'être* individually; on the other side, the Women's Movement regarded artists as outsiders, hardly belonging to it at all, as Henni Lehmann also remarked. In books by well-known representatives of the Movement, for instance Helene Lange, women artists are rarely mentioned.

Compared with the 18th century, the branches of art activity open to women of the 19th century had diminished in variety. A portion of the outlets which had existed earlier, fell to the female crafts workers, whose numbers increased constantly in modern times. However, since many of these women were not professionals in the sense of having received the "classical" training at an academy, we must largely exclude them from our present considerations.

Some few women carried on the older traditions, e.g., the Swiss enamel painter Françoise Chatel (1832–1874), who came into the atelier of the well-known enamel artist Lamunière at an early age. After his death she joined forces with his widow in continuing to operate the shop for portraits on enamel. Another die-hard is the Swedish

Lea Ahlborn (1826–1897), the daughter of a die maker at the Royal Mint of Stockholm; after a period of studies in Paris she was appointed, after her father had died in 1853, to administer his position at the Mint; from 1855 on she became the officially appointed die maker for medals. For a period of time she singlehandedly kept medal engraving going in Sweden. Whole series of Swedish and Norwegian coins and medals came from her designs.

The German painter Leonore Bräuer (1857–1902) followed another tradition of the early forerunners in entering the area of scientific illustration: she completed a monumental work on human anatomy begun by her artist-father.

Besides mural artists, sculptors, painters and craftswomen who also worked in other areas as a sideline, we once again behold from the middle of the century on, women active in the graphic arts. The modern version of this branch, however, is oriented toward illustration of books and magazines, also of advertising art, and is known as free-lance graphics. Their practitioners have recaptured, despite the greater economical difficulties, some of the ground they had lost when the new reproduction methods had killed the craft of copper engraving; in a sense, they have revived a tradition of bygone ages, although the old-time printshop is gone; in modern shop work the women employées are "hands" or, at the most, draftswomen and model makers. The new style was dubbed "free studio," which opened after a steady clientele had been secured—not the easiest thing in those pioneering days. Nevertheless it can be seen that women have illustrated countless books published since, some even written by the artist herself—a recent example is Else Lasker-Schüler (1876–1945)—and that many periodicals had female collaborators.

A favorite field, then as now, are of course children's books. Modern book illustration for young readers was established by the painter, illustrator and author, Kate Greenaway (1846–1901), together with Walter Crane and Randolph Caldecott. One of her books, *Under the Window*, published, in 1880, also in German, reached an edition of 150,000 copies. Her style has become the "Greenaway style" and has been widely imitated.

Some graphic genres are peculiar to modern times, for example caricaturing, in which the Irish-French drafts-

woman Marie de Solms (1833–1902) has been a successful originator. She was a daughter of the Irish diplomatist Thomas Wyse and the princess Laetitia Bonaparte, whose father was Lucien Bonaparte and who had been married three times. Marie drew caricatures chiefly for the *Revue artistique d'Aix-les-Bains*. A German satirical artist of somewhat later date is Käthe Münzer-Neumann (born 1877), a pupil of Skarbina and others; she worked in Warsaw, Saint Petersburg and Berlin; besides portraits and landscapes she made drawings for the *Lustige Blätter, Ulk*, and other satirical periodicals. Generally speaking, many women's names appear in journals of the period, more particularly in the *Jugend*.

Speaking of journalism, the American painter, writer and critic, Helen Mary Knowlton (1832–1913), should be mentioned; an active artist in the Boston area for thirty years, she also published jointly with her sister, and was editor-in-chief of the art journal *The Worcester Palladium* for forty years.

Women also found their way into what nowadays is summed up in the term of commercial art. One of the most important artists in this branch is the German painter and graphic artist, Aenne Koken (1885–1919), who worked her way into the front ranks of commercial designers of the period: her work, such as, for instance, the packaging she designed for *Bahlsen-Keks*, were standard-setting at the period and extolled as models. Many women did poster design, for example the English Mabel Dearner (born 1872) who became also known as a writer; the daughter of an army surgeon, she began, in or around 1895, to create modern posters—i.e., "modern" for the period—besides making fanciful illustrations, in part for her own poetry, novels and mystery plays. There were others, but they are forgotten today—the fate of most poster designers of yesteryear.

A new field of creativity opened up for women artists around the turn of the century: stage and theatrical costume design, previously deemed to be exclusively a masculine preserve. A succession of Russian modernist painters were the pioneers in this branch. Russian women artists were more deeply engaged in the evolution of the avant-garde than the women of any other country; they had been instrumental in the formulations of the aims of cubism, suprematism and constructivism in the early years of the 20th century. Their generation has produced more highly gifted women in Russia than were ever seen before anywhere else.

Russia had been traditionally generous in the reception awarded women artists: we have seen the successes of Dorothea Gsell, Elisabeth Vigée-Lebrun and Marie Anne Collot-Falconet. Native Russian women, to be sure, are barely visible in the earlier times; some of the few of whom we have knowledge are the draftswoman and poetess Yekaterina Dershavina (1760–1794), foster-sister of the Czar Paul I and the first wife of the Russian statesman and poet Dershavin; and the engraver on copper, Marfa Dovgalev (born 1798), a graduate of the Saint Petersburg Academy and winner of several medals. Besides the sculptor Maria Annenkoff, in the middle years of the 19th century, the painter Emilia Gauger (born 1836) is noteworthy as winning the artist's diploma of the Saint Petersburg Academy; also the Livonian painter Julie Hagen-Schwarz (1824–1902), daughter and pupil of a painter, and later a student at the Academies of Dresden and Munich, and the painter Pelagia Couriard (1848–1898), who founded the first Russian association of women artists at Saint Petersburg in 1882.

After the Russian academies were opened officially to female students about mid-century, the roster of women artists begins to swell considerably, of whom the younger names gained European fame as protagonists of the avant-garde, as we have said. Most of them spent some time in Paris; some settled there for good, which is why they and their art have become better known in the western countries than those who worked at home, although the latter also frequently exhibited their work in the West. One of these is Natalia Davydoff (about 1874), a graduate of the Moscow Art School, later chiefly interested in reviving and fostering national Russian crafts and stylistic traditions; she conducted home workshops of this kind in Russian villages. Decorative designs of her's were shown at the Paris World Fair of 1900.

Some of the women painters who worked in Russia and the Soviet Union, respectively, were pupils of the famous painter, Ilya Repin: we name Olga Kardovska-Della Vos (born 1875), descendant of a family of Spanish immigrants, who likewise sent works to international art exhibitions—in 1908 she was awarded a stipend for for-

eign studies by the academy and, in the same year, also won a prize offered by the state—; and Zinaida Serebriakova (1884–1967), who settled in Paris in 1924. Another 20th century artist of importance is the painter Marianne von Werefkin (1860–1937), who came to Munich as early as 1896 and was closely associated with the artists' group *Blauer Reiter*.

Of the sculptors, we have already mentioned Anna Golubkina as a pupil of Rodin's, who attracted attention in 1890 at the Paris Salon with her portrait sculpture. Incidentally she had been sentenced to a year in prison because of participation in the revolution of 1905. Vera Mukhina has likewise been mentioned; she was a pupil of Juon and Mashkov in Moscow, later of Bourdelle in Paris; she became a professor at the Moscow Art Institute in 1927 and has come to be known chiefly through her monumental revolutionary sculptures.

But the chief contribution of Russian women artists of our time has been in contemporary stage design. During the last decades before the First World War, in Russia as well as in western Europe, tendencies attacking the antiquated methods of "academicism" had multiplied, and some of the Russian artists who were later to devote themselves to stage design had already attracted attention with their advance guard pictures. The best-known of them is probably Natalia Gontcharova (1881–1962). She started out as a sculpture student at the Moscow Academy with Pavel Trubetskoi, but made the acquaintance of the painter Mikhail Larionov in 1900, who influenced her to take up painting. From 1914 on she regularly designed sets and costumes for the *Ballets Russes* of Diaghilev which were spectacularly successful in Paris and London, and so were the designs by Gontcharova who often inspired herself with Russian folk art. Perhaps her most famous works in this genre are the sets and costumes for Rimski-Korsakov's opera *The Golden Cockerel* and Stravinsky's ballet *Les noces* (1923). In 1915 she accompanied Larionov, first to Switzerland and subsequently to Paris, where she continued to create designs for the Diaghilev theater, and later also for other ballet groups, such as the Ballets de Monte Carlo.

Next to her, we must also name Alexandra Exter (1882–1949) and Lyubov Popova (1889–1924); both have become known through their paintings which are an integral part of the modern Russian school, but especially through their theatrical work. Exter designed for Tairov, whose genius created the modern theater, and later also made film sets. After a promising start in poster and textile design, Popova became the collaborator of the important theater director Meyerhold in 1920, for whose Moscow theater she designed sets and costumes. Lastly, Sonya Delaunay (1885–1979), who was a native Russian who settled in Paris in 1907 after studies at Karlsruhe; associated at first with the Fauves group, she later opened a fashion studio for modern design, but continued to paint somewhat abstract compositions on the side. She was ninety years old when she designed the poster for the International Year of the Woman in 1975.

This breakthrough into artistic new territory on the part of the Russian and Soviet female avant-garde only seems unconnected with earlier phases; actually the link with the past is quite visible in the earlier development of the professional image of women artists in Russia, which process was consummated by the end of the preceding century, when German women, for instance, were still battling for their equality with men. Thus the Russian women artists reached a stage of self-confidence well in advance of their western sex-mates, and their self-realization was less obstructed. Better than that, in Russia the women had taken an active part in socio-political events, at least since the Decembrist Uprising in 1825; they had not excluded themselves from vital experience, like the women in many other lands, but to the contrary had often committed their entire personality to a cause which they saw as the right one; we need only to refer to Anna Golubkina. Thus they had won an assurance and strength which of course benefitted their art also. At a time when most of the European women artists still contented themselves with traditional themes, and painted portraits, animals, landscapes and genre scenes, the Russians had the courage to enter creatively into new artistic territories.

A similar élan may be noted from the mid-19th century on in the creations of American women artists. *Thieme-Becker* cites some 250 names for the period between 1850 and approximately 1935, but those are only of artists who became somewhat known in Europe; the actual number is much greater. American women, too,

contributed to the evolution of the professional image of the female artist at large. Many of them lived and worked in Europe, especially in Paris, where they often stayed for the rest of their lives. The influence they had on European women is not due to their training, which was not unlike the professional preparation of the latter, i.e., private instruction, advanced studies at some public institution either in the U.S. or in Europe, etc., but to their example of matter-of-factness and self-reliance with which they pursued their calling, unhampered by those inherited resentments and hostilities afflicting the female artists of Europe. Through their example the Americans, similarly to the Russian women, strengthened and encouraged their European colleagues to feel themselves as part of a great army of independently creative artists claiming equal rights with men in every respect.

The relatively narrow working conditions in Europe for women may have led a part of the Americans to return to their native land after finishing their studies, where they breathed a freer air, and better economic opportunities existed for women, although the increase, and therefore the competition, of female artists in the United States was also very considerable, some 15,000 painters and painting teachers being listed as active in the year 1900.

But many of them found a lasting second home in Paris. Perhaps the best-known is the painter Mary Cassatt (1845–1926). After initial training at the Pennsylvania Academy, followed by comprehensive studies in various European museums, she settled in 1874 in Paris, where she joined the Impressionist School, eventually advancing to leading rank in this movement. Her female portraits and mother-and-child scenes are absolutely comparable to the best impressionist painting anywhere. She was also influential in getting this style of painting accepted in America.

Rivière, Mlle.
Lady with Lyre

1806
State Museum of Fine Arts, A. S. Pushkin,
Moscow

The organization of the "Lady with Lyre" illustrates the style of the Empire. It is from the hand of a Parisian woman painter who has left numerous works; she is also said to have kept an atelier for painting instruction. In handling and details the composition reminds of David's famous portrait of Madame Recamier of 1800.

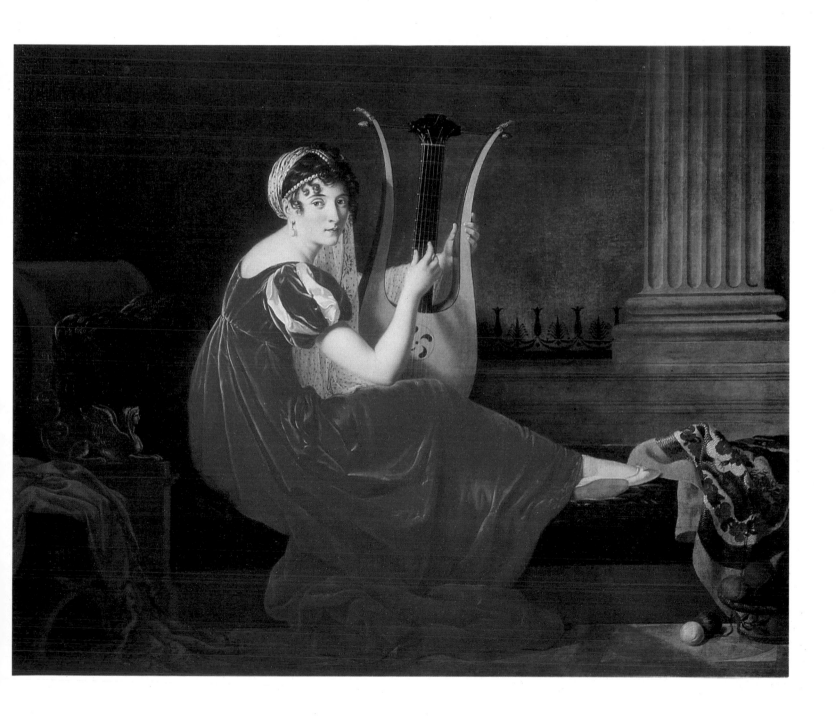

Ancher, Anna
Funeral Service

1891 / 103 × 124.cm
National Museum Copenhagen

Anna Ancher became a member of the
Copenhagen Art Academy in 1904. Her picture,
while remindful of turn-of-the-century genre
painting, is superior to the often objectionable
sentimentality of such scenes, because of its stark
and sincere handling of the theme.

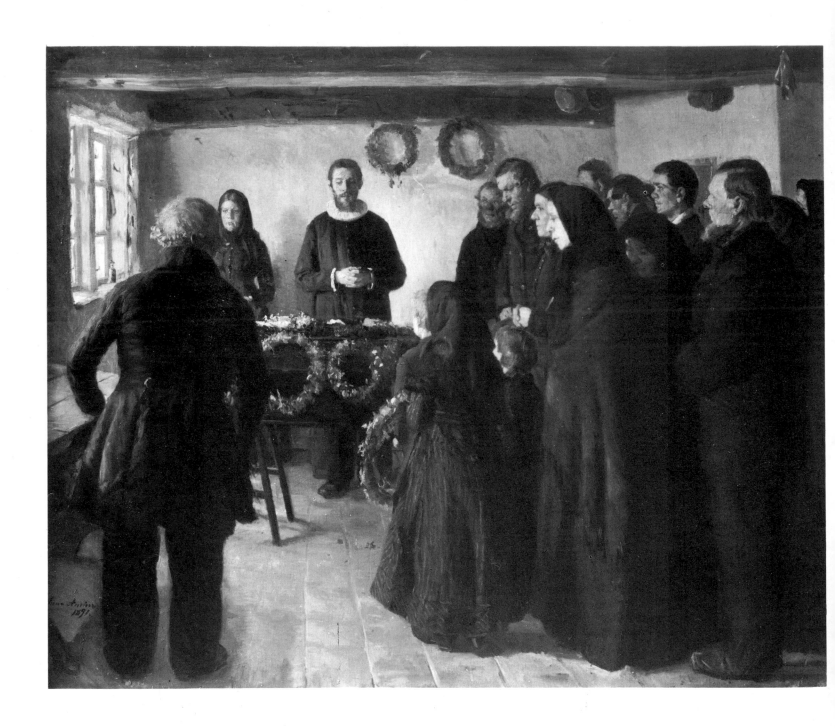

Bisschop-Swift, Catherine
A Painter's Widow

1870 / 79 × 52.5 cm
Rijksmuseum Amsterdam

The passion of the bourgeois public of the waning 19th century for sickly sob-scenes is met by this picture by the English artist Catherine Bisschop-Swift.

Krugelikova, Yelisaveta
Alexander Column

undated / colored drawing
State Tretyakov Gallery Moscow

The Russian graphic artist Yelisaveta
Krugelikova was a student at the Moscow State
Art School and later became a professor at the
Academy of Art in Leningrad. Her colored
drawing is a fine example of an architectural
scene combining the virtues of topographical
accuracy with an emotionally charged quality.

Mannheimer, Charlotte
Painting Class

undated / 46 × 43 cm
Art Museum Göteborg

This inside view of a women's painting class of
the late 19th century by the Swedish artist,
Charlotte Mannheimer, is typical for the period:
the plaster cast of the male statue in the
foreground is clearly visible, while the nude life
model in the distance is seen only indistinctly.

Collart, Marie
Stableyard in Brabant
1890 / 140 × 120 cm
Koninklijk Museum voor Schone Kunsten
Antwerp

The Belgian painter Marie Collart used to be represented in international art exhibitions for nearly 35 years. Known especially as a landscapist, she earned many prizes and medals in Paris, Vienna, Brussels, Geneva, Chicago and elsewhere. Her "Stableyard," although a little too conventional, shows sound training and a good sense of reality.

Breslau, Louise Cathérine
Parisian Street Urchins

1885 / 100 × 81 cm
Kunsthaus Zürich

Louise Cathérine Breslau was the daughter of a Munich physician. She lived and worked in Paris, where an exhibition of her paintings in the Galérie Petit in 1904 attracted the attention of the public toward her work. She thereupon achieved a degree of sudden fame, which however soon after faded away again; in 1901 she was made a Chevalier of the Legion of Honor. Her "Parisian Street Urchins" are certainly not social criticism, but they are equally remote from painting of compassion and one may be excused in beholding in this picture a first move toward portraying proletarian youth as it really is, still quite uncommon at her period.

Caspar-Filser, Maria
Spring Sunshine

1912 / 76 × 92 cm
Staatliche Museen zu Berlin, Nationalgalerie

The painter Maria Caspar-Filser counts amongst the best-known German women landscapists of the turn of the century. Most of her voluminous production was dedicated to Alpine motifs, like our illustration.

Seidler, Louise
Boy Holding a Dove

1826 / 37 × 29 cm
Museen der Stadt Erfurt, Angermuseum

Louise Seidler belonged to the circle of women artists encouraged by Goethe; her talent produced graceful, although not very profound, works, as this somewhat conventional portrait of a boy indicates.

Grant, Mary
Portrait Bust of Sir Francis Grant

1866 / marble / height 67 cm
National Portrait Gallery, London

As a niece of the President of the Royal Academy, Sir Francis Grant, the sculptor Mary Grant obtained many commissions from the court and from society. She is also responsible for statues in the cathedrals of Lichfield, Winchester and Edinburgh. This portrait bust of her uncle may be too academically conceived but it shows sound technical ability.

Soyer, Emma
Plaster Cast Vendor

1841 / 45 × 38 cm
Museen der Stadt Gotha, Schlossmuseum

Emma Soyer's drawing is one of the few works by female artists of the period in which a person of the "lower" classes is shown from life, albeit merely genre-like and without social involvement. Emma Soyer worked in Paris and England.

Monjé, Paula
A German Public Merrymaking
of the 16th Century

1883 / 207 × 165 cm
Staatliche Museen zu Berlin, Nationalgalerie

This busy folk scene by the Düsseldorf painter Paula Monjé appeals to the popular demand for folksy and idyllic, "historicizing" subjects of the early Wilhelminian era; in our time it looks antiquated and stuffy, but as recently as 1905 it was still highly vaunted by Anton Hirsch as "breathing a serene joy of living."

Bardua, Caroline
Portrait of the Baron Friedrich
de la Motte Fouqué

1827 / 56 × 44 cm
Staatliche Galerie Dessau

Friedrich de la Motte Fouqué is remembered chiefly as the author of the fairytale *Undine*, which was set to music by E. T. A. Hoffmann and Lortzing, and also for his role in the Wars of

Liberation. Although he posed for Caroline Bardua in his uniform with orders and medals, she has succeeded to portray him as an intrinsically civilized and poetic being.

Cassatt, Mary
Mother Washing her Tired Child

1880 / 100 × 65 cm
County Museum of Art, Los Angeles, California

The American Mary Cassatt, when in Paris, joined the circle of the Impressionists and is one of the few woman painters who have achieved some importance in this school. The painting here is on a level with works by Renoir, Manet and other leaders of Impressionism.

Holten, Sofie
August Strindberg

1885 / 148 × 85 cm
National Museum, Stockholm

This interesting three quarter length portrait of the Swedish poet August Strindberg (1848–1912) is the creation of the Danish painter Sofie Holten. She interprets admirably the dualistic character of Strindberg, even in the structuring of the body pose, which reminds one of *Art Nouveau*.

Modersohn-Becker, Paula
Sketchbook Page with
Two Study Heads

undated / pencil and red chalk / 31 × 37 cm
Staatliche Museen zu Berlin, Kupferstichkabinett
und Sammlung der Zeichnungen

The painter Paula Modersohn-Becker had a brief professional life of only ten years, as she died in 1907 at the age of 31, after the birth of her first child. She was married to the painter, Otto Modersohn, and belonged to the group of artists who had formed the artists' colony of Worpswede, in protest against the academicism of their time. Paula Modersohn-Becker's recognition as a major figure in art has been tardy; some of her works were destroyed by the Fascists as "degenerate art." Together with Käthe Kollwitz, Paula Modersohn-Becker is the most important German woman painter of the 20th century. Her study page, here reproduced, testifies to the sincerity of her artistic conception, and the "Goose Girl" likewise has nothing of a village idyl about it, but is a serious statement of the sorrow of existence.

172

Modersohn-Becker, Paula
The Goose Girl

1899–1902 / etching / 25.1 × 20.3 cm
Staatliche Museen zu Berlin, Kupferstichkabinett
und Sammlung der Zeichnungen

Boberg, Anna
The Valley of Jehoshaphat
1921 / 65 × 80 cm
National Museum Stockholm

Besides landscapes such as we illustrate here, broad in vision and of vigorous brushwork, the Swedish painter Anna Boberg also did more decorative works for public buildings in Stockholm. She was well-known in her time and often exhibited in Paris and Berlin.

Yakunchikova, Maria
Church of the Old Estate
Cheremushka near Moscow

1897 / 64.4 × 46 cm
State Tretyakov Gallery Moscow

The Russian painter Yakunchikova who died at an early age anticipated to a certain degree tendencies of Expressionism in this painting. This becomes evident in the moving, dynamic depiction of a static motif which besides shows her special interest for traditions in Russian art.

Goncharova, Natalia
Self-Portrait with Yellow Lilies

1907 / 23 × 17 cm
State Tretyakov Gallery Moscow

In Western Europe Natalia Goncharova is probably the best-known Russian woman painter of the early 20th century. She was part of the Russian avant-garde from about 1913 on and was also a significant stage designer. In her self-portrait, she is working out problems of the style of *Art Nouveau*, but she has scrutinized herself in a soberly critical manner.

Popova, Lyubov
Man—Air—Space

undated / 125 × 107 cm
Russian Museum Leningrad

This example of the art of the Russian avant-garde certainly dates back to the period before 1920 for the artist worked exclusively for the theater and industry after 1920. The painting was made when she was closely connected with the circle of futurist artists of Moscow.

Kraszevska, Ottolia, countess
Scherzo
Jugend, 1898

Olga or Ottolia, countess Kraszevska, was born in 1859 at Zhitomir and settled after a period of studies at Saint Petersburg in Munich in 1890. She became one of the star illustrators in the staff of the *Jugend*, doing also easel paintings on her own, and painting fans. Her drawings express the taste of the time, which was largely fashioned by the magazine for which she worked.

Wolf-Thorn, Julie
Title Page of Jugend, 1898

The design for this title page is a characteristic
example of the bold and provoking editorial
attitude of the *Jugend*.

Mädchensommer
Von Ernst Rosmer.

I.

Sie haben viel von Dir gesprochen,
Nur ich hab' nicht ein Wort gesagt,
Hab' nichts berichtet, nichts gefragt,
Nur in den Wangen fühlt' ich's pochen.

Brach Blumen von der grünen Matte
Und flocht sie mir in's helle Haar.
Daß ich so gar verschwiegen war —
Weil ich zu viel zu sagen hatte.

II.

Wo steht denn in aller Welt geschrieben:
Die Prinzessin darf nur einen Prinzen
 lieben?
Wie ging' es denn allem Poetenspiel,
Wenn nicht der Prinzessin der Bauer gefiel?

III.

Am Morgen gold'nes Sonnenzittern,
Am Mittag dunkles Wolkengewittern.
Enttäuschter Tag! Wird den leidgelösten
Ein hellgerötheter Abend trösten?

IV.

Schweige, schweige und warte!
Warte, warte und schweige!
Der Tag geht zur Neige.
Was er vergebens erharrte,
Kann Dir auf feuchten Schwingen
Ein neuer Morgen bringen.
Warte, warte und schweige!
Schweige, schweige und warte!

V.

Ach wär ich nicht so zwiefach gesponnen
Da sitzt ein Mädel, verliebt und versonnen,
Und kann in stundenlangem Verträumen
Den Tag versäumen.
Aber da stellt sich ihm zur Seite
Der spöttisch blickende Seelenzweite,
Der hagere, klug' und wilde Geselle
Mit Augenhelle.
Mit scharfen Worten und scharfen Blicken,
Mit Händen, die alle Blumen knicken
Und was verliebt, verträumt und versonnen
Ist all zerronnen.

VI.

Viele Wörtlein hab' ich geschrieben,
Lustige, lose,
Nur eines nicht.
Wie man dem Kind,
Dem man süß gesinnt,
Viel Blumen scherkt und mehr noch
 verspricht,
Nur keine Rose —
Viele Wörtlein hab' ich geschrieben,
Nur eines nicht —

VII.

Das weiß nun Keiner!
Nur Blumen und Licht,
Ein graues Vöglein, ein arm Gedicht
O wüßt' es Einer!

Dauert es lange, dauert's ein Jährchen,
Das ungestandene Liebesmärchen?
Noch blüht es um alle Fenster und Mauern —
Dauern wird es ein Rosendauern!

VIII.

Was willst Du denn? Ja, wenn ich das
 wüßt'!
Das kann kein Weiser der Welt versteh'n!
Ich möchte, daß er mich einmal küßt
Und sterbe, eh' ich es laß gescheh'n!

IX.

Aus der Kirche leise Orgelklänge,
In den Wipfeln leise Windgesänge.
Hab' mich müd gefreut und müd gelitten,
Möcht' um Ruh' den Vater unser bitten.

X.

Da wir uns erst geseh'n,
Hauchte ein Sommerweh'n
Weit durch den Hag.
Sommervöglein sang
Bach und Birken entlang
Im Sonnentag.

Bis wir uns wiederseh'n,
Wird's über die Gassen schnee'n.
Wohl ist es gut.
Wintervögelein sag',
Wo mein sonniger Tag
Begraben ruht

Margarethe v. Brauchitsch (Halle).

CONCLUSION

If the achievements of women since the time when our professional profile begins were to be resumed in a single sentence, the saying of Lu Märten comes to mind: "The cause for wonder is in women accomplishing so much in the face of obstacles, not in their not accomplishing more." The obstacles varied with the different periods, and conditioned feminine life to an extent where one cannot speak of a continuous evolution of art by women, in the sense that art at large (i.e., male art) is always more or less continuous in all countries and times. Far more than men, women depended on the sociological structure of their respective periods in the over-all picture of European art, with the addition and added handicap of their biological function, of which it could still be asserted, not very long ago, that it must prohibit creativity a priori, regardless whether this judgment referred to a mother of a family or to an unmarried woman.

The criteria whereby the creations of women were judged during the past centuries were dictated by the conception of ideal femininity of each period. Works of art by women received praise in the Renaissance and the sensuous rococo, because their critics looked for sensations, and in adoring the works of women adored their sex; at other periods, e.g., in the later years of the 19th century, the fruit of their labors met with a studied neglect, because of the scepticism with which the Women's Movement was regarded. Statements like "pretty good for a woman," or "almost good enough to be by a man" abound through the ages and surely betray a perhaps

Brauchitsch, Margarethe von
Margin
Jugend, 1898

Several women artists have contributed to the design of the *Jugend* during its existence.

quite unconscious subjectivity of the critic. This type of attitude is even more pronounced when reproach is mingling with criticism, for instance, when it is said that such and such an artist is "unwomanly" or that she "exceeds the boundaries set by Nature herself." In this subjective type of criticism, the word "like a man" is meant as praise; "unwomanly" is depreciatory.

Be that as it may—if the yardstick by which the works of male artists were measured was to a good extent codetermined by the collective criteria of contemporary art appreciation and philosophical concepts of the over-all function of art in society, which varied of course with the different social climates of countries and the Spirit of the Age, how much more open to all this was the critique of women's art, burdened as it was by the subjective but constantly changing demands made of the ideal feminine type from century to century. Epochs when women had been free to unfold their personalities were followed by restrictive periods in which meeknees and modesty were the watchword, and the productions of female art were judged accordingly.

At its worst, the critique of art by men was safe from such variable gauges which are constituted by an ideal conception of "true" femininity, thus of course also of the creative woman; episodes like the scene in Johanna Schopenhauer's house with Goethe and Caroline Bardua could scarcely have occurred in Renaissance times.

If female artists, tolerated more or less gladly according to the times, have stayed with their vocation for so many centuries, despite fluctuating standards and their unfavorable effect on any continuity of creativity by which women's works were judged—if they have been both willing and able to face and to overcome all kinds of handicaps, and have adhered to their calling so stoutly, the most likely explanation is, that it was the only profes-

sion open to women, their only outlet for creative talents, because the other artistic careers were traditionally deficient either in economic guarantees or in social respectability. Many women had musical and literary talents as well as visual-plastic gifts; where we have seen some of them, for instance Angelika Kauffmann or Caroline Bardua, initially undecided whether to become a musician or a painter, ultimately choosing painting as a career, we may guess that they did so because the painter's profession was the most likely to combine economic and social advantages.

Compared to the numbers of men, the roster of women artists may not be great, although future research is likely to add to it, but without their works the international art scene would be the poorer in many respects, particularly in the middle range of achievement, which tells the most of the general state of the arts of a given country. We do not deny that female artists have occasionally produced substandard works, or that in many cases their level of attainment was below that of men's art, for reasons which we have tried to explain, and never forgetting that works of art were and are rated by subjectively fluctuating standards. The overall result of the intensive study of women's art in more recent times shows that their productions were not only more varied than was previously known—which of course, says nothing about their quality—but also that women have often created works entirely on a level of parity with those of famous male contemporaries.

The intention of our study was not so much one of quality evaluation as of reconstructing, to the extent to which this was possible, the conditions of professional production under which women artists have worked. In consequence of this plan, many celebrated women were given less attention than their fame deserves, since the emphasis was to be given to the circumstances in which illustrious as well as forgotten female artists have created their works. References to the famous few were kept down for the sake of the many, though obscure, who may have gone unnoticed in their lifetime, but have been here included because of the living and working conditions which their histories seem to illustrate.

The way in which this professional image shaped itself was, as we have tried to underline, subject to the shifting patterns of the respective periods, and depended, to a great extent, on the relative position of women in society. No woman who took her calling seriously has ever found it easy to make a living with her art. Almost always women artists had to invest most of their strength in their profession, often more so than men in comparable situations. But their reward was an independence which few of their sexmates, the highest strata of society perhaps excepted, could call their own. As they earned their own living, they did not have to concern themselves unduly with bourgeois notions of propriety; nevertheless they enjoyed not only individual freedom, but also—unless driven to the margin of the existence-minimum (as indeed many of them were in the late 19th and early 20th centuries)—they mustered the kind of social recognition of personal merit which is the due of every creative effort and which society is willing to give, although its standards may vary in different periods.

Summing up, we stress once again that, in the free Fine Arts, women had conquered, and maintained themselves in, an area of productivity which no other profession had offered them, at least not for so long and unbroken an historical period. There is hardly a branch of painting, sculpting or the graphic arts in which women have not worked with success; even in monumental art they have held their own, when they were trusted with a commission. If French artists led the van in the 18th and 19th centuries, the women of other countries in Europe were never far behind, and, in their time, Americans ran them close and have done their part to round out and consolidate the professional image. We have been obliged to omit discussion of China, Japan, India—in fact, of the whole Asian hemisphere including Australia, because of the absence of sufficient information. The isolated reports of the activity of women artists here and there in this vast region do not offer enough material for a total profile. We have therefore confined our interpretations to the European-American areas.

Our investigations end, as was stated, approximately with the point in time at which women were admitted to the academies on the same basis as men even in previously backward Germany. This period marks the beginning of equal legal and professional rights of women in regard to their male colleagues, and, in theory, ends the ages-

long discrimination on account of sex against which they had never ceased to protest. In practice, many of the ancient prejudices are still operating, because it seems probable that in many professions the biological and other limitations imposed upon women by their nature will be to their disadvantage. Their cry of "Regardless!" therefore does not only do them honor, but should, above all, be instrumental to remove lingering reservations on the part of the general public in regard to feminine creativity, of which myriads of proofs exist. Defining the term of "creativity," it seems fair to add that we do not intend to claim this quality for all the works of women we have enumerated, in the modern sense of the term; more than half of these artists belong, more properly, amongst the re-creative artists, analogous to musicians and stage artists, but of course this is equally true for men. Even famous figures were not invariably originators, but prac-

ticed, rather, traditional approaches which they have inherited; an art which, provided that the craftmanship is of a high order and the best quality, has been honored by society.

If thousands of women in a period of four centuries were able to transcend this respectable, craft-oriented middle ground and to rise to the sphere of artistic invention and originality, they thank this, aside from their personal endowment of talent, industry and energy, to their membership in a universally approved profession—the only one that was granted them for nearly a millennium which could give them the kind of independence without which creativity cannot prosper. Of historical growth, many-sided within clearly defined boundaries, the profession of the Fine Arts was the only occupation to lend women the support and security which they needed for the unfolding of their full potential.

APPENDIX

BIBLIOGRAPHY

Reference books and compendia

NAGLER, G. K.: *Neues Allgemeines Künstlerlexikon.* Leipzig Berlin, 1835 ff.

THIEME, U., and F. BECKER, *Allgemeines Lexikon der bildenden Künstler von der Antike bis zur Gegenwart.* Leipzig, 1907–1950.

VOLLMER, H.: *Allgemeines Lexikon der bildenden Künstler des XX. Jahrhunderts.* Leipzig, 1953–1962.

Exhibition catalogs

HARRIS, A. S., and L. NOCHLIN: *Women Artists.* Los Angeles, Country Museum of Art, 1976. New York, 1976.

Deutsche bildende Künstlerinnen von der Goethezeit bis zur Gegenwart. Berlin, Staatliche Museen, 1975.

Künstlerinnen international 1877–1977. Berlin (West), Schloss Charlottenburg, 1977.

Künstlerinnen der russischen Avantgarde 1910–1930. Cologne, Galerie Gmurzynska, 1979.

Stadtpfarrkirche St. Lorenz Kempten, Katalog zur Baugeschichte. Series *Kleine Kunstführer.* Munich, Zürich, no year.

Select bibliography

ARKIN, D. E.: *Vera Muchina.* Dresden, 1958.

BASHKIRZEVA, M.: *Tagebuchblätter und Briefwechsel.* Berlin, Leipzig, 1908.

BECKER-CANTARINO, B. (ed.): *Die Frau von der Reformation zur Romantik.* Bonn, 1980.

BERGER, R.: *Malerinnen auf dem Weg ins 20. Jahrhundert.* Cologne, 1982.

BONUS-JEEP, B.: *Sechzig Jahre Freundschaft mit Käthe Kollwitz.* Boppard, 1948.

BÖRSCH-SUPPAN, H.: *Die Kataloge der Berliner Akademie-Ausstellungen 1786–1850.* Berlin (West), 1971.

BRAUN, L.: *Die Frauenfrage.* Leipzig, 1901.

BRODMEIER, B.: *Die Frau im Handwerk.* Münster, 1963.

BURCKHARDT, J.: *Die Kultur der Renaissance in Italien.* Berlin, 1941.

CASSIRER, E.: *Künstlerbriefe aus dem 19. Jahrhundert.* Berlin, 1923.

COLLINS, J., and G. B. OPITZ (ed.): *Women Artists in America. 18th Century to the Present (1790–1980).* 3rd edition, New York, 1980.

DREY, P.: *Die wirtschaftlichen Grundlagen der Malkunst.* Stuttgart, Berlin, 1910.

EBERT, H.: *Die Kriegsverluste der Dresdner Gemäldegalerie.* Dresden, 1963.

FEIST, P. H.: *Künstler, Kunstwerk und Gesellschaft.* Dresden, 1978.

FIDIÈRE, O.: *Les femmes artistes à l'Académie Royale.* Paris, 1885.

GREER, G.: *The obstacle race.* London, 1979.

GRIMM, H.: "Goethe und Luise Seidler", in: *Fünfzehn Essays.* lst series, Berlin, 1884.

GUHL, E.: *Die Frau in der Kunstgeschichte.* Berlin, 1858.

HARMS, J.: *Judith Leyster, Leben und Werk.* Frankfurt (Main), 1927.

HAUSER, A.: *Kunst und Gesellschaft.* Munich, 1973.

HAUSER, A.: *Soziologie der Kunst.* Munich, 1974.

HILDEBRANDT, E.: *Leben, Werke und Schriften des Bildhauers E. M. Falconet.* Strasbourg, 1908.

HILDEBRANDT, H.: *Die Frau als Künstlerin.* Berlin, 1928.

HIRSCH, A.: *Die Frau in der Bildenden Kunst.* Stuttgart, 1905.

HIRSCH, A.: *Die Bildenden Künstlerinnen der Neuzeit.* Stuttgart, 1905.

HOERSCHELMANN, E. VON: *Rosalba Carriera.* Leipzig, 1908.

JANSA, F.: *Deutsche Bildende Künstler in Wort und Bild.* Leipzig, 1912.

KOCH, G. F.: *Die Kunstausstellungen.* Berlin (West), 1967.

KOLLWITZ, K.: *Aus Tagebüchern und Briefen.* Berlin, 1964.

KRICHBAUM, J., and R. A. ZONDERGELD: *Künstlerinnen von der Antike bis zur Gegenwart.* Cologne, 1979.

KRÜNITZ, T. G.: *Ökonomisch-technische Enzyklopädie.* Brünn, 1793.

LEHMANN, H.: *Das Kunststudium der Frauen.* Darmstadt, 1913.

LEWALD, F.: *Italienisches Tagebuch.* Berlin (West), 1967.

MÄRTEN, L.: *Die Künstlerin.* Munich, 1914.

MAILLINGER, J.: *Bilder-Chronik der Königlichen Haupt- und Residenzstadt München.* Munich, 1876–1886.

MÜLLER, H.: *Die Königliche Akademie der Künste zu Berlin 1696–1896.* Berlin, 1896.

MUNSTERBERG, H.: *A History of Women Artists.* New York, 1975.

NABAKOWSKI, G., SANDER, H., and P. GORSEN: *Frauen in der Kunst.* 2 vols. Frankfurt (Main), 1980.

ÖTTINGEN, W. VON: *Daniel Chodowiecki.* Berlin, 1895.

PETERSEN, K., and J. G. WILSON: *Women Artists, Recognition and Reappraisel.* New York, 1976.

SACHS, H.: *Die Frau in der Renaissance.* Leipzig, 1970.

SCHEFFLER, K.: *Die Frau in der Kunstgeschichte.* Berlin, 1908.

SCHEIDIG, W.: *Die Weimarer Malerschule.* Weimar, 1950.

SCHOPENHAUER, J.: *Ihr Glücklichen Augen.* Berlin, 1978.

SEIDLER, L.: *Erinnerungen.* Weimar, 1962.

STOLL, A.: *Der Maler Johann Friedrich August Tischbein und seine Familie.* Stuttgart, 1923.

TUFTS, E.: *Our Hidden Heritage.* New York, London, 1975.

VASARI, G.: *Lebensbeschreibungen der berühmtesten Architekten, Bildhauer und Maler.* Edited by Gottschewski and Gronau. Strasbourg, 1960 ff.

VIGÉE-LEBRUN, E.: *Souvenirs.* Weimar, 1912.

VOSS, G.: "Die Frau in der Kunst", in: *Der Existenzkampf der Frau.* Ed.: G. Dahms. Berlin, 1895.

WERNER, J.: *Die Schwestern Bardua.* Leipzig, 1929.

WIESNER, M.: *Die Akademie der Bildenden Künste zu Dresden.* Dresden, 1864.

WITTKOPP-MÉNARDEAU: *Madame Tussaud—ein seltsames Leben.* Zurich, 1973.

WITTKOWER, R. AND M.: *Künstler—Aussenseiter der Gesellschaft.* Stuttgart. 1965.

ZAHN-HARNACK, A. VON: *80 Jahre Frauenbewegung 1849–1928.* Berlin, no year.

INDEX

The artists are listed under the names under which they generally are known. Maiden names or married names are indicated in some cases. The numbers in roman type refer to the text and those in *italics* to the illustrations.

SOURCES OF ILLUSTRATIONS

Alinari, Florence 68
Breitenborn, Dieter, Berlin 164
Corvina Kiádo, Budapest 86
County Museum of Art, Los Angeles/Cal. 170
Deutsche Fotothek, Dresden 139, 140
Herzog Anton Ulrich-Museum, Brunswick 23
Koninklijk Instituut voor het Kunstpatrimonium, Brussels 69, 90, 162
Korff, Heinz, Berlin 178, 179, 180
Kunsthaus Zurich 92r., 163
Kunsthistorisches Museum, Vienna 19, 25, 83
Kunstsammlungen der Veste Coburg 15, 52, 57, 60, 62, 73, 75, 77, 78, 109, 110l.
Madame Tussaud's Ltd., London 41
Metropolitan Museum of Art, New York 41, 132, 135
Museen der Stadt Erfurt 165
Museen der Stadt Gotha 106, 107

Museum der bildenden Künste, Leipzig
 42, 43, 45, 104/105
Museum of African Art, Washington 48
Museum of Art, Göteborg 65, 161
Museum of Fine Arts, Budapest 95
National Museum Poznan 18
National Museum Stockholm 64, 96, 118l., 171, 174
National Museum Warsaw 20, 39, 127, 133
National Portrait Gallery, London 63, 97, 98, 100, 166
Novosti, Moscow 70, 176
Öffentliche Kunstsammlung, Basel 22
Österreichische Galerie, Vienna 99
Petersen, Hans, Hornbaek 37, 158
Photo Meyer, Vienna 26/27, 72, 117
Photo studio Otto, Vienna 108
Picture library Preussischer Kulturbesitz,
 Berlin (West) 17, 53, 54, 55, 61, 85, 130
Reinhold, Gerhard, Leipzig 21, 24, 81, 82, 88, 101, 122, 124
Rijksmuseum Amsterdam 28, 59, 118r., 159

Santa Barbara Museum of Art, Santa Barbara/
 Cal. 107
Schröter, Wolfgang, Leipzig 120, 121
Service de documentation photographique de
 la Réunion des musées nationaux, Paris 40,
 94, 102, 103, 136, 137
Staatliche Galerie Dessau 89, 91, 169
Staatliche Kunstsammlungen Dresden 44, 87,
 123, 125
Staatliche Museen zu Berlin 38, 46, 47, 51, 58, 66,
 67, 71, 92, 110r., 119, 128, 129, 168, 172, 173
Staatsgalerie Stuttgart 84, 93
Virginia Museum of Fine Arts, Richmond/Virg.
 138
Vnezhtorgizdat, Moscow 126, 131, 157, 160,
 175, 177